Virginia Plantation Homes

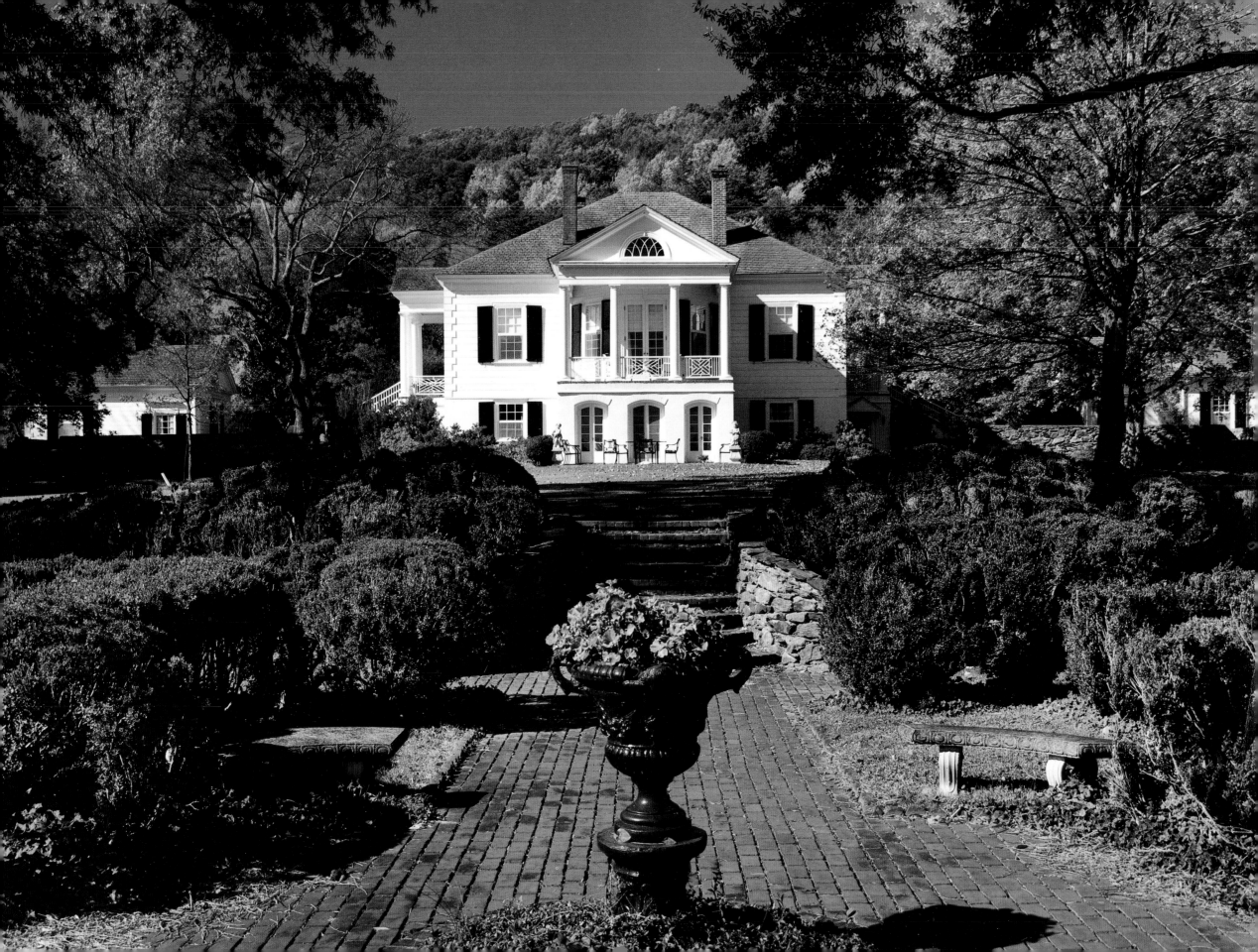

Virginia Plantation Homes

Photographs and Text by
DAVID KING GLEASON

LOUISIANA STATE UNIVERSITY PRESS
Baton Rouge and London

Copyright © 1989 by Louisiana State University Press
All rights reserved
Manufactured in Japan
First printing

98 97 96 95 94 93 92 91 90 89 5 4 3 2 1

Designer: Laura Roubique Gleason
Typeface: Bembo
Typesetter: G & S Typesetters, Inc.
Printer and Binder: Dai Nippon, Tokyo, Japan

Library of Congress Cataloging-in-Publication Data
Gleason, David K.
 Virginia plantation homes/photographs and text
 by David King Gleason.
 p. cm.
 Includes index.
 ISBN 0-8071-1570-3 (alk. paper)
 1. Plantations—Virginia—Pictorial works.
 2. Dwellings—Virginia—Pictorial works. 3. Vir-
 ginia—Description and travel—1981– —Views.
 I. Title.
 F227.G58 1989
 975.5—dc20 89-31733
 CIP

Frontispiece: Edgemont

The paper in this book meets the guidelines for
permanence and durability of the Committee on
Production Guidelines for Book Longevity of the
Council on Library Resources. ∞

The owners and managers of the Virginia plantation homes we visited welcomed us with a gracious hospitality that was a delight to experience. Others went far beyond the demands of southern hospitality and took much time out of their busy schedules to help us. My wife Josie and I would like to thank them personally: William T. Stevens, Stevens Realtors, Charlottesville; Calder Loth, Virginia Division of Historic Landmarks; Jack Francis, Association for the Preservation of Virginia Antiquities; Richard Couture, Bolling Island; Rosemary Hall, Tuckahoe; Ron Singleton, Mary Washington College; Mary Calos, Hopewell; and Ken Kipps, Colonial Williamsburg Foundation.

Special thanks to Adrian Callais, Jr., architect, and to the staff at Gleason Photography, who kept the studio running while we were on the road for three months: Gisela O'Brien, studio manager, who printed all my sometimes-erratic negatives; Craig Saucier, research assistant and "finder extraordinaire"; Cyndy Branton, who ran the office; Sondra Dornier and Paige Dugas, receptionists and all-round assistants; and Peggy Galmon, who keeps our place livable.

I would also like to thank the staff at the Pentax facility in Atlanta, who kept my 6 x 7s and assorted lenses in A-1 condition and responded to my small emergencies with alacrity and good spirits; the staff at Balcar-Techno in Chicago, who did the same with my Balcar MonoBloc strobes; and Pete Stadler from Eastman Kodak.

To George Scheer,
My friend and mentor

Contents

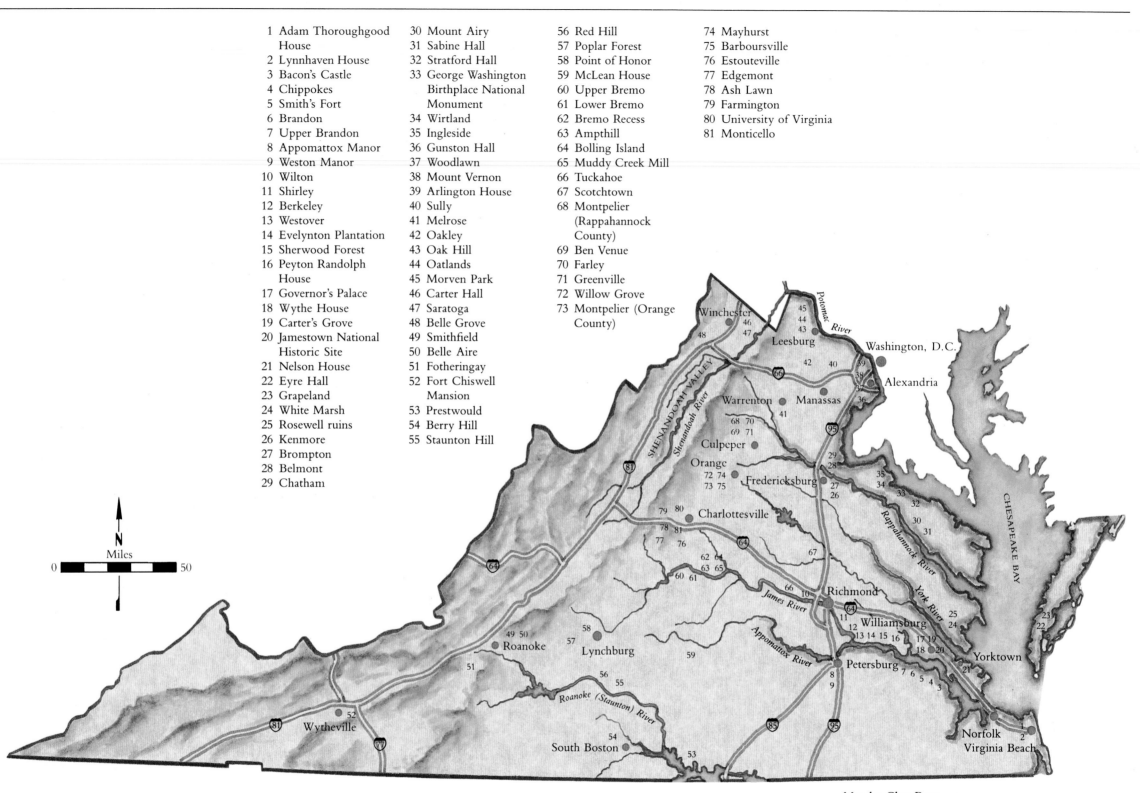

1 Adam Thoroughgood House
2 Lynnhaven House
3 Bacon's Castle
4 Chippokes
5 Smith's Fort
6 Brandon
7 Upper Brandon
8 Appomattox Manor
9 Weston Manor
10 Wilton
11 Shirley
12 Berkeley
13 Westover
14 Evelynton Plantation
15 Sherwood Forest
16 Peyton Randolph House
17 Governor's Palace
18 Wythe House
19 Carter's Grove
20 Jamestown National Historic Site
21 Nelson House
22 Eyre Hall
23 Grapeland
24 White Marsh
25 Rosewell ruins
26 Kenmore
27 Brompton
28 Belmont
29 Chatham
30 Mount Airy
31 Sabine Hall
32 Stratford Hall
33 George Washington Birthplace National Monument
34 Wirtland
35 Ingleside
36 Gunston Hall
37 Woodlawn
38 Mount Vernon
39 Arlington House
40 Sully
41 Melrose
42 Oakley
43 Oak Hill
44 Oatlands
45 Morven Park
46 Carter Hall
47 Saratoga
48 Belle Grove
49 Smithfield
50 Belle Aire
51 Fotheringay
52 Fort Chiswell Mansion
53 Prestwould
54 Berry Hill
55 Staunton Hill
56 Red Hill
57 Poplar Forest
58 Point of Honor
59 McLean House
60 Upper Bremo
61 Lower Bremo
62 Bremo Recess
63 Ampthill
64 Bolling Island
65 Muddy Creek Mill
66 Tuckahoe
67 Scotchtown
68 Montpelier (Rappahannock County)
69 Ben Venue
70 Farley
71 Greenville
72 Willow Grove
73 Montpelier (Orange County)
74 Mayhurst
75 Barboursville
76 Estouteville
77 Edgemont
78 Ash Lawn
79 Farmington
80 University of Virginia
81 Monticello

Map by Chet Boze

A Note on the Plantations and Architecture

by CALDER LOTH
SENIOR ARCHITECTURAL HISTORIAN
VIRGINIA DIVISION OF HISTORIC LANDMARKS

Virginia's historic plantations are one of America's great cultural treasures. Not only do they tell us much about domestic life and agrarian economy in our country's formative years, but they give us a glimpse of the environment into which many of our greatest leaders were born, the environment that nourished them materially, intellectually, and spiritually. The plantations, particularly the houses and their landscaped settings, also constitute a great artistic heritage. Some of Virginia's plantation dwellings represent the highest level of America's architectural achievement in the colonial, Federal, and antebellum periods. The houses illustrate the most exacting standards in design, craftsmanship, and materials, and their settings show the attention given to siting and garden layout.

The term *plantation* is used loosely not only in Virginia but throughout the South. In its historical sense, a plantation was an agricultural unit of hundreds, and in some cases thousands, of acres on which one or more cash crops were grown. The crops required tending and harvesting by a large labor force, which before emancipation was provided by slaves. A plantation was distinct from a family farm; in its strictest sense the latter was a much smaller unit producing a broad range of foods and other agricultural products to meet the direct needs of the owning family, whose members provided the labor. The owner of a plantation was called a planter but did no planting or manual labor. He served as the chief executive officer of what was for its time a complex form of agribusiness.

In Virginia, applying the term *plantation* to a property's name is primarily a modern practice. A place was called merely Westover, for example, not Westover plantation. A small plantation, particularly during the early colonial period, was most often called by the name of the owning family, such as Thoroughgood's. Also, except in rare instances, only the land was named, not the house. Indeed, a majority of plantation names allude to some physical characteristic of the land: Berry Hill, Belle Grove, Poplar Forest, and the like. Many other names honored places in the British Isles from which the settlers or their ancestors came: Brandon, Brompton, Wilton, Stratford.

The establishment of the Virginia plantation system came on the heels of John Rolfe's successful cultivation of tobacco in 1614. Tobacco provided the fledgling colony's first marketable cash crop, and a highly popular one at that. England's craving for tobacco placed immediate demand for production on the colonists, who prior to that time were mainly coping with survival. Meeting the demand required labor, which was supplied by more colonists and, very soon, slaves. The year 1619 saw the first importation of African laborers, who came initially as indentured servants and later as slaves. Before long nearly all of the colony's efforts were geared to tobacco growing and the tobacco trade. With the tremendous popularity of the snuffs and smoking materials made from the pungent weed, prosperity came quickly.

Some of Virginia's plantations, especially those in the immediate vicinity of Jamestown Island, such as Chippokes and Brandon, are among the oldest identifiable agricultural units in the country, having been farmed for over 350 years. As with any frontier society, priorities among the settlers did not include artistic achievement but were focused on taming the wilderness and then making one's fortune. Many of the earliest settlers became very prosperous but did not express their wealth in elegant architectural surroundings Prosperity throughout most of the first century of settlement was counted in the number of acres and slaves one owned, not in the size or beauty of one's house. Hence the earliest plantation houses were generally rather rude affairs: clapboard-cladded structures supported on wooden posts driven directly into the ground. As such, they were temporary buildings, and thus none of this earliest form of housing, employed consistently throughout the seventeenth century, has survived. The few brick houses of the first century or so of settlement, such as Bacon's Castle, the Adam Thoroughgood House, and the Lynnhaven House, give a false impression of the typical housing of the period. These brick structures were uncommonly well built, and have therefore lasted while the scores of their post-framed neighbors have all rotted, burned, or been replaced with more substantial structures.

More than a century passed before the upper ranks of planters began to turn their attention to more refined abodes, ones with consciously considered aesthetic qualities. Such architectural pursuits were probably inspired by the construction of the Governor's Palace in Williamsburg in the first decade of the eighteenth century. The palace represented Virginia's first truly elegant, architecturally up-to-date residence. It gave the leaders of colonial society something to emulate. The completion of the palace coincided with the beginning of the age of the great plantations. Unlike the seventeenth century in Virginia, which was marked by small settlements and relatively small plantations, the early eighteenth century was characterized by the development of huge establishments such as the Lee family's Stratford and the Page's Rosewell, vast manors worked by scores of slaves. These large plantations were essentially self-sufficient communities trading directly with the mother country. This direct trade inhibited the development of towns and cities. Thus, except for Williamsburg, colonial Virginia had practically no towns, and nothing resembling a city such as Philadelphia or Boston. Plantations were isolated along the great tidal rivers that provided transportation arteries and the harbors necessary for direct trade with England.

Probably Virginia's first really great plantation house was that at Corotoman, home of Robert Carter, who owned so much land and held so much political and economic power that he was referred to as "King" Carter. Corotoman was early destroyed by fire, but many of Carter's relatives followed his example by erecting houses that the English gentry would not find uncomfortable or inelegant. Surviving Carter family homes include Shirley, Sabine Hall, and Carter's Grove. "King" Carter's descendants married into practically every important colonial family, and the taste for fine houses multiplied. Thus, in the eighteenth century, leading families such as the Beverleys, Burwells, Byrds, Harrisons, Lees, Randolphs, and Tayloes, whose various members were related many times over, all developed impressive family seats on their sprawling estates. They knew one another's homes well and frequently shared designers and artisans.

Impressive though they may seem to us today, Virginia plantation houses like Shirley and Berkeley are hardly large by English standards. Most

contain less than a dozen principal rooms. Unlike those in English country houses, the service areas in a Virginia plantation dwelling were in separate buildings, not under the roof of the main house. Some service areas were in architecturally related flanking structures called dependencies. In a few of the more elaborate houses, dependencies were linked to the main house by passageways called hyphens. Hyphens sometimes continued to be used in the Federal period, as at Woodlawn. Original hyphens are employed at Mount Airy, Brandon, and Chatham; not infrequently, however, the passageways are twentieth-century additions, as at Carter's Grove and Westover.

In contrast to dependencies, the more utilitarian service structures were referred to simply as outbuildings. Important colonial houses could require as many as ten to fifteen outbuildings for domestic support, including a kitchen, a laundry, smokehouses, a dairy, a weaving house, a schoolhouse, an office, and privies. If all the rooms of such a complex were gathered under one roof, the result would be a house of thirty or forty rooms. Thus the domestic core of a colonial plantation was more of a village than a single impressive mansion. House servants normally lived in the dependencies or outbuildings, rarely in the main house. Field hands lived in rows of slave quarters usually far from the main dwelling. Because few plantations today retain anywhere near their original number of outbuildings, it is difficult to conjure up an image of the sprawl or complexity of a plantation's core. A notable exception is Mount Vernon, the villagelike quality of which is best appreciated in an aerial view.

While most plantations have suffered the loss of a majority of their outbuildings, the loss of farm structures has been even more acute. Plantations required barns, cribs, sheds, stables, blacksmith's shops, slave quarters, and frequently mills, wharves, and warehouses. Except for Bremo, which preserves a large grouping of uncommonly well-built if not architecturally distinguished farm buildings, practically no Virginia plantation preserves any notable collection of original farm structures. Ironically, slave quarters, the support structures most often associated with the southern plantation, are now almost extinct in Virginia. The atypically well-built brick slave houses

at Ben Venue are among the handful of known slave quarters in the entire state.

Nearly all of Virginia's plantation houses, even its most sophisticated ones, are conservative architecturally, usually simplified but not necessarily unrefined adaptations of the English Georgian style. Only the architecture of Thomas Jefferson can be said to be truly innovative. Jefferson, both in his own home, Monticello, and the houses he designed for his friends, as well as in his buildings for the University of Virginia, tried to give Virginians more interesting models of architectural taste, drawing inspiration from Classical orders, Palladian villas, and French pavilions. A few houses, such as those at Bremo, Estouteville, and Edgemont, were inspired by Jeffersonian examples, but the owners of most Virginia plantations, both before and after Independence, continued to adhere to straightforward Georgian forms.

With the loss of fertility of the land through years of tobacco planting, Virginia's Tidewater plantations went into a decline following the American Revolution. A new generation of the planter families thus moved to landholdings in northern and western Virginia, and it is there that one finds the best examples of plantation houses of the Federal and antebellum periods. The beautiful rolling landscape of northern Virginia offered scenic settings for such stately Federal plantation houses as Farley, Oatlands, and Woodlawn. Likewise, the fertile lower Shenandoah valley saw the construction of the kindred dwellings Carter Hall, Belle Grove, and the Tuleyries. Although such houses might not be considered architectural breakthroughs, they have a patrician beauty rarely equaled in American domestic design.

Unlike the Deep South, Virginia saw no great wave of plantation house construction in the antebellum period. Virginia, being an old state, possessed an ample stock of plantation homes by the 1830s and 1840s. This fact, coupled with the wearing out of the Tidewater lands and a general agricultural depression, suppressed demand for impressive new plantation dwellings. Virginia thus has a short supply of great-columned Greek Revival mansions, much less ones in the more exotic Gothic and Italianate styles. The Bruce family on their vast grain-producing plantations in Southside Virginia provided a notable excep-

tion, giving us at Berry Hill and Staunton Hill, respectively, what are probably the nation's finest Greek Revival and Gothic Revival plantation houses. Ironically, it was Virginia that provided the prototype of the southern antebellum plantation house. George Washington Parke Custis' Arlington House, completed in 1817, is probably the earliest temple-form Greek Revival mansion in the South; fittingly, it later served as the home of the South's greatest military hero, Robert E. Lee.

David King Gleason's elegant photographs provide a seductive image of life in "Old Virginia." He presents one inviting house after another, complete with handsome interiors and period furnishings, lovely gardens, and spacious grounds dotted with boxwoods and venerable trees. Such places indeed were part of the Virginia plantation scene. But it must not be forgotten that most Virginians in the first 250 years of the state's history were not occupants of the gracious, fine surroundings pictured in this volume. Hardly one percent of the population knew homes that remotely resembled Brandon or Morven Park, or even Scotchtown. The average planter, even up to the eve of the Civil War, lived in the plainest of wooden cottages, usually having only one or two rooms and hardly any furniture. Like the post houses of the seventeenth century, these too have vanished, and the remaining homes give a somewhat distorted picture of what life was like. Slaves, a substantial portion of the population, of course knew even less commodious quarters. They might live and work on a great plantation, but they enjoyed few of its amenities. One might conclude that Virginia's plantations, being founded on the tobacco industry, being the exclusive reservations of an aristocratic few, and being vehicles for perpetuating slavery, had few redeeming virtues. But it was Virginia's plantation system and society that produced the likes of George Washington, Thomas Jefferson, James Madison, George Mason, and Richard Henry Lee, the founding fathers of the most democratic nation of modern times.

Virginia has lost many of its plantation houses through war, economic depression, social restructuring, and fire. Despite the losses, this book is evidence that an impressive quantity remains, including some of the most famous historic houses

in the nation. What Gleason's photographs do not convey is the new threat to Virginia's plantation houses, the loss of the integrity of their settings through commercial development. More than any other medium, Gleason's aerial photographs emphasize the importance of setting to a plantation house. A plantation house is not another home on the block; it is the focal point of a visually interrelated complex of dependencies, outbuildings, farm buildings, formal gardens, walkways, roads, parkland, pastures, fields, orchards, and forests. Sites were carefully chosen for their views, exposure, and accessibility to water, not to mention the fertility of the soil. Development of the land thus destroys the historic context of the house, leaving it simply a detached artifact. Virginia is currently experiencing the greatest economic prosperity of its history, which is resulting in the most intense development of its best rural lands. It is hoped that the photographs in this work will generate a greater appreciation of these historic plantation houses and the importance of preserving their irreplaceable settings.

From the James to the Potomac

Adam Thoroughgood House, 1680s

Virginia Beach

On land acquired by Adam Thoroughgood in 1635 stands one of Virginia's oldest homes, built by either Thoroughgood's son or his grandson in the 1680s. In the mid-1740s, a later owner replaced its casement windows with sliding sash and paneled the interior.

In the 1950s, the Adam Thoroughgood House Association restored the National Historic Landmark to its seventeenth-century appearance. Administered by the Chrysler Museum of Norfolk, the house and garden illustrate the life and times of a prosperous seventeenth-century Virginia farmer.

Lynnhaven House, *ca.* 1724 (right)

Virginia Beach

Although current research indicates that the Lynnhaven House was built about 1724 for Francis Thelabell, its style and methods of construction look back to the late 1600s. The Oliver family donated the early brick farmhouse, located near the Lynnhaven River, to the Association for the Preservation of Virginia Antiquities in 1971. In 1974 and 1975, the association gave Lynnhaven House, also known as the Wishart House, a much-needed and carefully researched restoration, rebuilding the leaded casement windows and dormers, and opened it to the public as an example of one of the oldest houses in Virginia.

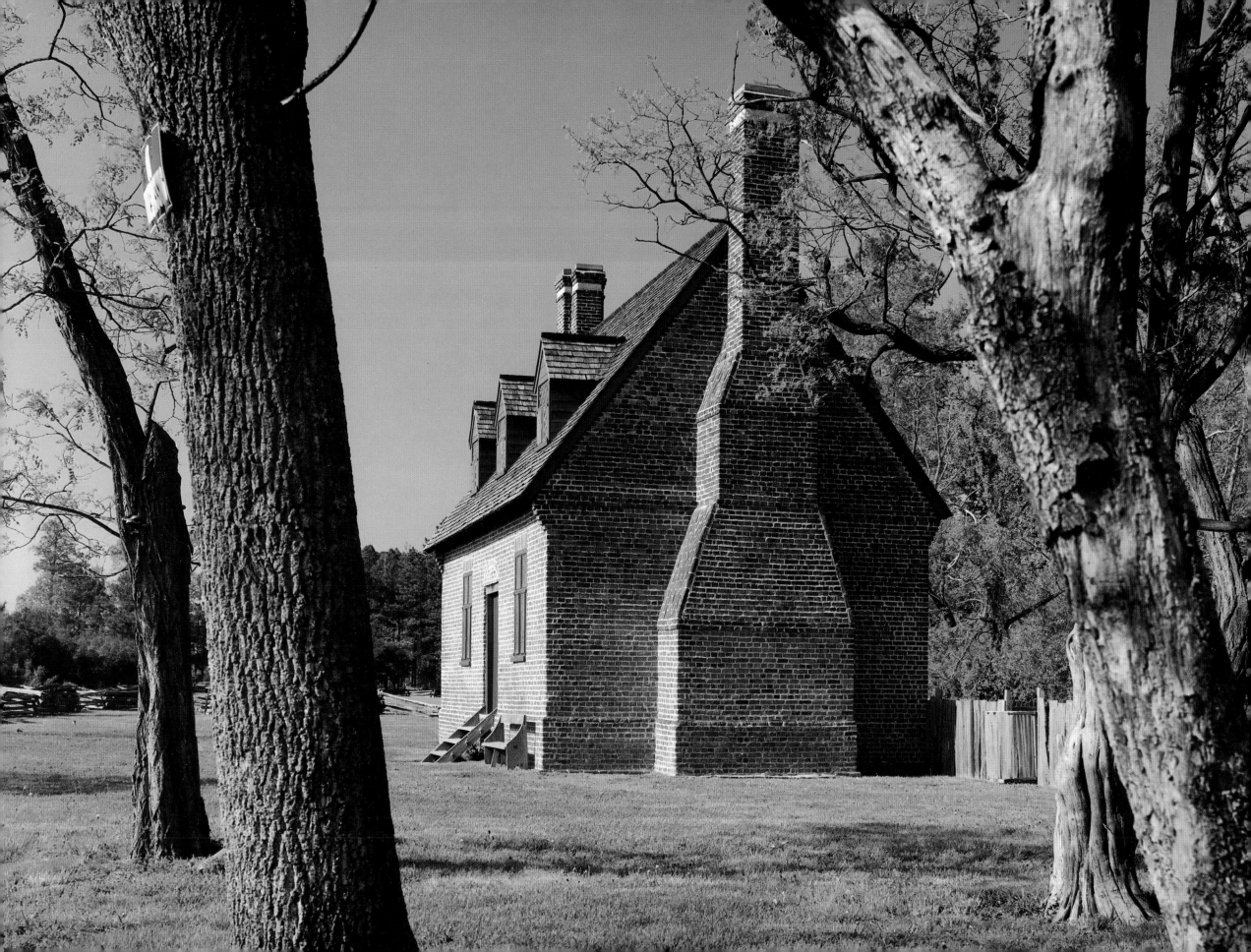

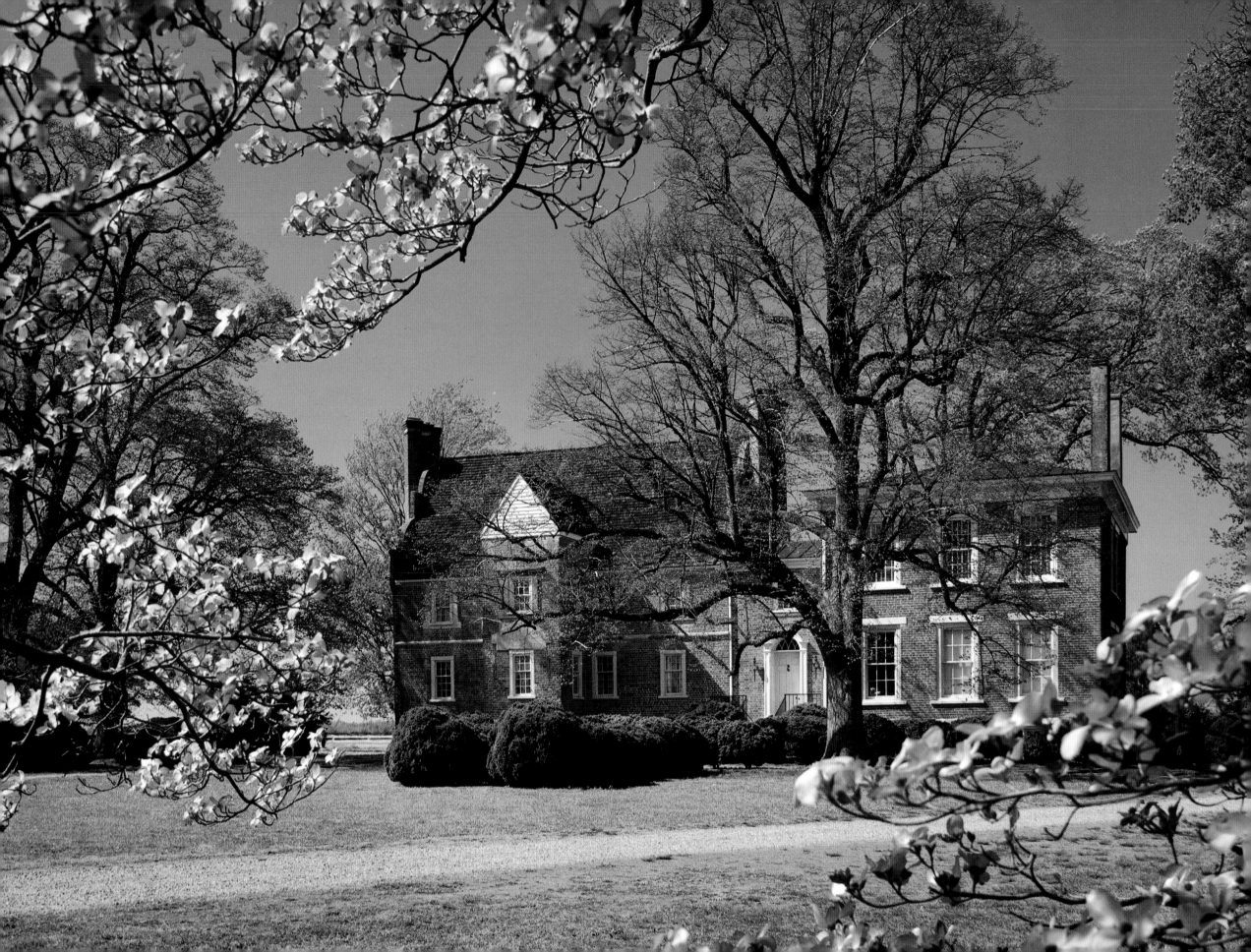

Bacon's Castle, 1665 (left)

Surry County

In Surry County, on the south side of the James River, stands the oldest house in Virginia and English-settled North America, Bacon's Castle. Built by Arthur Allen, a planter and merchant who was one of the richest men in the area, the house is the last survivor of Virginia's manor houses of the seventeenth century.

Eleven years after its construction, the Jacobean mansion became a fortress, seized and occupied for four months by followers of Nathaniel Bacon, who led a rebellion against the British Crown a hundred years before the American Revolution.

Afterwards known as Bacon's Castle, the great house was modified in the 1700s, and a Greek Revival wing was added in the 1840s. In 1973, the Association for the Preservation of Virginia Antiquities acquired Bacon's Castle and embarked upon a long-term program to study and stabilize the unique house.

Chippokes, *ca.* 1854

Surry County

Although the Greek Revival manor house built by Albert C. Jones in 1854 on Chippokes plantation is a relative newcomer to the James River, the plantation itself has been in existence since the acreage, across the river from Jamestown Island, was granted to Captain William Powell in 1616. Captain Powell named the plantation after a local Indian chief, Choupocke, a friend to the Jamestown settlers.

Following Powell's death, Chippokes was owned by Governor William Berkeley. It remained in the Ludwell family, descendants of Berkeley's widow, until 1837.

Chippokes, a working plantation until given to the Commonwealth of Virginia in 1967 by Mrs. Victor Stewart, is now a state park interpreting early agricultural practices.

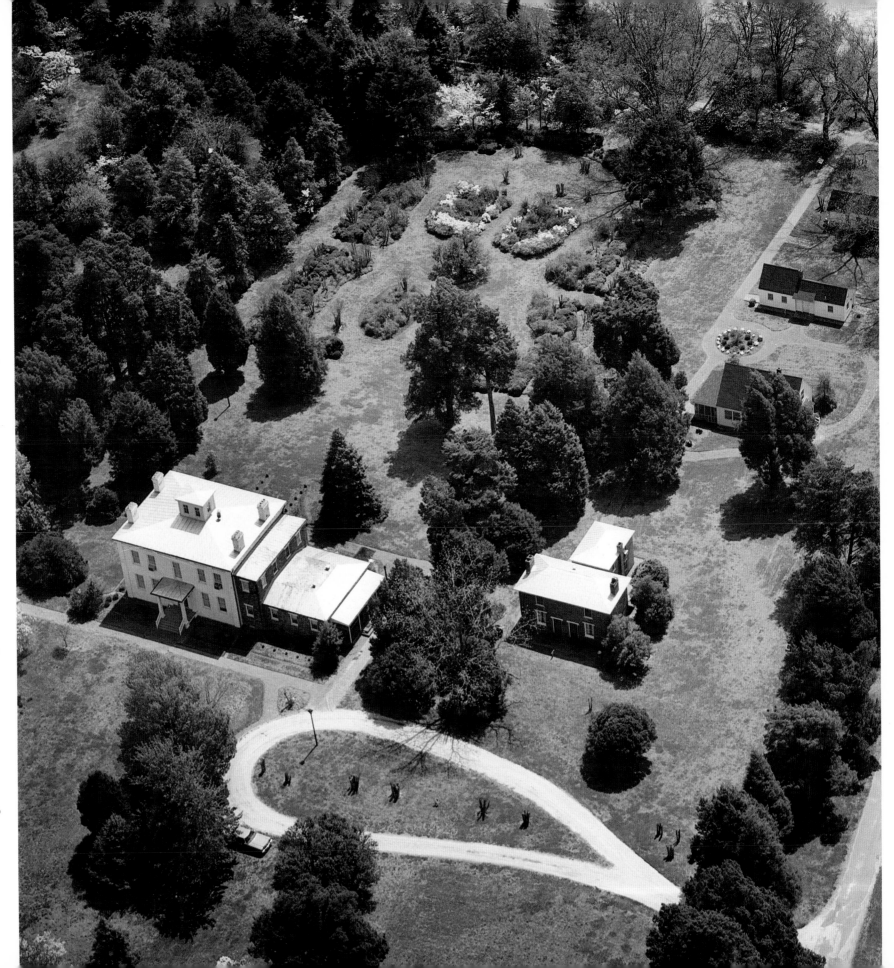

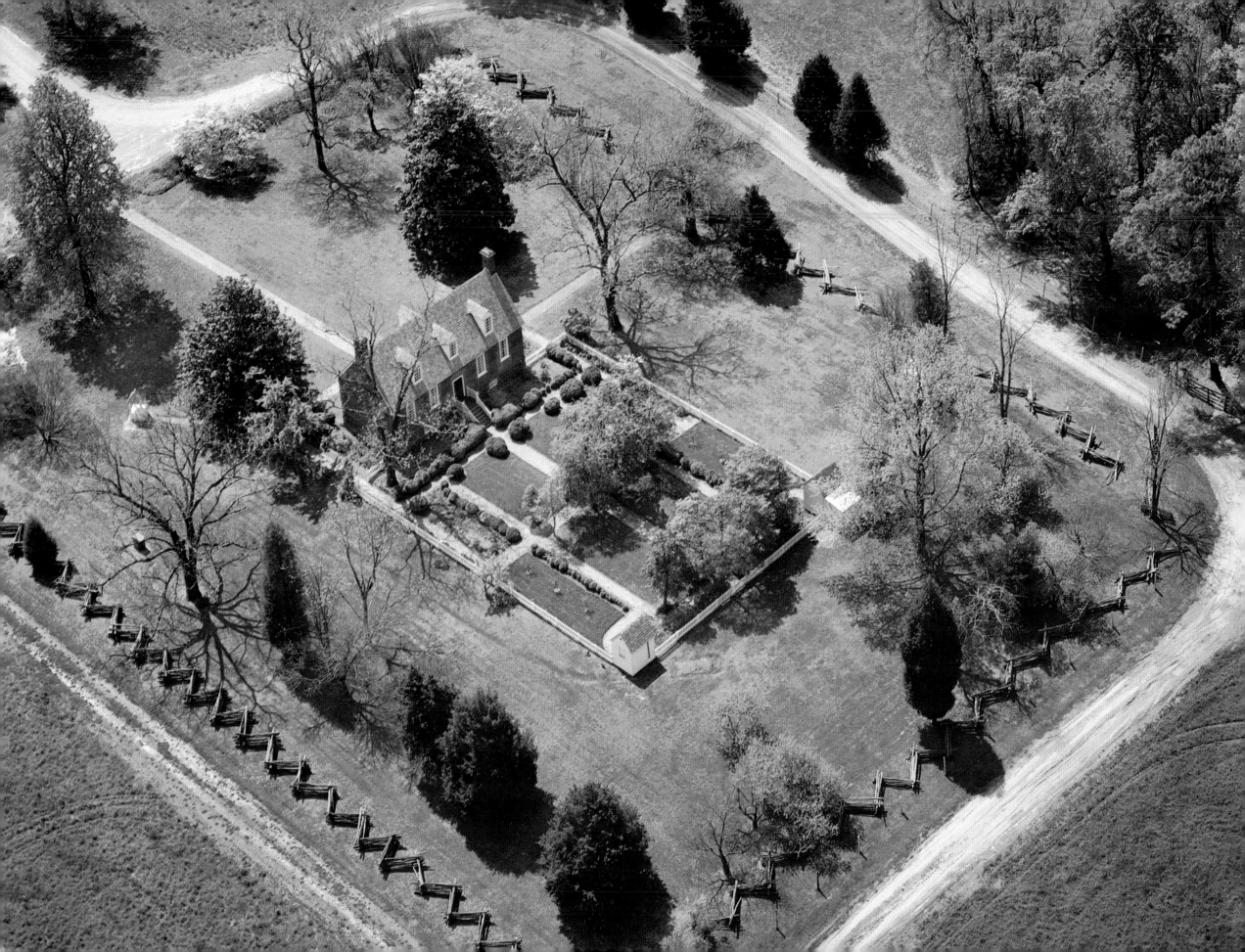

Smith's Fort, mid-1700s

Surry County

Behind the manor house of Smith's Fort plantation is a barely noticeable earthwork built in 1609 under Captain John Smith's orders, to form part of a "new forte" for the protection of Jamestown's settlers. Five years later, Chief Powhatan gave the land to John Rolfe, husband of his daughter, Princess Pocahontas, as part of a wedding gift.

The house was built between 1750 and 1775, probably for Jacob Faulcon, whose father owned the plantation. The Faulcon family owned the 350-acre property until 1835. The plantation then saw a succession of owners until 1934, when the Association for the Preservation of Virginia Antiquities acquired it from the Colonial Williamsburg Foundation.

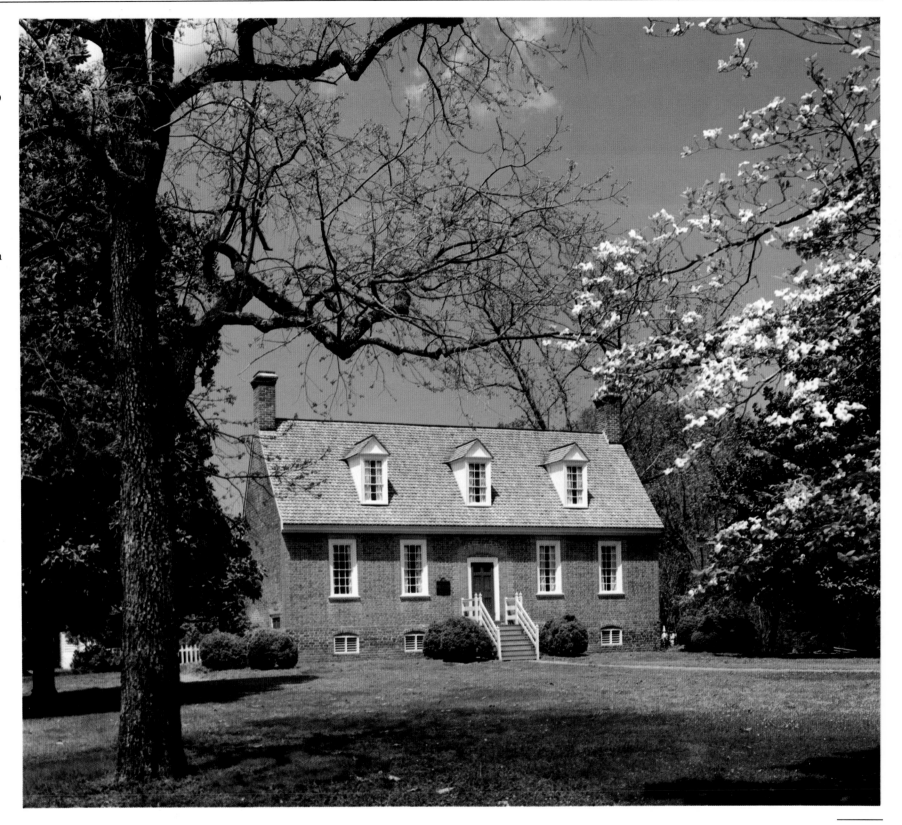

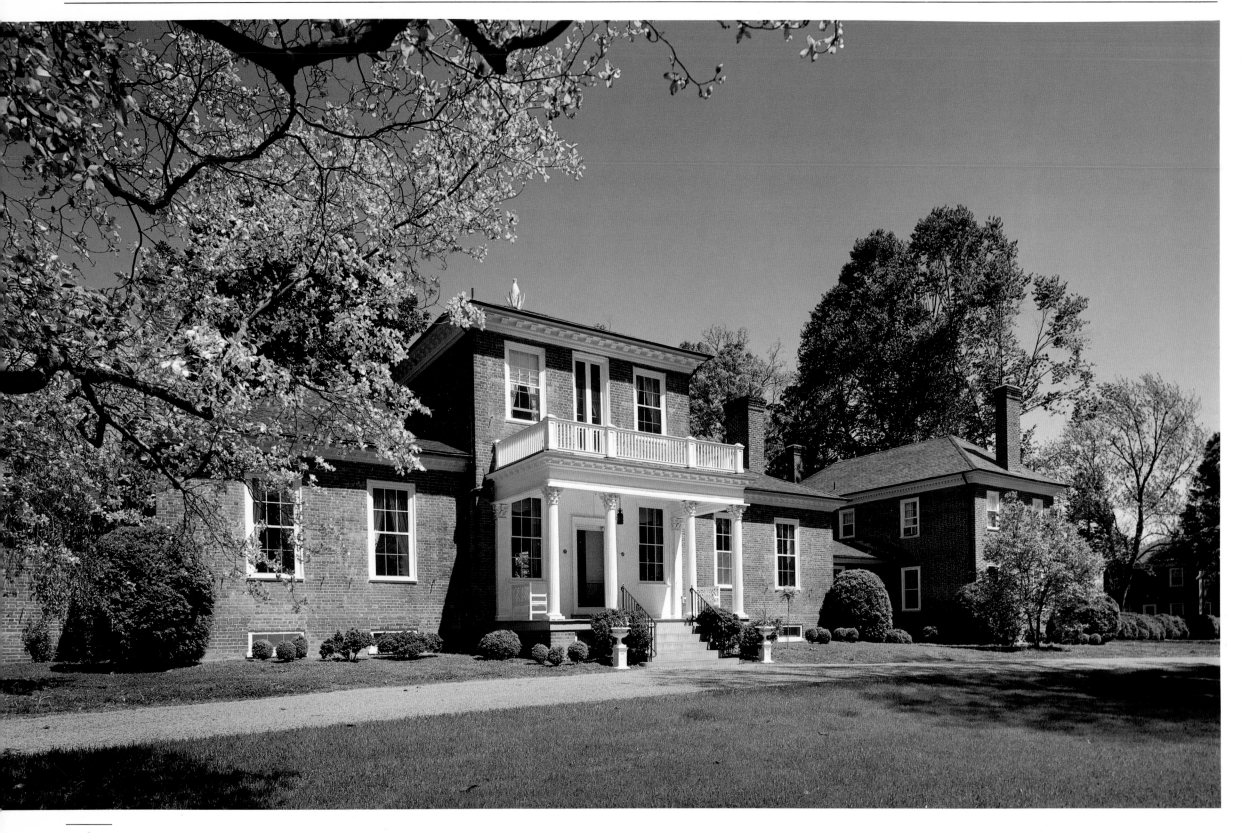

Brandon, *ca.* 1765 (left)

Prince George County

Brandon plantation has been under continuous agricultural operation since 1616, when Captain John Martin was given a patent to 5,000 acres on the south side of the James River about 15 miles upstream from the fledgling Jamestown settlement.

Nathaniel Harrison acquired the plantation in 1720, and about that time two 4-room brick houses were built, apparently intended as dependencies of a larger manor house to be erected between them. This was not done until Benjamin Harrison, son of Nathaniel Harrison II, married in 1765. One of his groomsmen was Thomas Jefferson, who according to family tradition designed the main house and remodeled and connected the two existing houses to form a stately structure, the manor house of Brandon plantation.

Scarred by British gunfire during the Revolution and by Union gunboats during the Civil War, Brandon was purchased by Robert Williams Daniel in 1926. The 4,500-acre Brandon farm is currently owned and operated by Robert W. Daniel, Jr.

The dining room of Upper Brandon

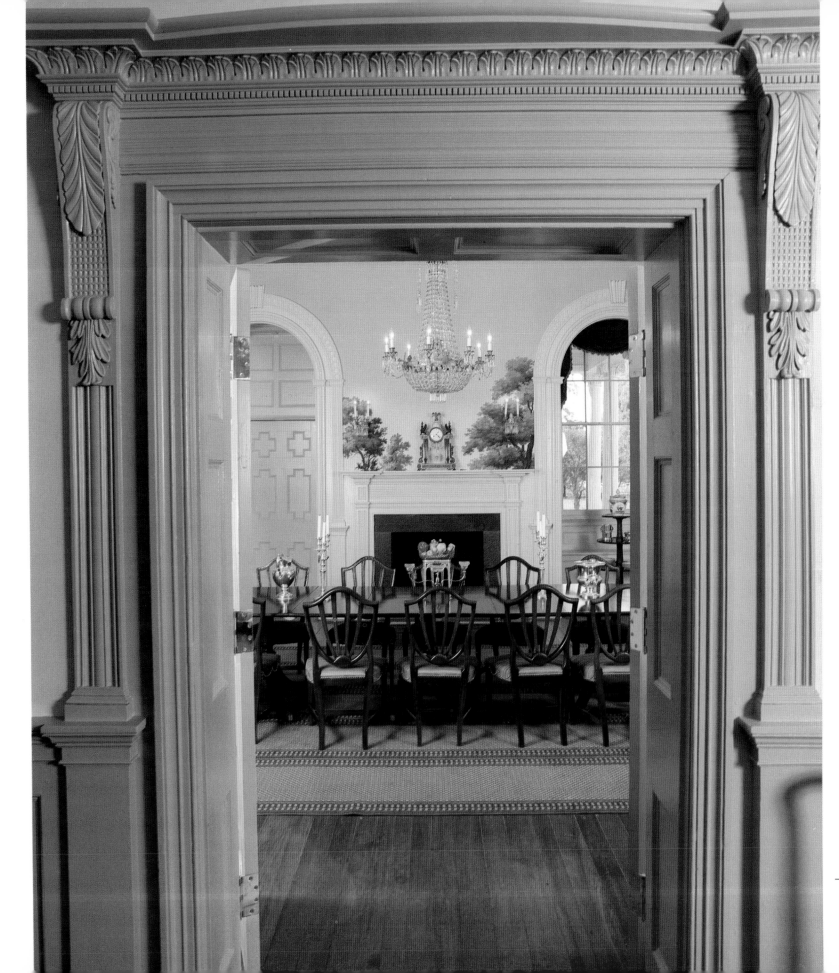

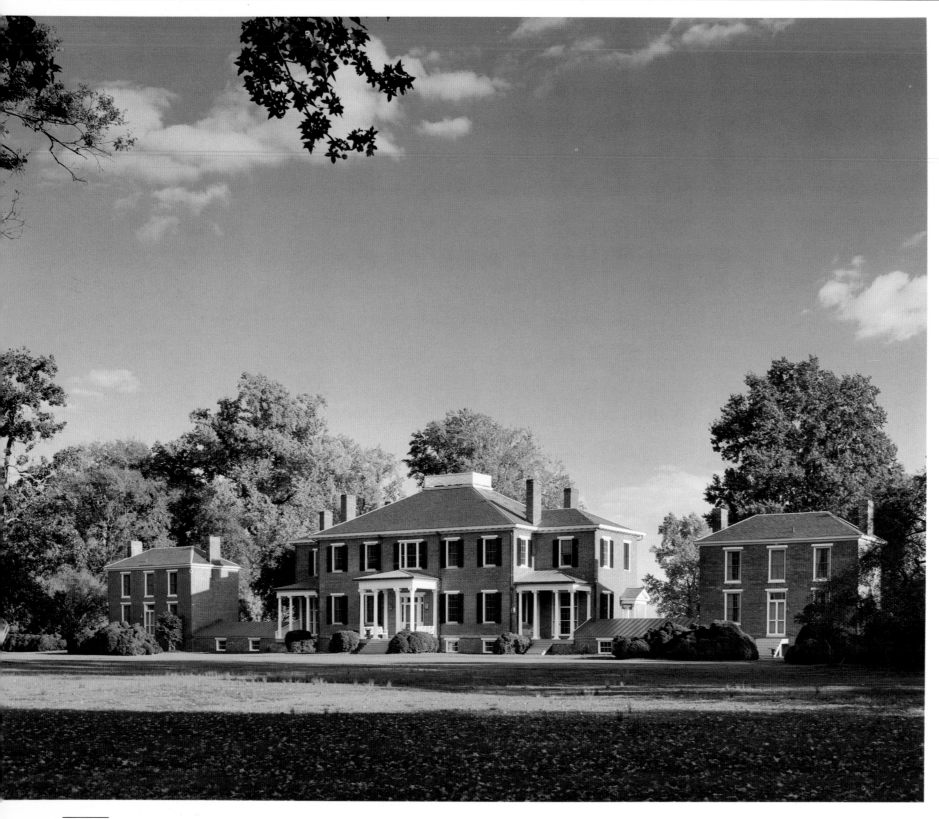

Upper Brandon, 1825, 1857

Prince George County

When Benjamin Harrison III died in 1807, he left a will dividing Brandon plantation into two parts. The downriver portion, including the 1765 manor house, is still called Brandon, or Lower Brandon. Upper Brandon and its 3,550 acres were inherited by William Byrd Harrison, who completed his mansion in 1825. He married his fourth cousin, Mary Randolph (Polly) Harrison, in 1827.

Thirty years later Polly, the mother of five sons, died. In 1857 Harrison married Ellen Wayles Randolph and added two wings with bathrooms to the main house. The dependencies, a kitchen to the west and an office building to the east, had been built with the mansion in 1825, and were connected to the main building by hyphens, constructed primarily below grade. Outbuildings included slave quarters (there were 105 slaves on Upper Brandon in 1861), an icehouse, and a two-story 100-by-40-foot stable.

The Harrisons continued to own Upper Brandon until 1871, when a nephew, George Harrison Byrd, purchased the plantation. It remained in the Byrd family until 1948. The James River Paper Corporation bought Upper Brandon in 1984 and gave the house and outbuildings an extensive restoration. The corporation continues to operate the plantation as a working farm, and uses the house as a corporate retreat center.

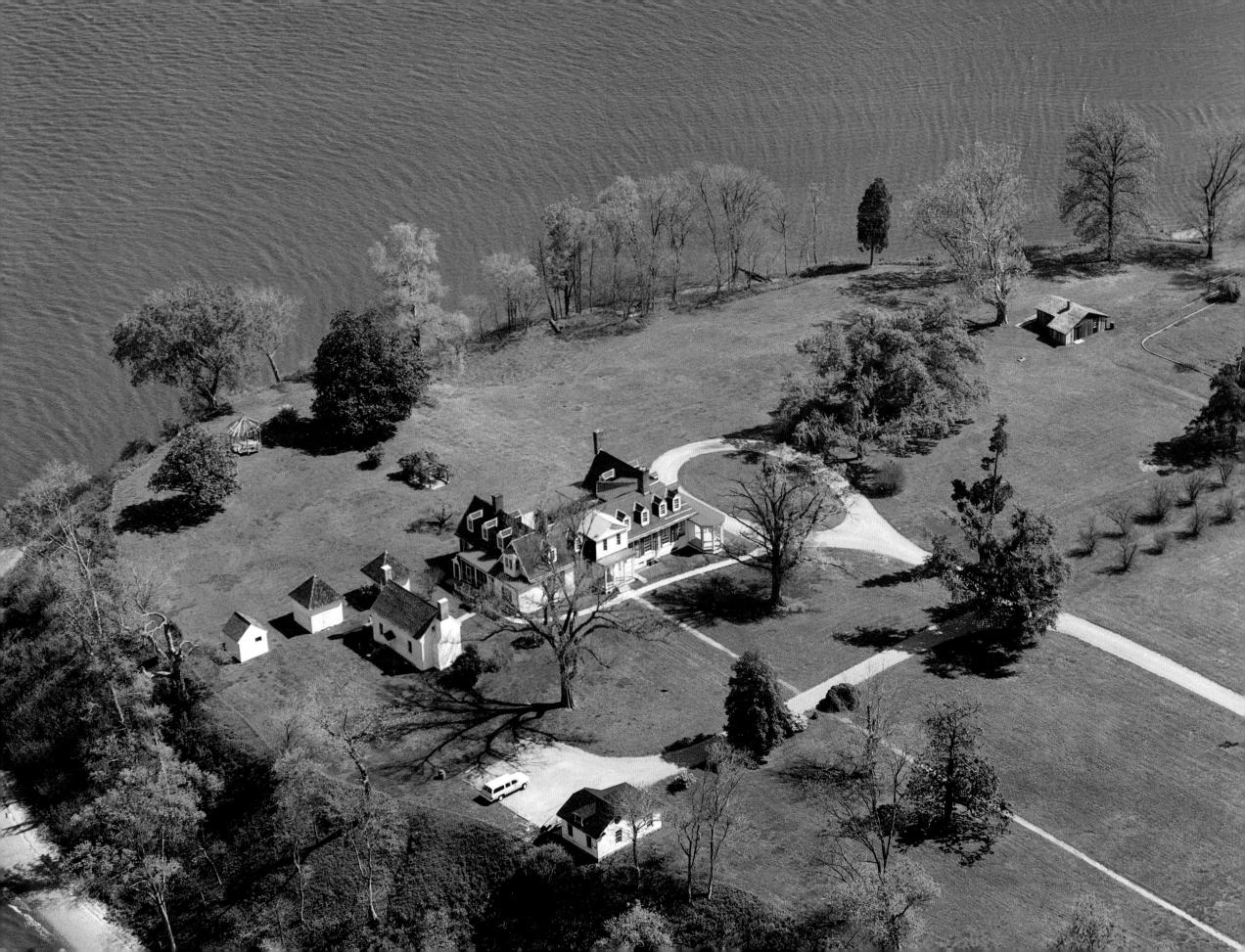

Appomattox Manor

ca. 1763, 1840 (left)

Hopewell

The headquarters of Union general Ulysses S. Grant during the Petersburg campaign of the Civil War, Appomattox Manor was owned by the Eppes family from 1635 to 1979. The earliest part of the house was built about 1763, and an east wing was added in 1840.

Located at City Point, a peninsula at the confluence of the Appomattox and James rivers near Petersburg, the plantation saw the advent of British soldiers under Benedict Arnold during the Revolutionary War and a Union army under General Grant during the Civil War. The City Point Unit, which included Appomattox Manor, became a huge encampment supplying more than 100,000 Union troops besieging Petersburg from June, 1864, to April, 1865. His troops built General Grant a small cabin (not much more than a shack) on the east lawn, while his quartermaster occupied the manor house. There President Lincoln met with Grant in 1864 and 1865.

Now owned by the National Park Service, Appomattox Manor is part of the Petersburg National Military Park.

Weston Manor, 1780s

Hopewell

Just up the Appomattox River from Appomattox Manor is a classic late eighteenth-century Georgian plantation house set above terraces leading to the river's edge. The house is on land acquired by William and Christine Eppes Gilliam and was probably erected for them in the 1780s. The dwelling is noted for its handsome proportion and excellent state of preservation.

During the Civil War, a Union gunboat fired on Weston Manor, leaving a cannonball embedded in the dining-room ceiling as a memento. During restoration by the Historic Hopewell Foundation the ball was dislodged, and it is still shown to visitors. Union cavalry general Philip

Sheridan occupied the house during part of the Petersburg campaign, and Weston Manor also served as a temporary hospital.

The Dolin family owned the Weston property from 1869 to 1962, when the Broyhill family acquired it. A decade later the Broyhills gave the house to the Historic Hopewell Foundation for use as a museum and cultural center.

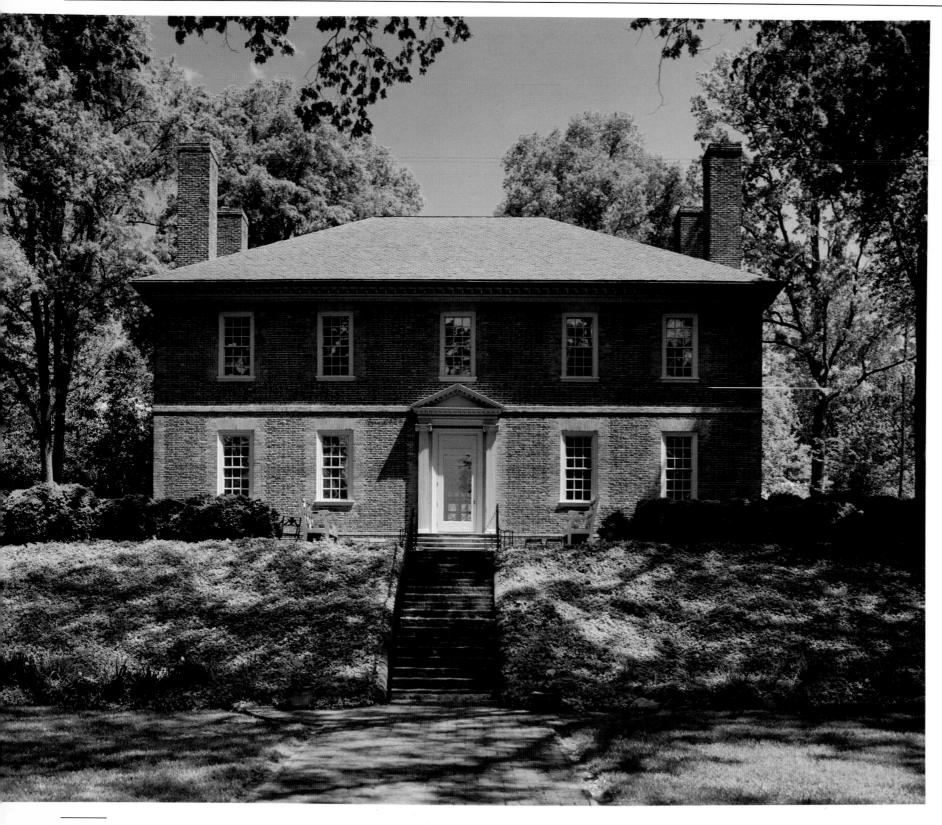

Wilton, 1753

Richmond

When it was completed in 1753 for William Randolph III (who married Ann Carter Harrison of Berkeley plantation), Wilton was the nucleus of a 2,000-acre plantation on the James River fifteen miles east of Richmond. The Marquis de Lafayette made his headquarters there in May, 1781.

One of the finest examples of Georgian architecture in the Old Dominion, Wilton is Virginia's only colonial residence in which every room is fully paneled.

In the early 1930s the manor house was threatened by neighboring industrial development. In 1933 the National Society of the Colonial Dames of America in the Commonwealth of Virginia had Wilton dismantled and painstakingly reassembled on a site overlooking the James River on Richmond's western side. Now a house museum furnished with an outstanding collection of American antiques, Wilton rests within terraced grounds, with plantings created by the Garden Club of Virginia to represent the colonial period.

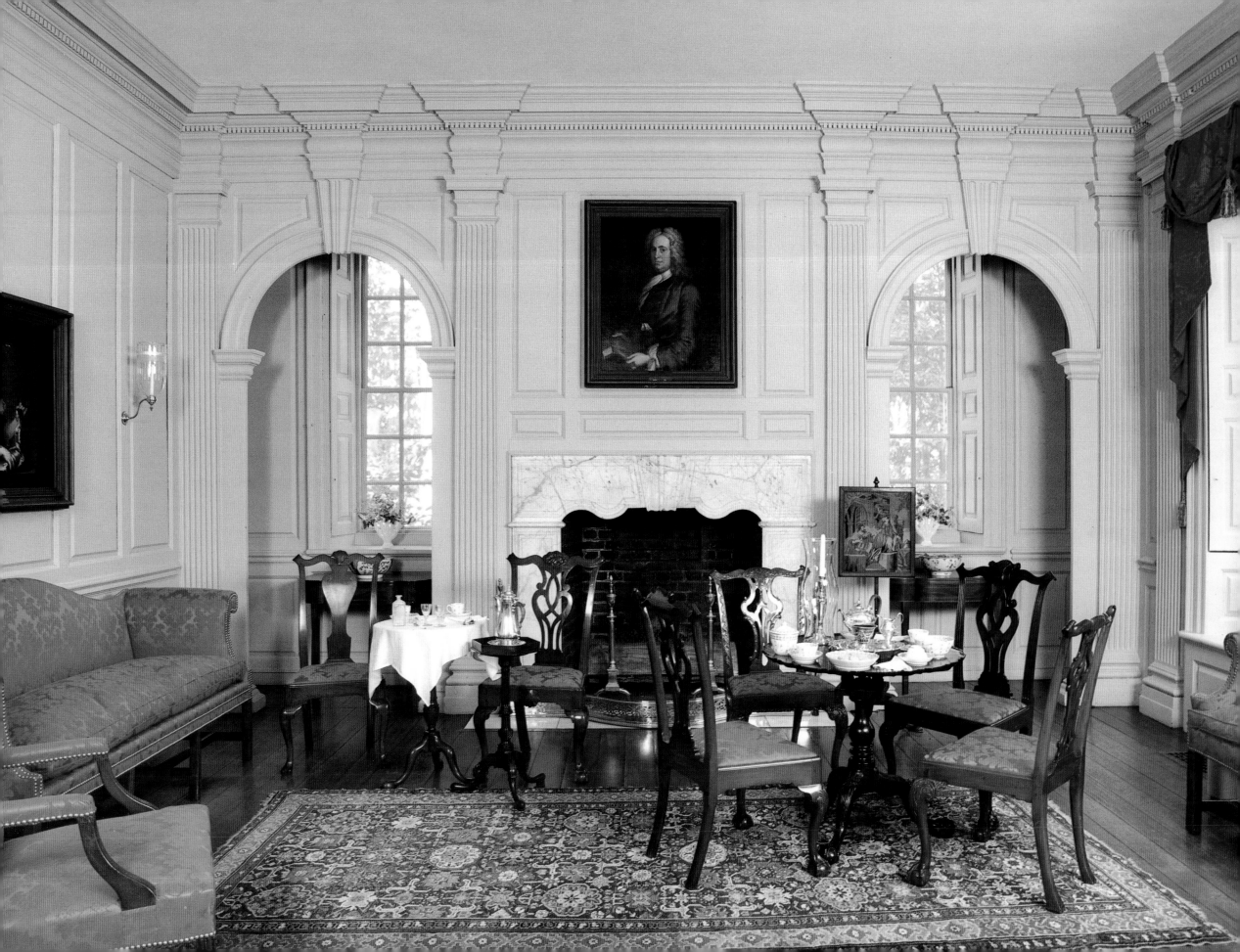

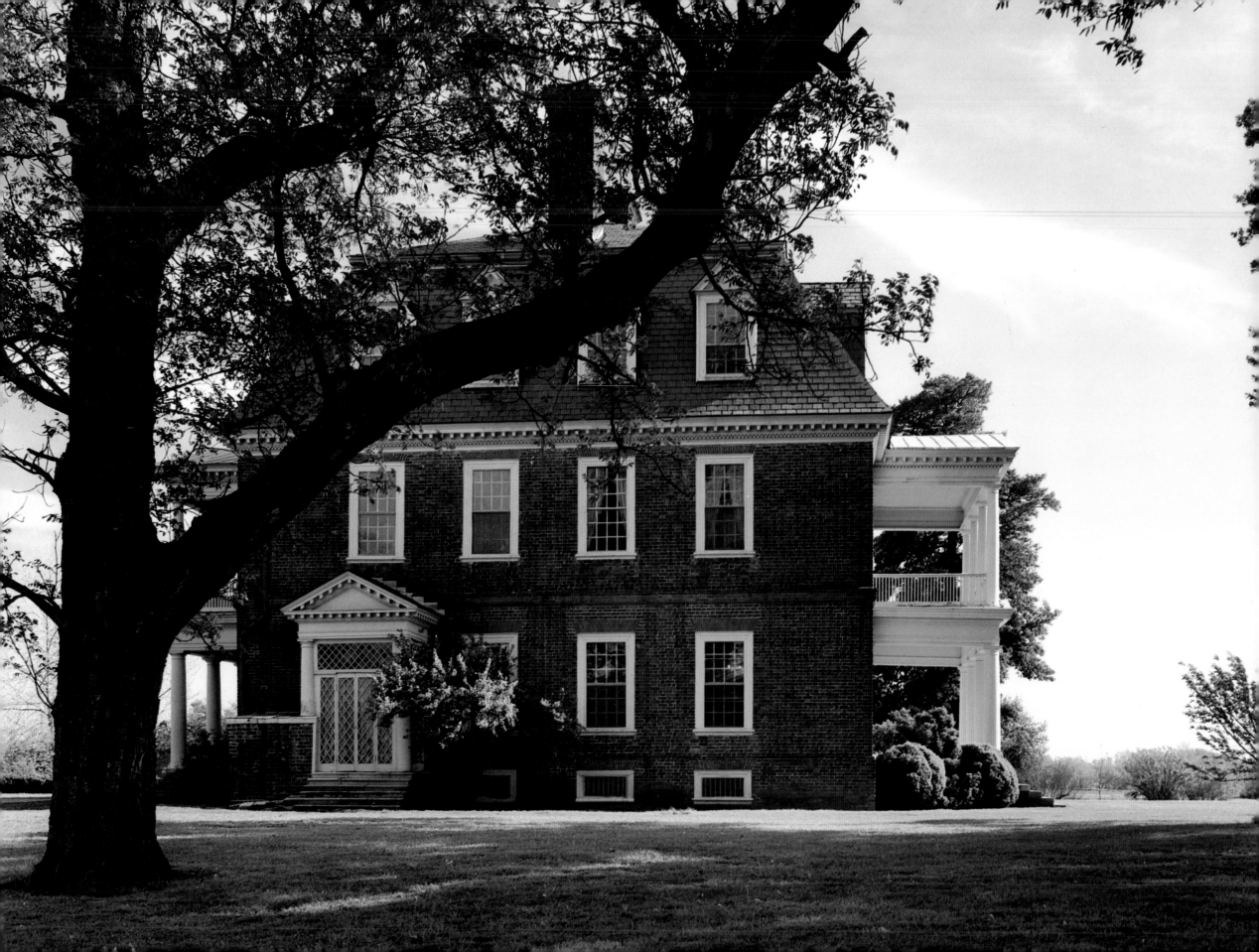

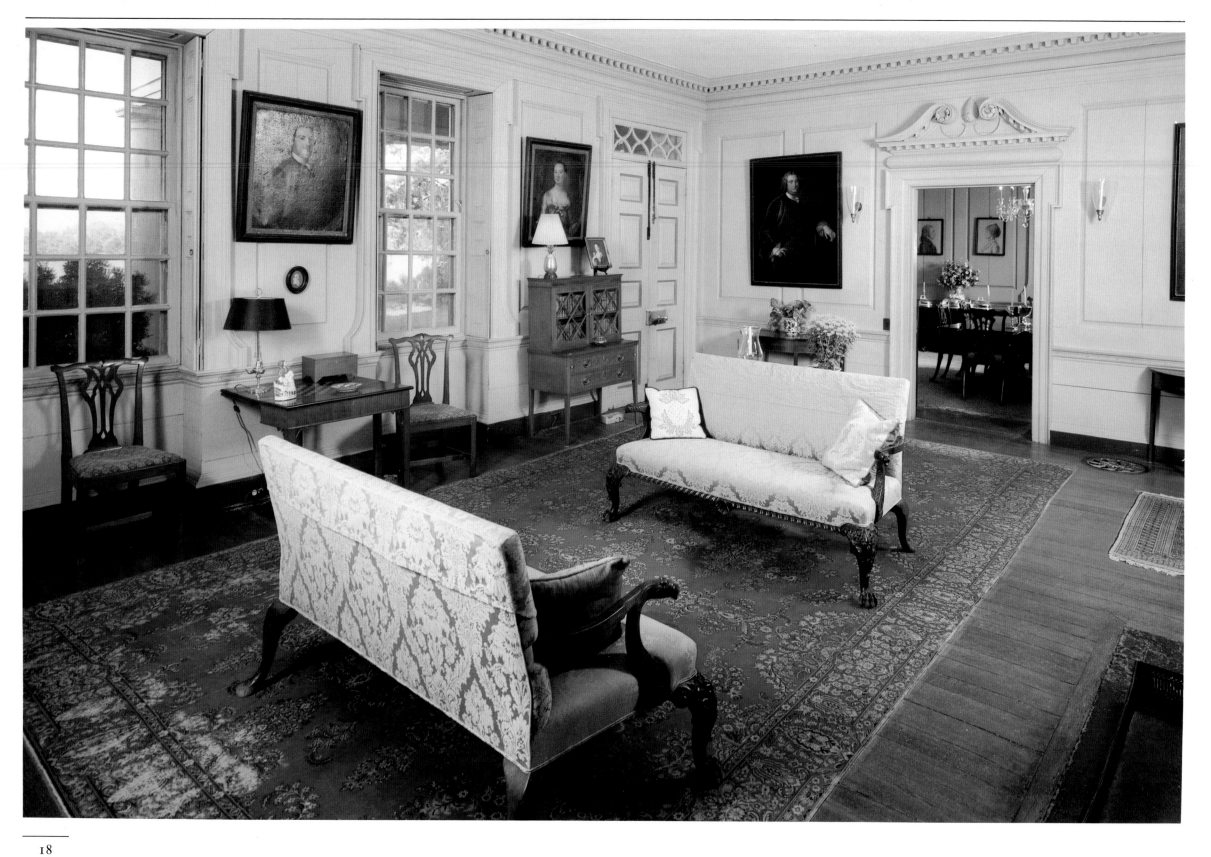

Shirley, *ca.* 1723
Charles City County

Dominating a historic plantation patented in 1660 by Edward Hill, the present great house at Shirley was begun in 1723 by Edward Hill III for his daughter, Elizabeth, who in the same year married John Carter, eldest son of Robert "King" Carter. Their granddaughter, Anne Hill Carter, married Light-Horse Harry Lee of Stratford plantation and became the mother of Robert E. Lee.

Shirley has many of its original outbuildings, including a two-story kitchen, a laundry house, a stable, a dovecote, a smokehouse, and two barns (one with an ice cellar beneath it), which create a village characteristic of colonial Virginia plantations.

A National Historic Landmark, Shirley remains a working plantation, owned and operated by descendants of its founder.

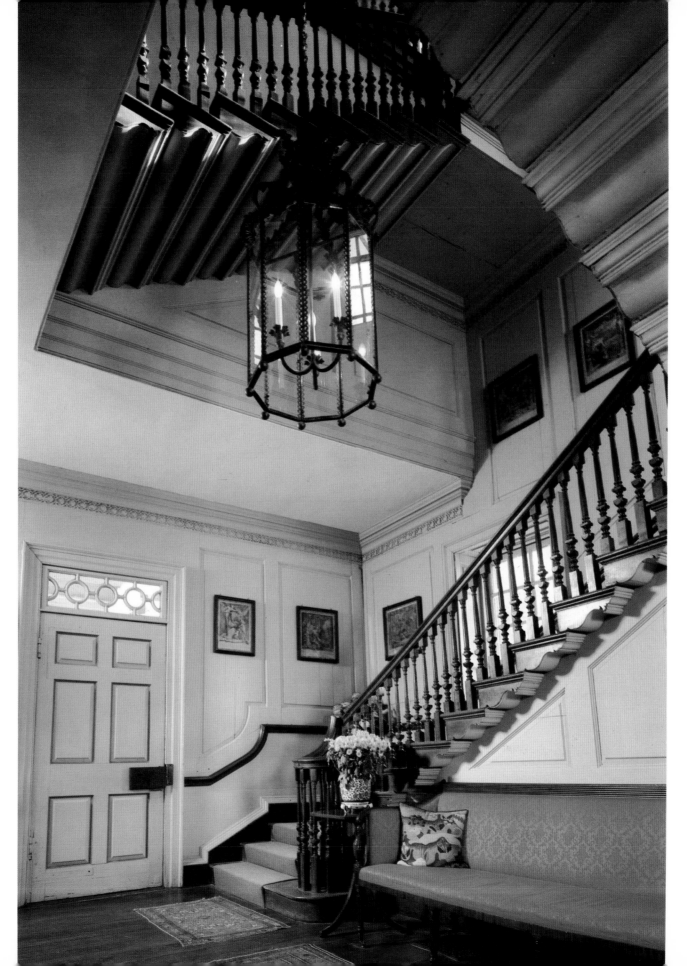

Berkeley, 1726

Charles City County

On December 4, 1619, a year before the Pilgrims saw Plymouth Rock, English settlers sponsored by the Berkeley Company stepped ashore on the banks of the James River and founded a settlement designated as "Berkeley Hundred and Plantation." Its proprietors required that "the day of our ships' arrival . . . shall be yearly and perpetually kept as a day of Thanksgiving."

In addition to celebrating the first Thanksgiving, Berkeley saw a number of other "firsts," including the first bourbon whiskey distilled in America in 1622. Berkeley was also part of the first Indian massacre in the colony, which wiped out the settlement that same year.

The Harrison family bought the plantation in 1691 and opened the first American commercial shipyard in 1695. Benjamin Harrison IV built the present manor house in 1726. His son, Benjamin Harrison V, was a signer of the Declaration of Independence and three-time Virginia governor.

William Henry Harrison, who became known as Old Tippecanoe fighting Indians in the Northwest Territory, was born at Berkeley. He was elected ninth president of the United States, and his grandson, Benjamin Harrison, became the twenty-third president.

During the Revolution, British forces commanded by Benedict Arnold plundered Berkeley, and in 1862 the Union army of General George B. McClellan occupied the home. Taps, composed by Union general Daniel Butterfield, was first sounded at Berkeley.

The Jamieson family acquired Berkeley in the late 1800s, and the present owner, Malcolm Jamieson, has restored and furnished the house to its late eighteenth-century appearance.

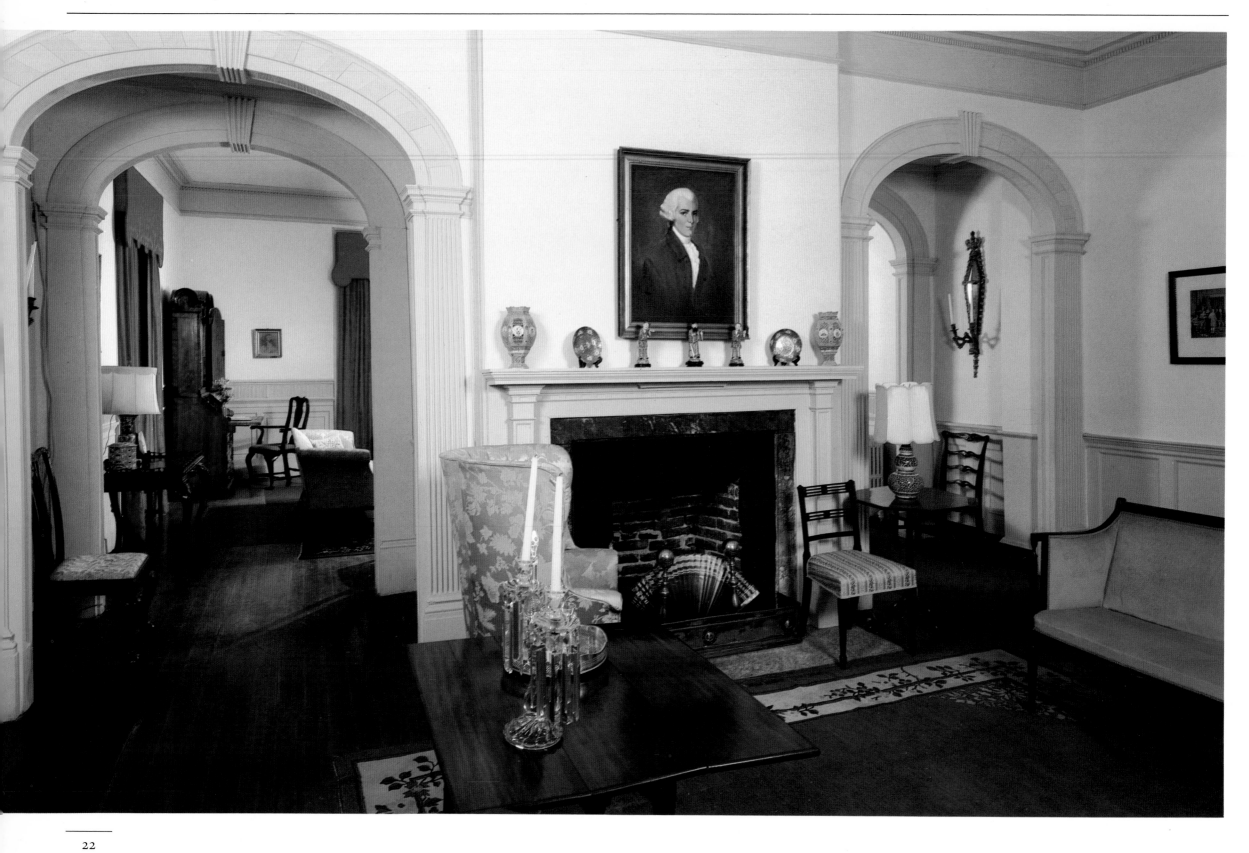

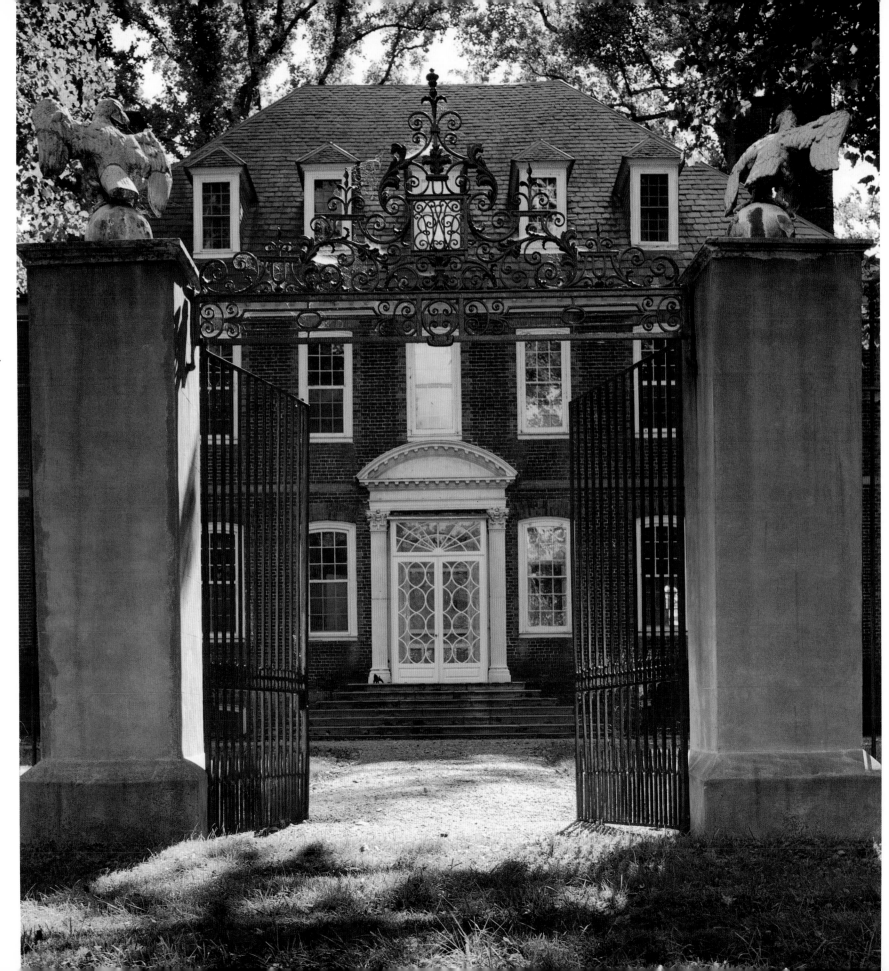

Westover, *ca.* 1730

Charles City County

Considered one of the most beautiful houses in the United States, Westover was built by William Evelyn Byrd II, founder of Richmond, Virginia. His father had purchased the 1,200-acre plantation from Theodrick Bland in 1688.

The house and dependencies form one of the finest Georgian complexes in the country. Its much-imitated stone doorways were imported from England, and its wrought-iron gate is unique. The stately tulip poplars forming a row on the river side are more than 150 years old.

During the Civil War, Westover was occupied by Union troops, who camped on the grounds and erected a signal platform on the roof. Its library dependency burned during the northern occupation, and was rebuilt in different form about 1900 by Mrs. Clarice Sears Ramsey, who also added connecting hyphens.

Westover was acquired by Mr. and Mrs. Richard Crane in 1921, and has remained in the same family since then.

(left) *The double parlor at Berkeley*

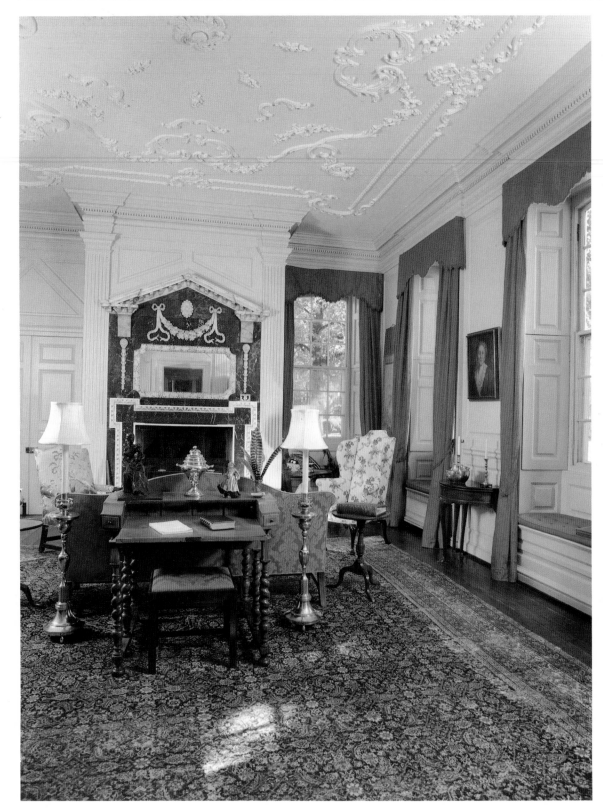

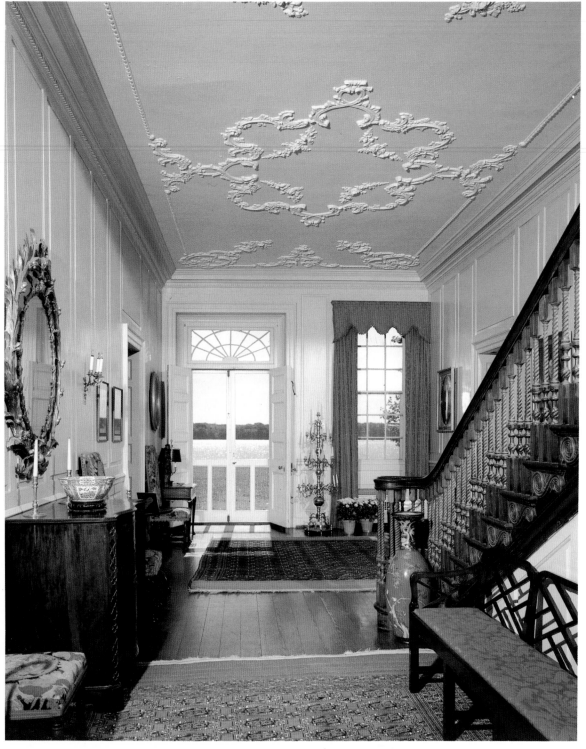

The parlor and center hall at Westover. At right is West-over's river side, with the James in the background.

Evelynton Plantation
Charles City County

Originally a part of Westover, the 860 acres of Evelynton plantation overlooking Herring Creek and its marshes were named for Evelyn Byrd, daughter of William Byrd II. Denied permission to marry her English suitor, Evelyn is said to have died of a broken heart, and according to legend, her ghost is still seen at Westover and Evelynton.

Edmund Ruffin acquired the plantation in 1847 and brought the worn-out land to a new state of prosperity, spreading marl (Ruffin called it "calcareous manure," a mixture of clay, shells, and shellfish dredged from the bottom of tidal creeks) to fertilize the soil. A fervent secessionist, Ruffin sailed to Charleston, South Carolina, to fire the shot at Fort Sumter that began the Civil War.

During the peninsula campaign in 1862, Union troops devastated Ruffin's plantation, burning every building, girdling the trees, and salting the fields. Three years later, after Lee's surrender at Appomattox, Ruffin shot himself, wrapped (according to tradition) in the folds of the Confederate flag.

In 1932, Ruffin's great-great-grandson, John Augustine Ruffin, Jr., built a Georgian Revival house on the site of the original home, using architect Duncan Lee, who also supervised the restoration of Carter's Grove. The Ruffin family continues to own and operate Evelynton plantation.

Sherwood Forest, 1730, 1844
Charles City County

In 1844, while he was president of the United States, John Tyler bought the 1,600 acres of Sherwood Forest and added wings, hyphens, and a 68-foot-long ballroom to the existing eighteenth-century house to create perhaps the longest antebellum house in Virginia, 300 feet from end to end.

Tyler, with his new wife, Julia Gardiner of Long Island, retired to Sherwood Forest following his presidency. Later, he served as president of the peace convention of 1861 and as a member of the Confederate Congress.

Sherwood Forest has been farmed continuously for more than 240 years and is the home of President Tyler's grandson, Harrison Ruffin Tyler, and his family.

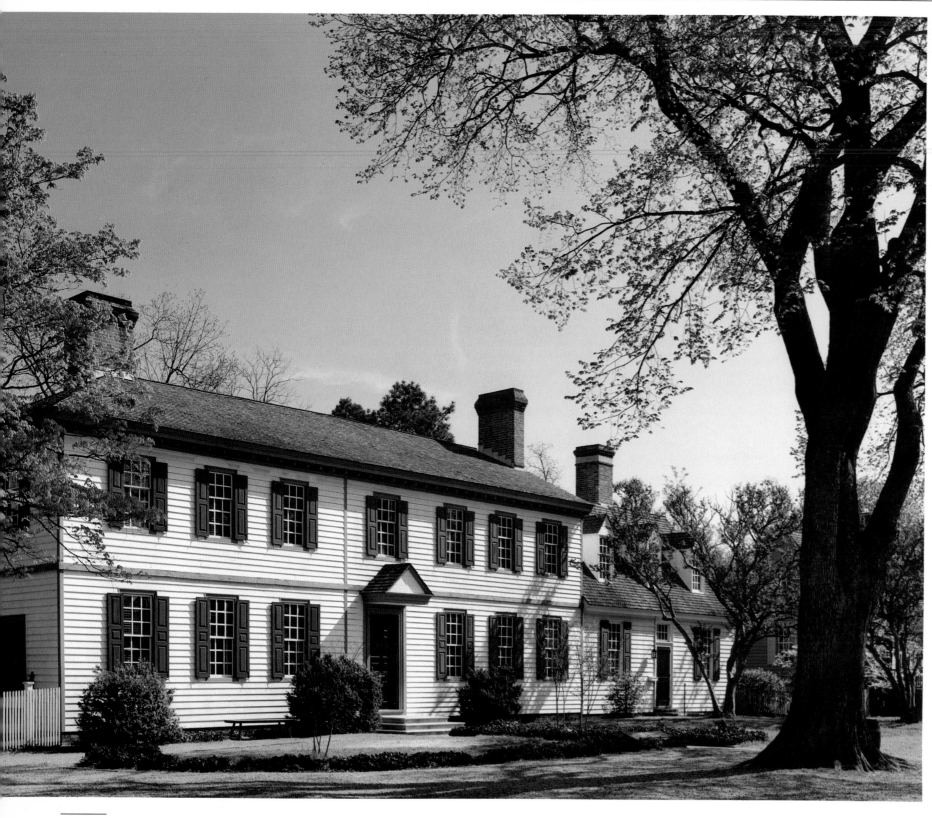

Peyton Randolph House
1716, 1724
Williamsburg

Peyton Randolph, advocate of American independence, lived at this Williamsburg house from 1745 until he died in 1775.

Randolph was Speaker of the House of Burgesses when Thomas Jefferson served his first term in that assembly, and was president of the first and second Continental Congresses. Randolph left his famous library to the young Jefferson.

An earlier occupant was William Robertson, colonial clerk of the Council from 1701 to 1739, for whom the smaller, three-bay western section was built. The Colonial Williamsburg Foundation reconstructed the east wing in 1939 and 1940.

Governor's Palace
1706–1720, 1754
Williamsburg

The richly detailed residence of the governor in Williamsburg (foreground) had a widespread influence on the design of planters' homes and gardens throughout the Old Dominion. So ornate that it became known as the Governor's Palace, the mansion had spacious, lavishly appointed interiors and elaborate formal gardens that were echoed by planters in their own homes along the rivers of colonial Virginia.

The mansion burned in 1781, and was reconstructed in the early 1930s by the Colonial Williamsburg Foundation. The palace opened its doors to tourists in 1934. In 1981, it was completely refurnished to incorporate fresh insights and historical discoveries made over the past fifty years.

The Governor's Palace looks northward along the palace green. Bruton Parish Church (1712–16) is in the upper right-hand corner, and the Wythe House is between the church and palace.

Williamsburg was laid out by Governor Francis Nicholson, and served as the colony's capital from 1699 to 1776. It was the capital of the Commonwealth of Virginia until 1780, when Richmond became the seat of state government.

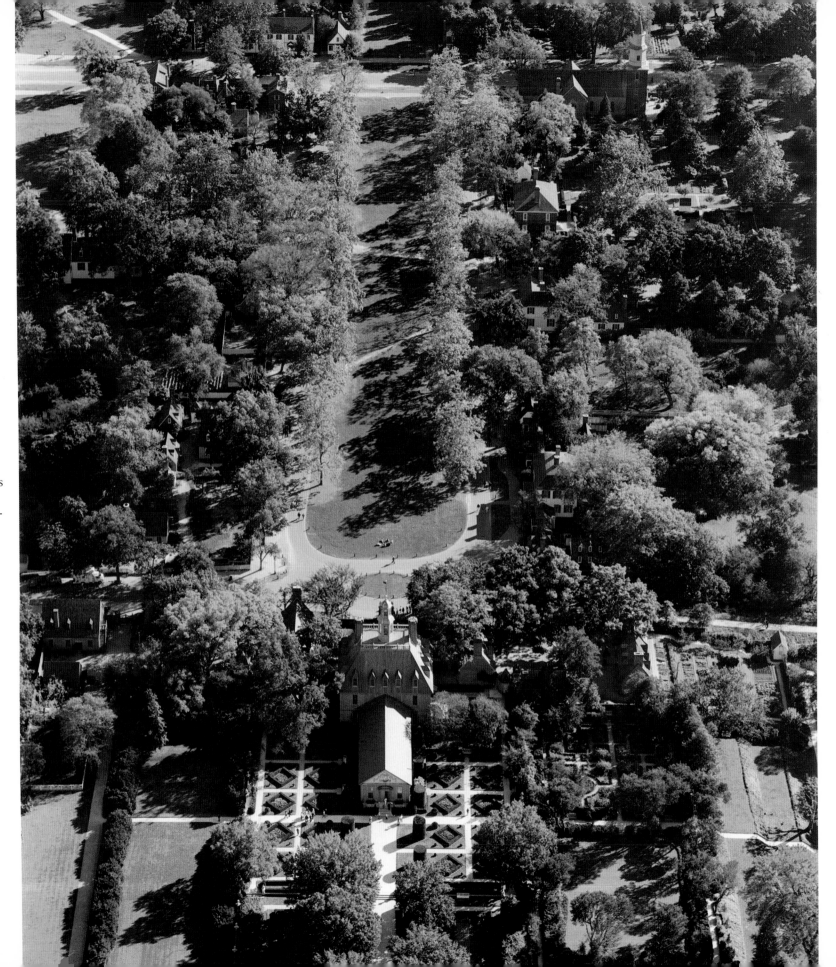

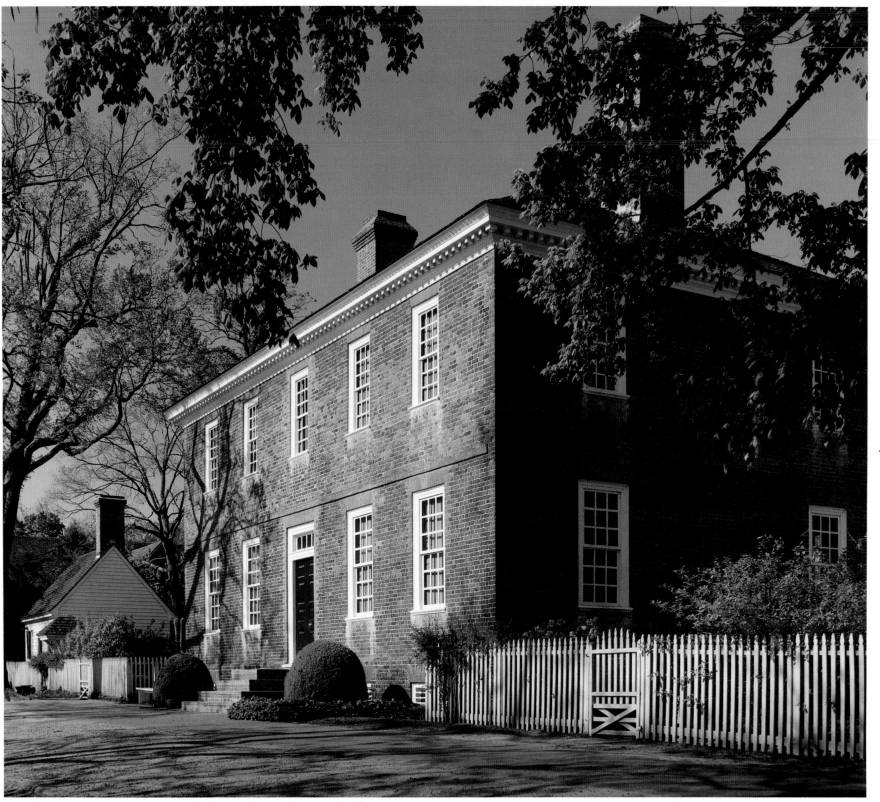

Wythe House, *ca.* 1750

Williamsburg

Richard Taliaferro is believed to have been the builder and designer of this mid-eighteenth-century Williamsburg town house. He also is credited with the addition of the new ballroom wing of the Governor's Palace in 1754.

Taliaferro's son-in-law was George Wythe, the first law professor at Williamsburg's College of William and Mary. Thomas Jefferson spent five years reading the law with Wythe, his mentor and friend. Wythe later became a signer of the Declaration of Independence.

The house survived the ensuing 150 years gracefully and was restored, without major repairs, in 1939 and 1940 by the Colonial Williamsburg Foundation.

Carter's Grove, 1750–1753 (right)

James City County

One of the finest colonial plantation homes in Virginia, Carter's Grove was constructed between 1750 and 1753 by Carter Burwell, a grandson of Robert "King" Carter, who owned over 300,000 acres and 1,000 slaves. Overlooking the James River below Williamsburg, the house is distinguished by its original paneled interiors, considered the finest in Virginia.

Carter's Grove was the manor house not only of The Grove itself (as the plantation was later known) but also of five other plantations owned by Burwell, whose family retained the estate until 1838.

After a decline caused essentially by the Civil War, the plantation house was rescued by the E. G. Booth family in the 1880s. Mr. and Mrs. Archibald McCrea restored the home, adding hyphens and a dormered roof, in the late 1920s. A Rockefeller-supported fund purchased the estate in the 1960s, and Carter's Grove is now operated by the Colonial Williamsburg Foundation.

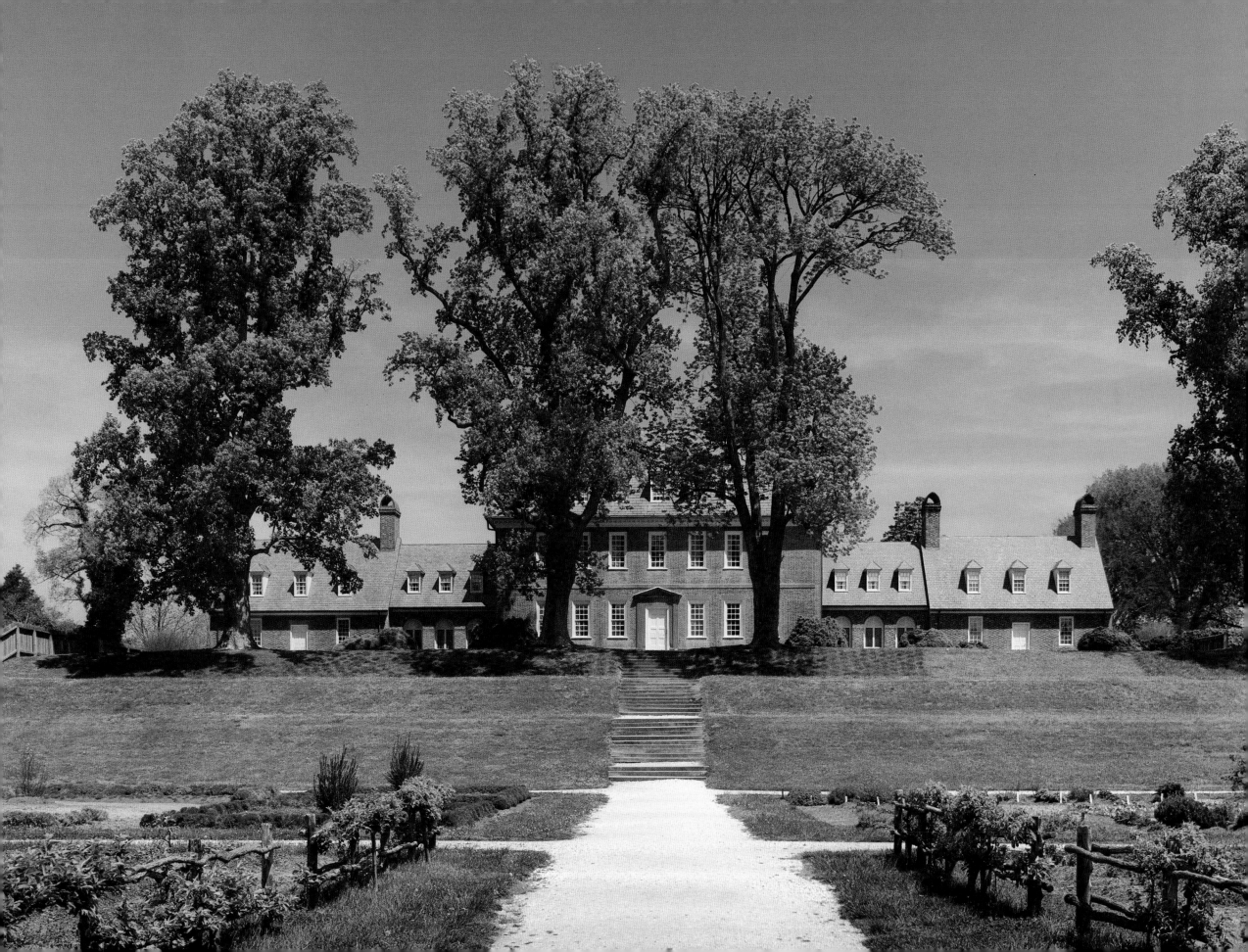

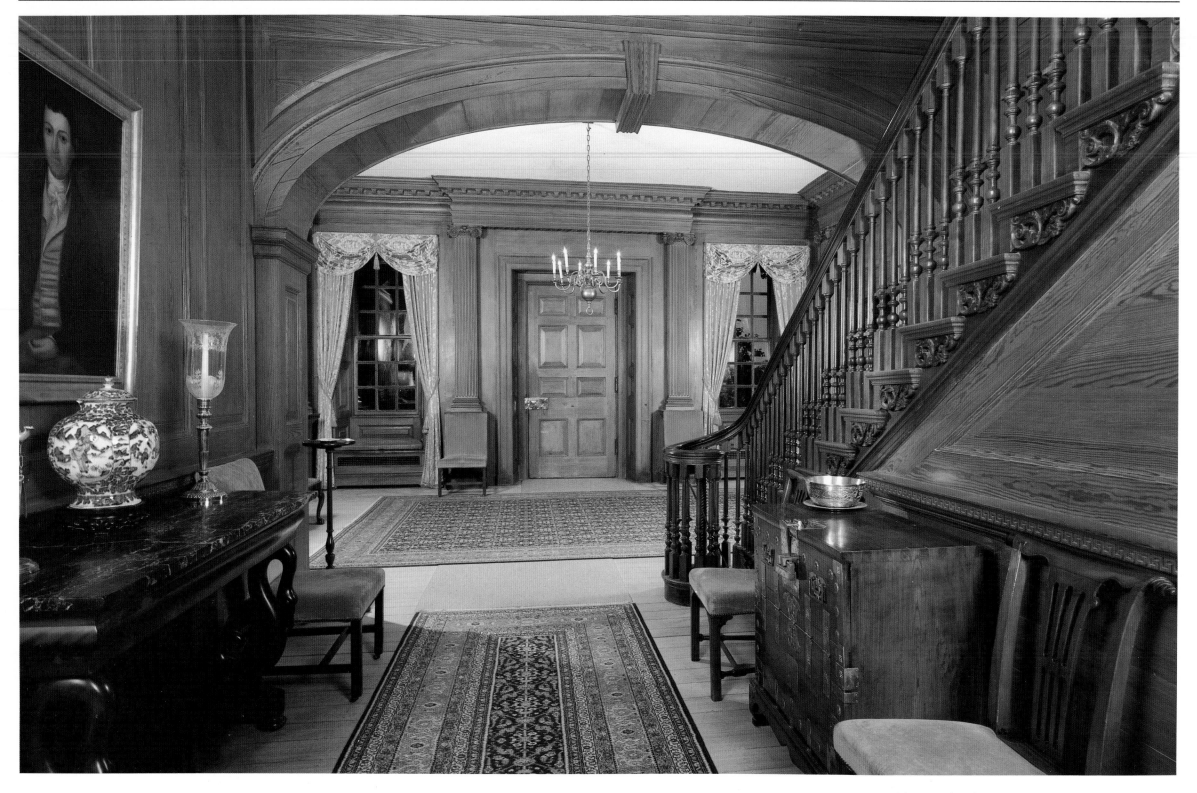

(above and right) *Carter's Grove*

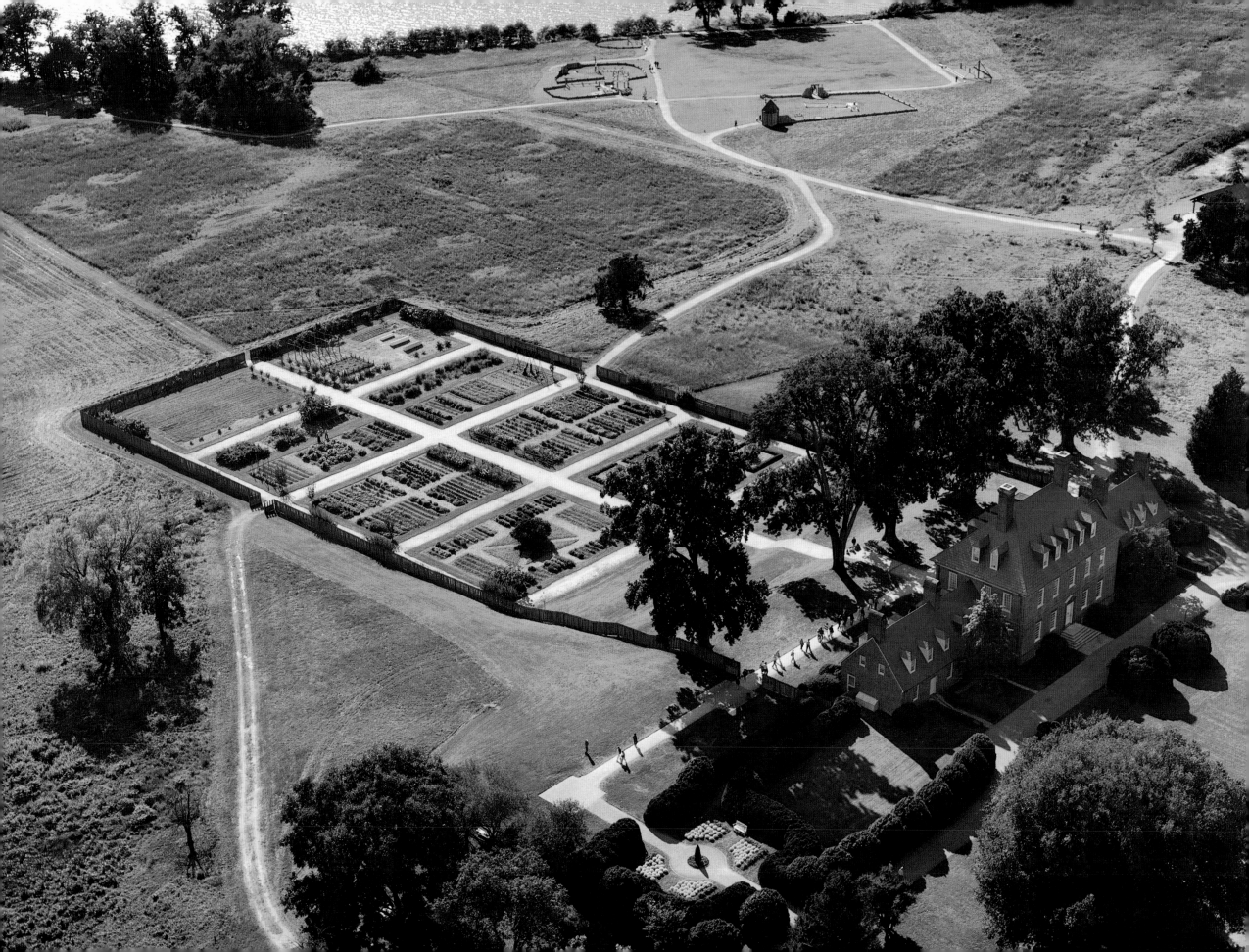

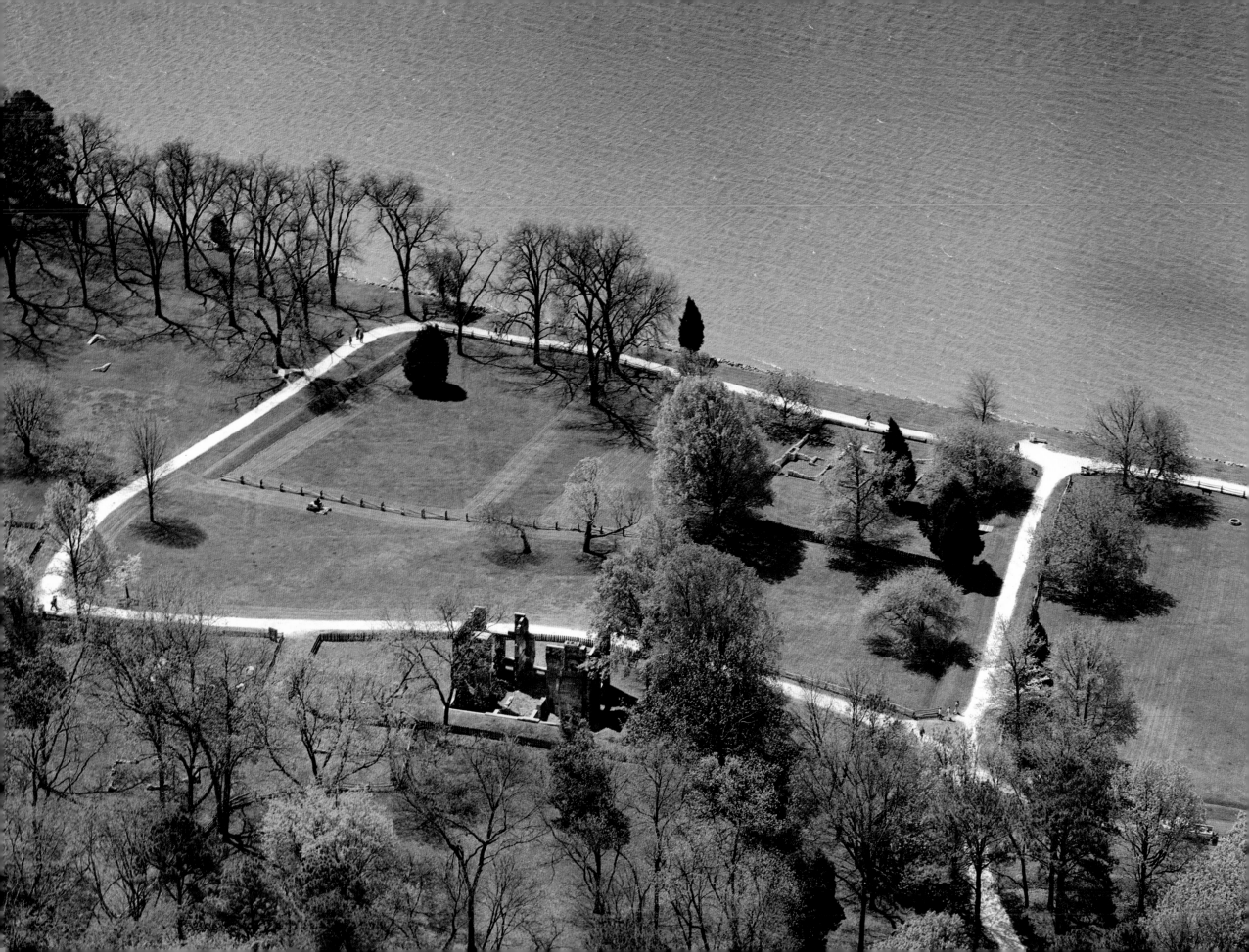

Jamestown National Historic Site, 1607 (left)

James City County

It was on an island in the James River that the English made their first permanent settlement in the New World in 1607, and Jamestown became the capital of Virginia for almost a hundred years. In 1699 the capital was moved to nearby Williamsburg, and Jamestown's fortunes declined. Most of the island eventually was owned by the Ambler family, who built a two-story brick plantation house overlooking the James in the mid-1700s.

Only ruins of the Ambler house, visible in this aerial view, an earthen Confederate fort, and a 1640s tower of the Jamestown church were left when the Association for the Preservation of Virginia Antiquities bought acreage on the island in 1893. The association and the National Park Service jointly preserve and exhibit Jamestown Island as a part of the Colonial National Historical Park.

Nelson House, 1720s

Yorktown

"Scotch Tom" Nelson sailed to Virginia from northern England in 1705, and became a merchant, planter, and ship owner. His house, which has survived with few changes, became home to two more generations of Nelsons: his son William and his grandson Thomas Nelson, Jr., a signer of the Declaration of Independence and, in 1781, governor of Virginia. Thomas Nelson, Jr., also commanded Virginia's militia during the Revolution.

During the siege of Yorktown, British general Cornwallis made his headquarters at another Nelson house (belonging to Thomas' uncle), which American and French gunners destroyed. Anticipating Cornwallis' moving to his own

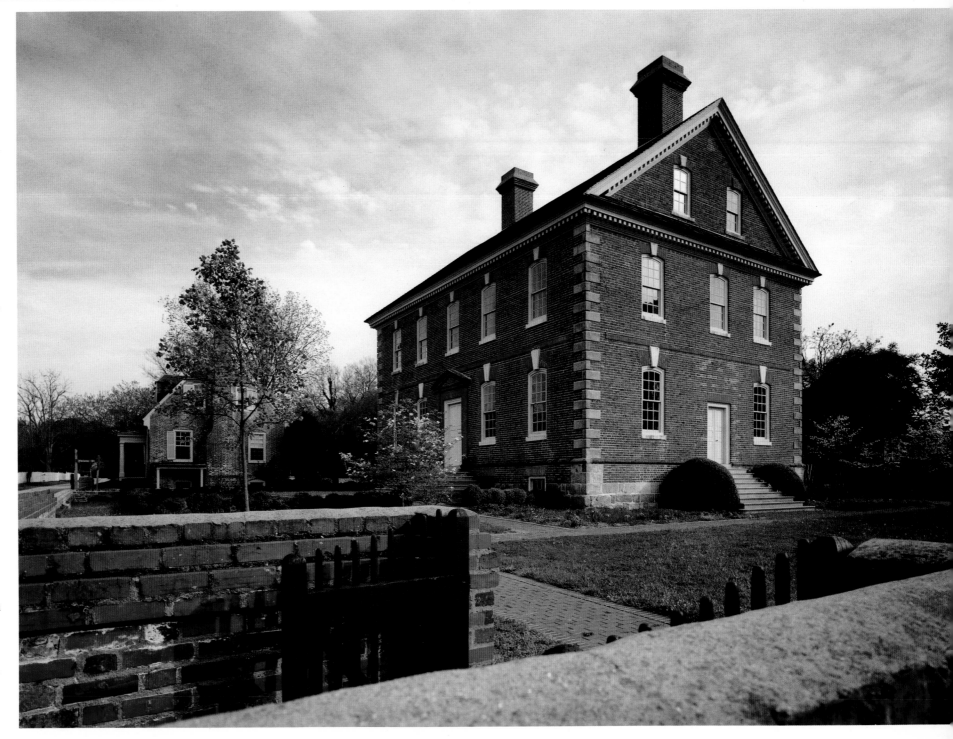

house next, Nelson ordered his gunners to fire on it first. The heavy brick walls still show scars of that bombardment.

Nelson repaired his house after the British sur-render, and the imposing town house remained in the Nelson family until 1908. Now a part of the Colonial National Historical Park, it was restored by the National Park Service in the mid-1970s.

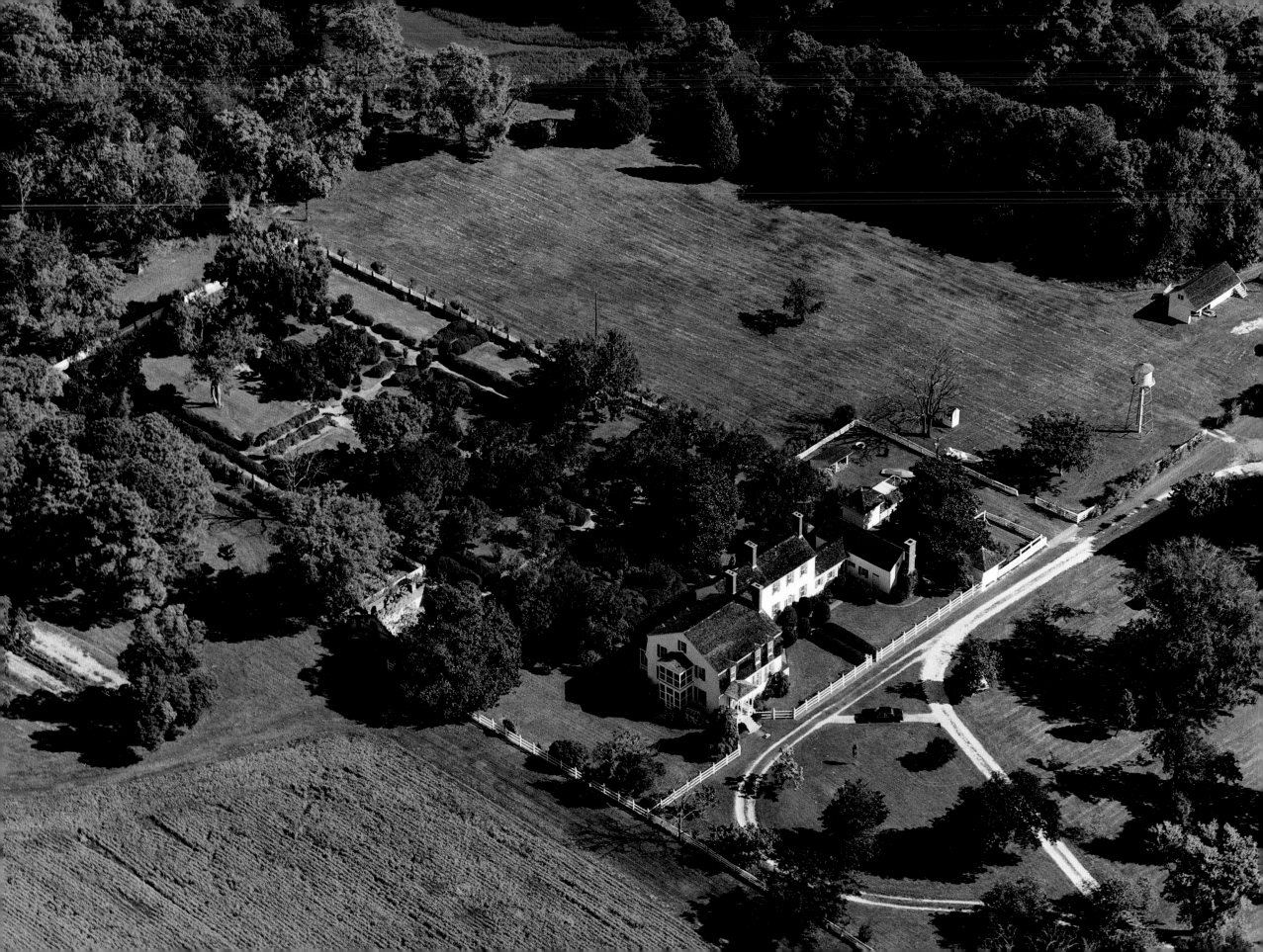

Eyre Hall, *ca.* 1735 and later

Northampton County

A wing of rambling, eighteenth-century Eyre Hall, near Cheriton on the Eastern Shore, is said to have been built by the Lee family, its owners, in the first half of the century.

Littleton Eyre bought the plantation in 1754, and his grandson John Eyre completed the largest, gambrel-roofed section of the house. Its carriage entrance (on the southern, land side) opens directly into a spacious paneled hall on the west end of the house divided by a handsome carved elliptical arch.

The waterway entrance, at the north end of the hall, is approached through an extensive, original formal garden, and is accented by 1816 French wallpaper by Dufour along the staircase wall.

Eyre Hall plantation has been continuously owned and farmed by descendants of Littleton Eyre, now the eleventh and twelfth generations.

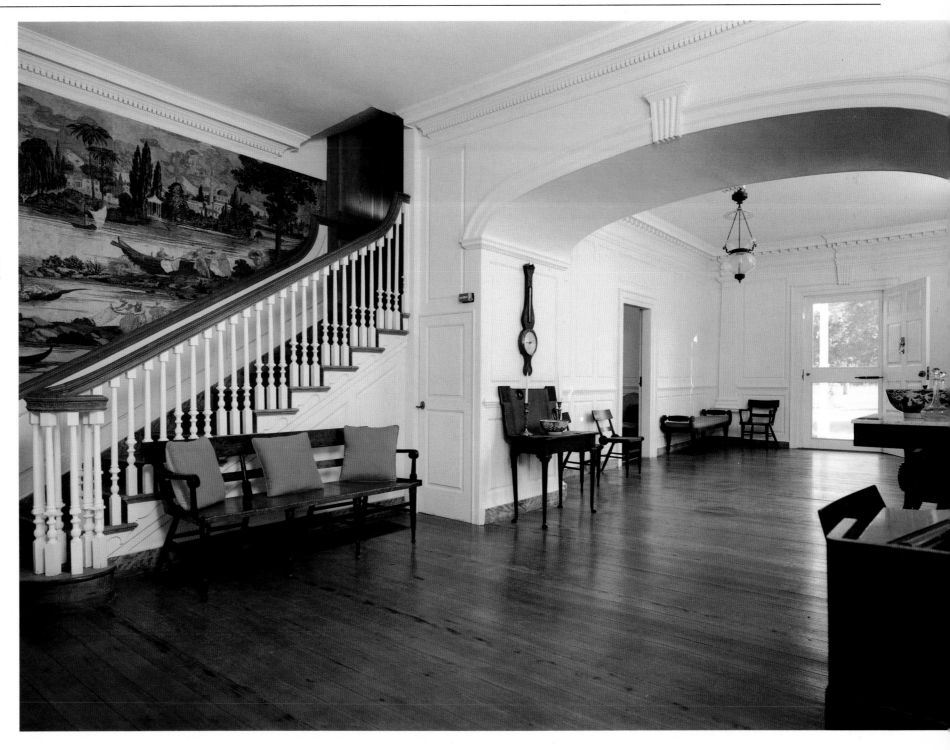

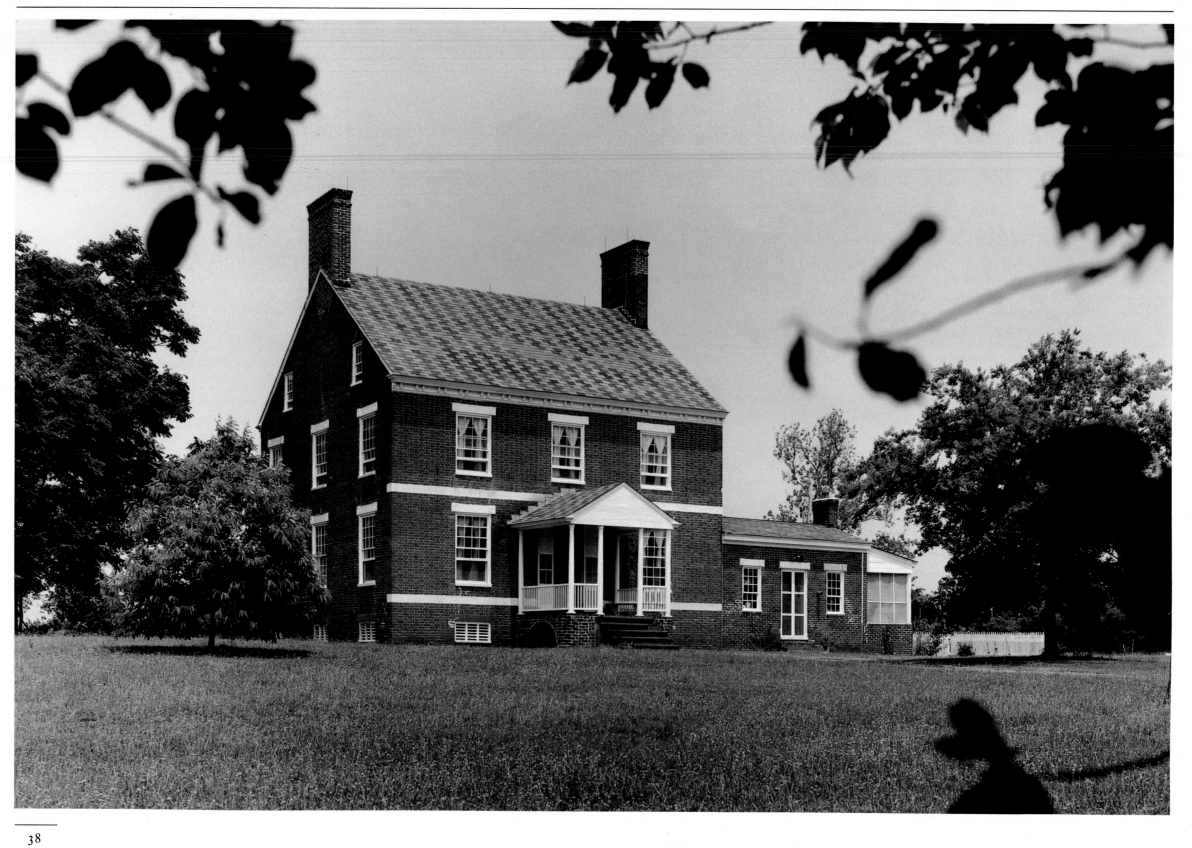

Grapeland, *ca.* 1825

Northampton County

A small but carefully detailed brick house over-
looking the Eastern Shore's Occohannock Creek,
Grapeland was built about 1825 for Edward W.
Addison. An earlier cottage on the property, near
the creek, possibly dates from the first quarter of
the 1700s.

 Although the house was deserted for many
years, Grapeland's interiors retained much of
their original hand-painted wood graining and
marbleizing. These interiors were painstakingly
restored by the present owner, who bought the
house and surrounding acreage in 1973.

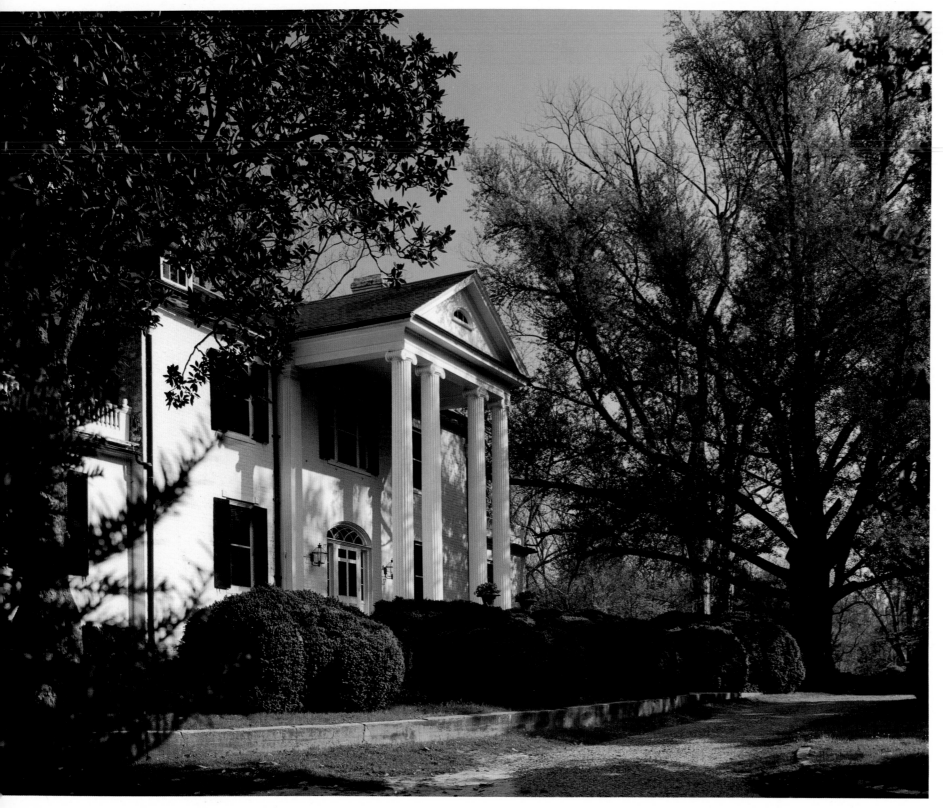

White Marsh, *ca.* 1750

Gloucester County

The earliest part of White Marsh was built on a 1640s land grant to Lewis Burwell, which the Whiting family later purchased. Descendants began the present mansion in the 1750s, and subsequent owners, John and Matilda Tabb, expanded the plantation in the 1850s to 3,000 acres and over 300 slaves.

Robert E. Lee visited White Marsh a number of times, the last in 1868, three years after the end of the Civil War. He referred to White Marsh as "the most beautiful place I have ever seen."

Rosewell, 1726–1734 (right)

Gloucester County

Thomas Mann Page I began construction of one of colonial Virginia's most magnificent houses in 1726, but died in 1730 before its completion. His son, Mann Page II, finished the three-story "mansion house," as Rosewell was called in the elder Page's will, in 1734. The manor house, overlooking the York River, was distinguished by twin cupolas (one a staircase entrance and the other a summer house), hand-carved staircases, and paneled woodwork. Its brickwork is considered the finest of the colonial era.

John Page, a grandson, added further embellishments in the 1770s. Page was a close friend of Thomas Jefferson and became governor of Virginia in 1802. His descendants sold Rosewell in 1838, and a later owner stripped and sold the interiors and lead roof.

The great house burned in 1916. The walls continued to stand, crumbling, until they were stabilized by the Gloucester Historical Society in 1980.

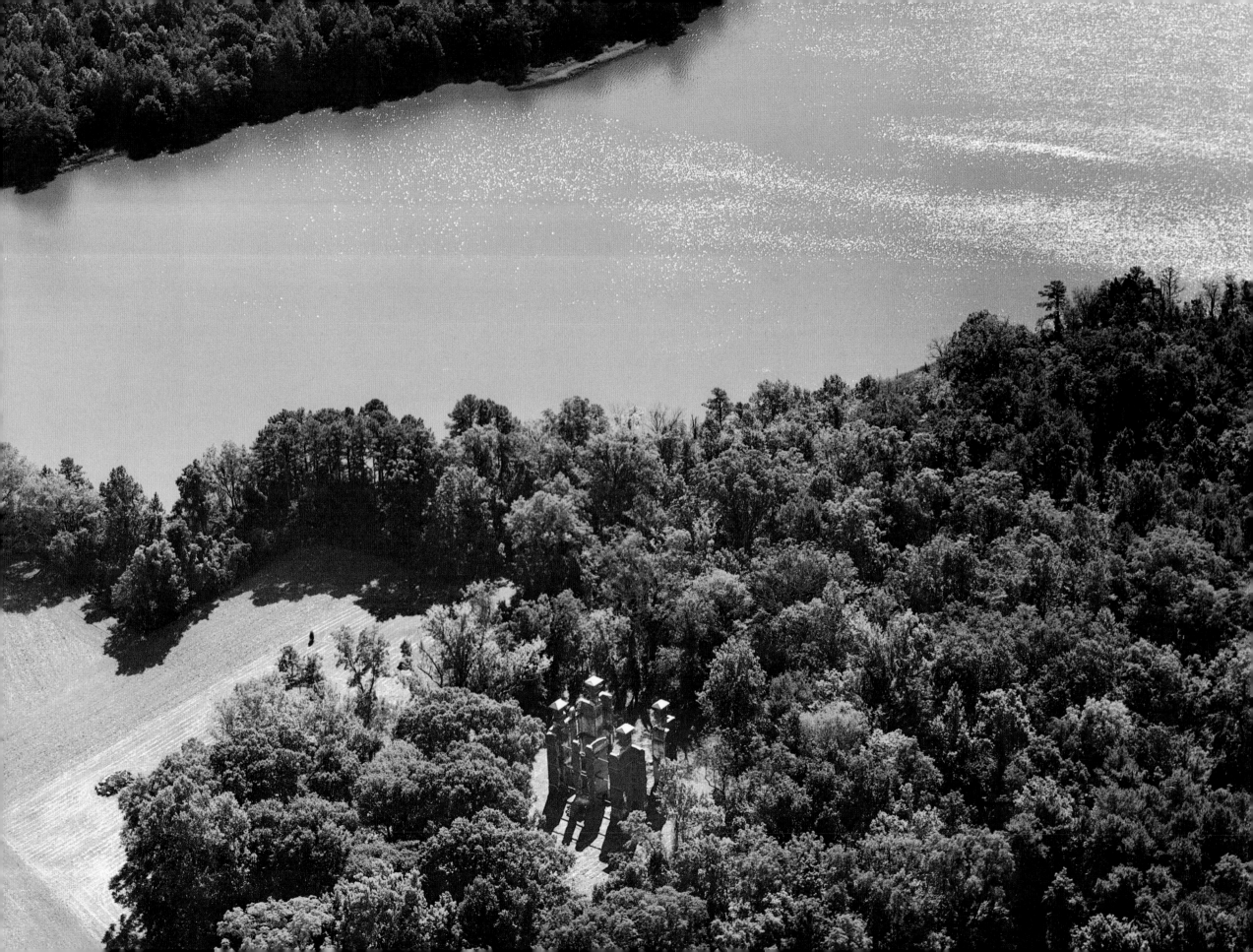

Kenmore, 1752–1756

Fredericksburg

George Washington's sister, Betty, married a wealthy merchant and planter, Colonel Fielding Lewis. He built his bride a handsome mansion at the edge of his 863-acre plantation on the outskirts of Fredericksburg. Construction of Kenmore began in 1752 and was finished four years later.

In 1775, Lewis employed a talented English artisan to ornament his ceilings and chimneypieces, creating some of the most richly embellished plasterwork in the country. Washington borrowed the same worker ("stucco man" was his term) from Lewis to execute his dining-room ceiling at Mount Vernon.

During the Revolution, Lewis devoted a large portion of his personal fortune to establishing a "gun manufactory," which built and repaired arms for Virginia units of the American army.

Kenmore survived the Civil War campaigns at Fredericksburg, but was scheduled for demolition in 1922. The Kenmore Association organized to preserve the historic mansion and bought it that same year. Handsomely restored and furnished by the association, Kenmore is one of the outstanding house museums of the country.

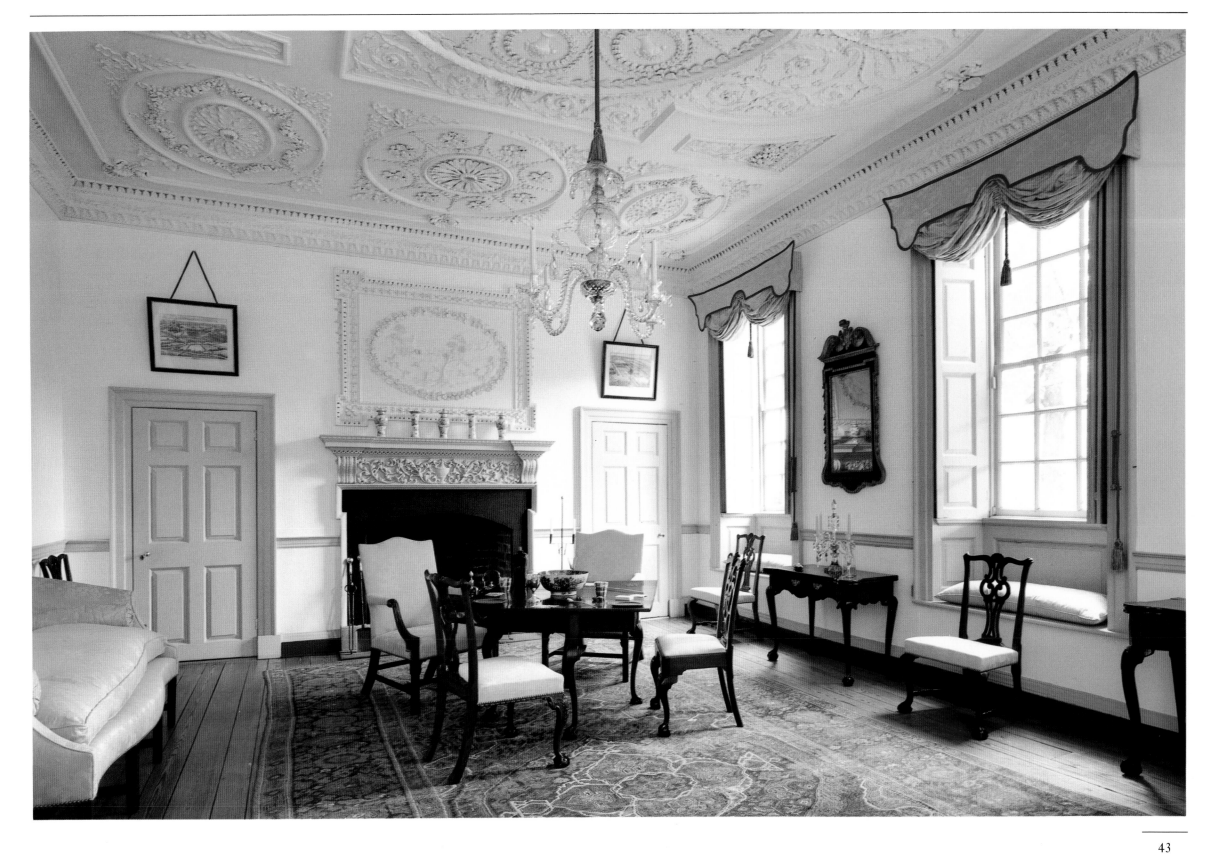

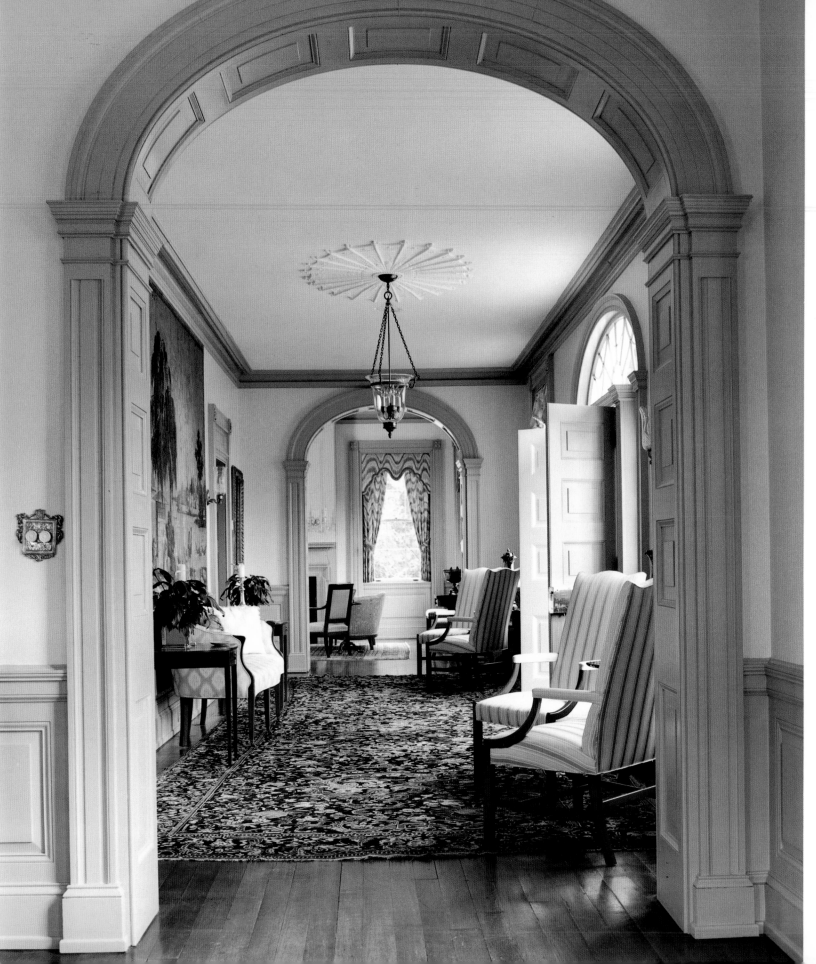

Brompton, 1740s, 1820s

Fredericksburg

On Marye's Heights overlooking historic Fredericksburg is Brompton, now the official residence of the president of Mary Washington College.

During the Civil War, in the Battle of Fredericksburg, Brompton was a fortified position defending the heights, one of the objectives of General Ambrose Burnside's Union troops. Defenders included the Washington Artillery from New Orleans, deployed adjacent to the house.

When the battle was over (it involved more than 200,000 troops, the largest engagement yet fought in the Western Hemisphere), Burnside had lost over 12,000 men in his futile effort to reach the Sunken Road below Marye's Heights.

In the second battle of Fredericksburg, Union troops took the house, which later served as a hospital during the Battle of the Wilderness in 1864. Photographs taken by Mathew Brady about that time show Brompton standing without one intact pane of glass in its nine windows and Palladian doorway that overlooked the Sunken Road.

Belmont, *ca.* 1761, 1826

Falmouth

The Reverend John Dixon, a professor at the College of William and Mary, built Belmont on a ridge overlooking the falls of the Rappahannock River, across from Fredericksburg, in about 1761. A later owner, Joseph Burwell Ficklin, bought the property in 1825 and enlarged the house the next year.

Belmont remained in the Ficklin family until artist Gari Melchers bought the estate in 1916. He built a stone studio near the house, where he painted for the next sixteen years. Some of the stone is said to have come from the ruins of water-powered mills along the Rappahannock and from bridgeheads dynamited during the Fredericksburg campaign.

Melchers' widow, Corrine, donated the estate to the Commonwealth of Virginia in 1942. Now operated by Mary Washington College, Belmont is an art center and memorial to Gari Melchers, one of the most decorated turn-of-the-century American artists.

Chatham, 1768–1771

Stafford County

William Fitzhugh began his country seat on a bluff across the Rappahannock River from Fredericksburg in 1768 and completed it in 1771. A noted host and friend of George Washington, Fitzhugh named the imposing mansion for William Pitt, the earl of Chatham. He later sold the house and moved north to Alexandria.

Chatham was always a center of hospitality; its noted guests included Washington and the Marquis de Lafayette. Unwanted occupants included Union generals Irvin McDowell and Ambrose Burnside.

During the Civil War, Chatham's owner, William Lacy, served as a staff officer in the Confederate army. His home, then known as the Lacy House, became a Union headquarters (northern artillery on its grounds devastated Fredericksburg) and hospital. Walt Whitman and Clara Barton cared for many of the wounded. When their generals were not in residence, Union troops burned the paneling for firewood and rode horses through the center hall.

Chatham had lost its supporting prewar lands of over 1,200 acres when industrialist John Lee Pratt bought the mansion in 1930. He willed Chatham and 30 acres to the National Park Service in 1975. The house was opened to the public in 1977.

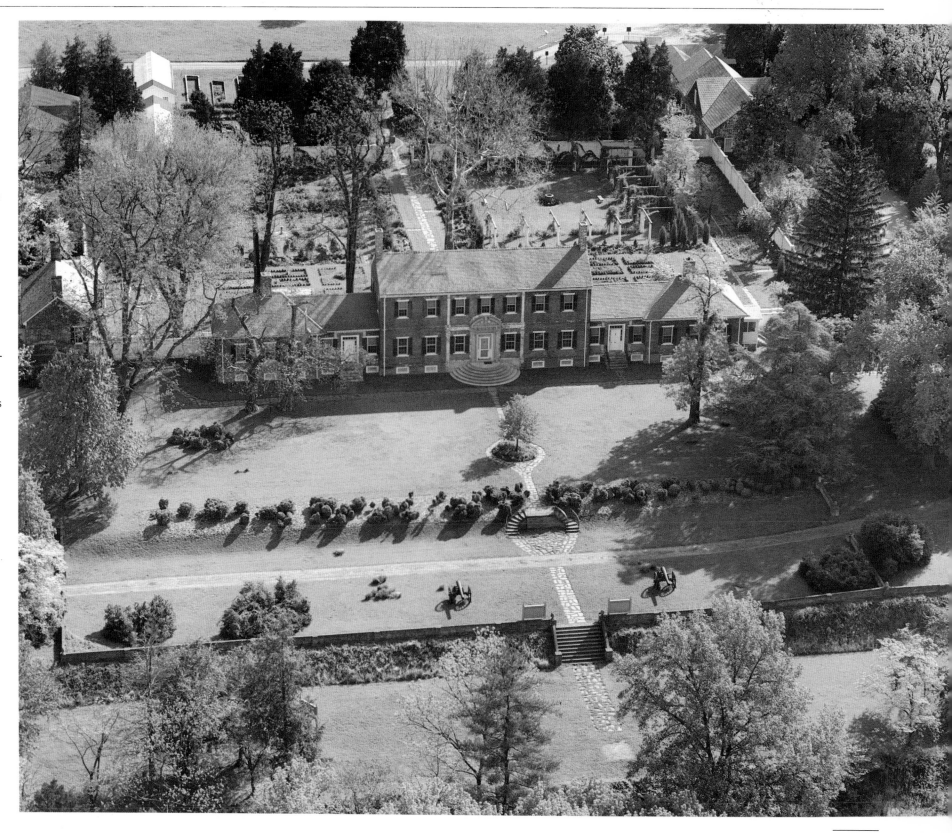

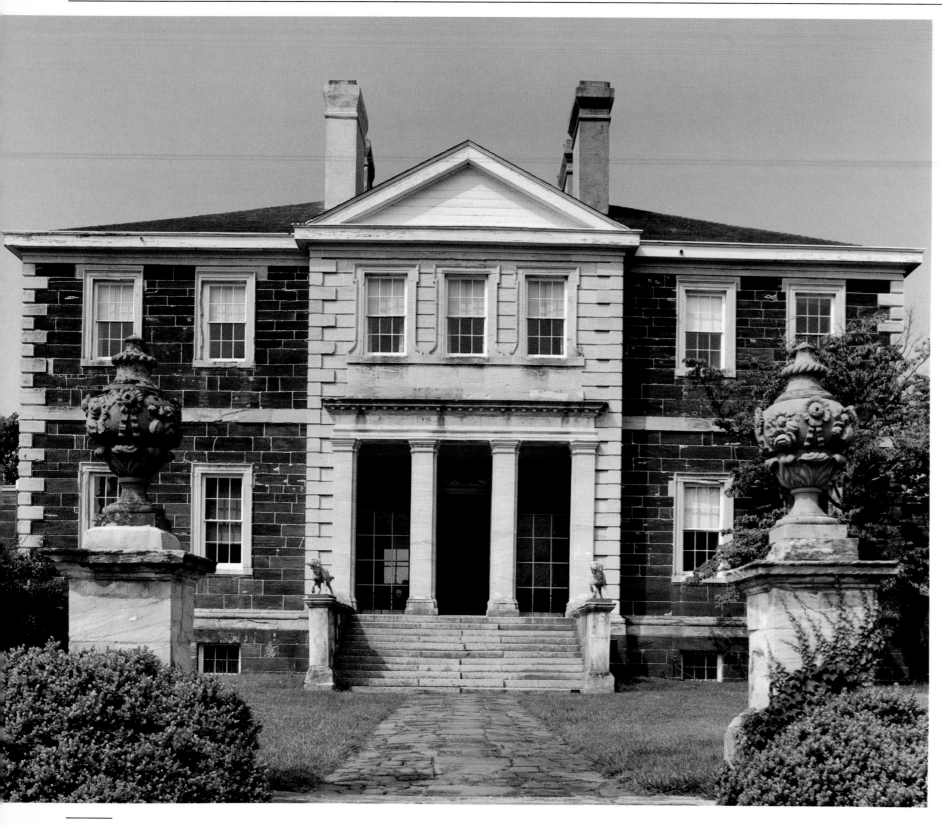

Mount Airy, 1748–1758
Richmond County

John Tayloe II built one of the most impressive colonial homes in the Old Dominion after his original Northern Neck residence burned in 1740.

Constructed of local brown sandstone, and trimmed with honey-colored stone from Aquia Creek near Fredericksburg, the Palladian mansion has curved hyphens that join the two-story dependencies to the center block.

The interiors, designed by William Buckland in 1762, were said to have been among the finest in the colonies. Unfortunately, they were destroyed when an 1844 fire gutted the house. The Tayloe family rebuilt shortly thereafter, using the services of brothers George and William Van Ness to complete the interiors in a simpler Greek Revival fashion.

Still the seat of the Tayloe family, Mount Airy plantation has more than doubled its original colonial acreage.

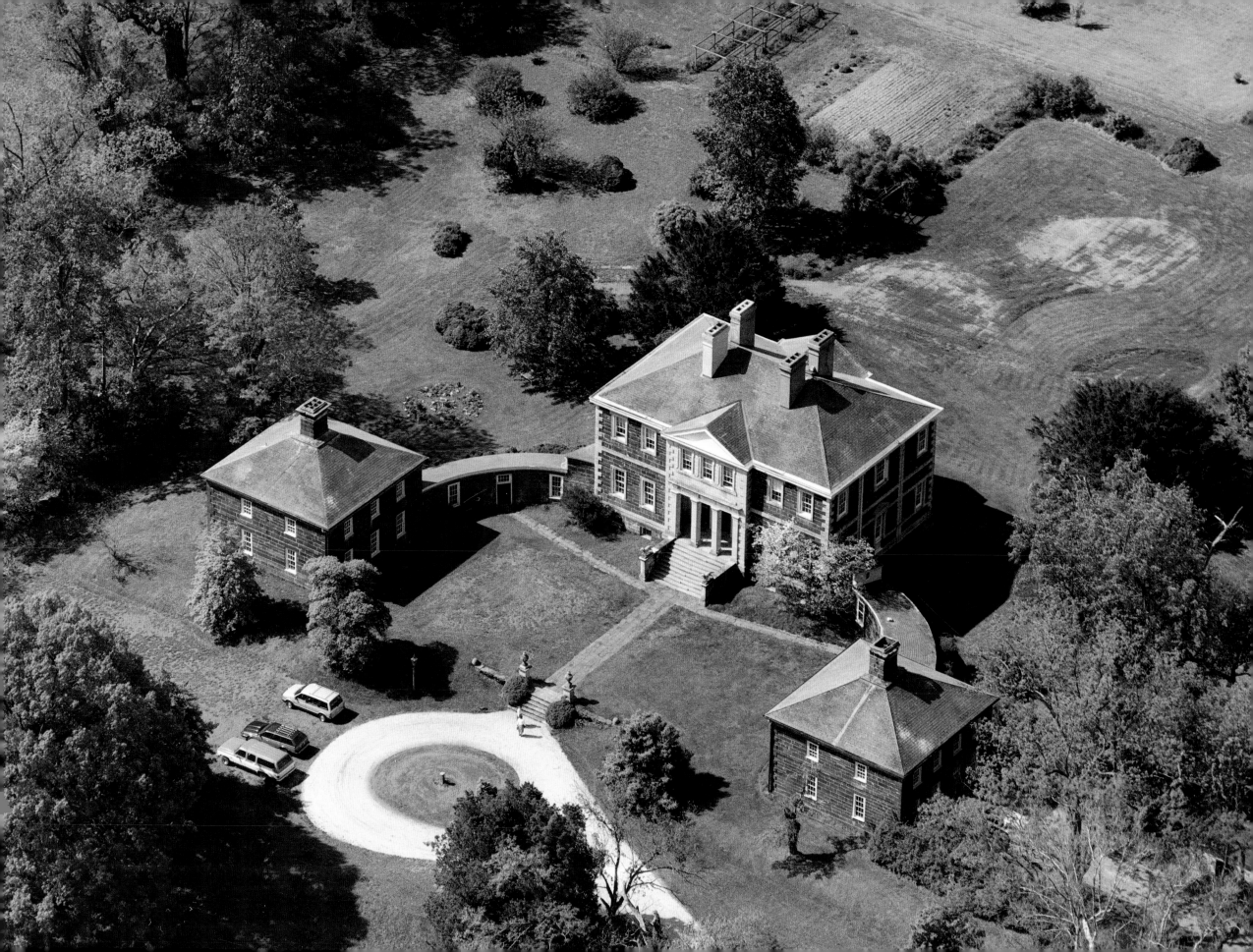

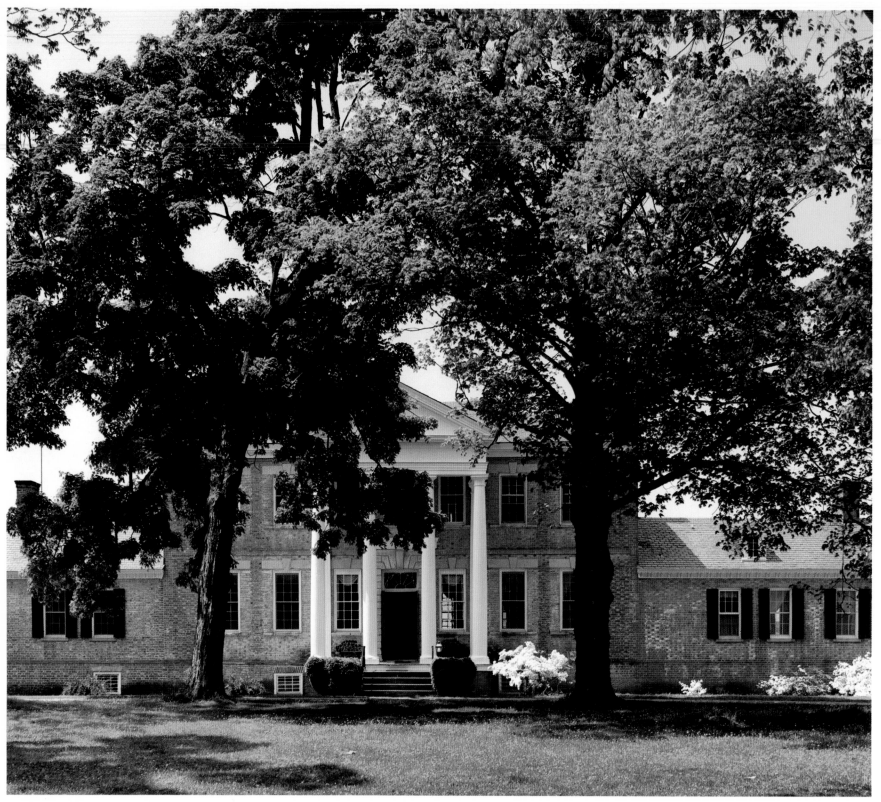

Sabine Hall, 1735, 1830s, 1929

Richmond County

Robert "King" Carter (1663–1732) was a Speaker of the House of Burgesses, an acting governor in 1726, and an agent for the Northern Neck proprietary owned by Thomas Lord Fairfax. Ultimately he acquired over 300,000 acres, becoming immensely wealthy in the process. His descendants include signers of the Declaration of Independence, two presidents, two chief justices, a number of governors of Virginia, and Robert E. Lee.

"King" Carter gave each of his sons a sizable Northern Neck plantation. In 1735, his son Landon built on his plantation near Mount Airy an elegantly appointed Georgian house, which he named Sabine Hall. An 1830s remodeling included the addition of the portico (with its four solid-cypress columns) and the lowering of the roof. The wings are later additions.

Sabine Hall's terraced gardens, which preserve their original geometric paths, are one of Virginia's few remaining intact formal gardens of the colonial era. The plantation is still owned by Carter descendants.

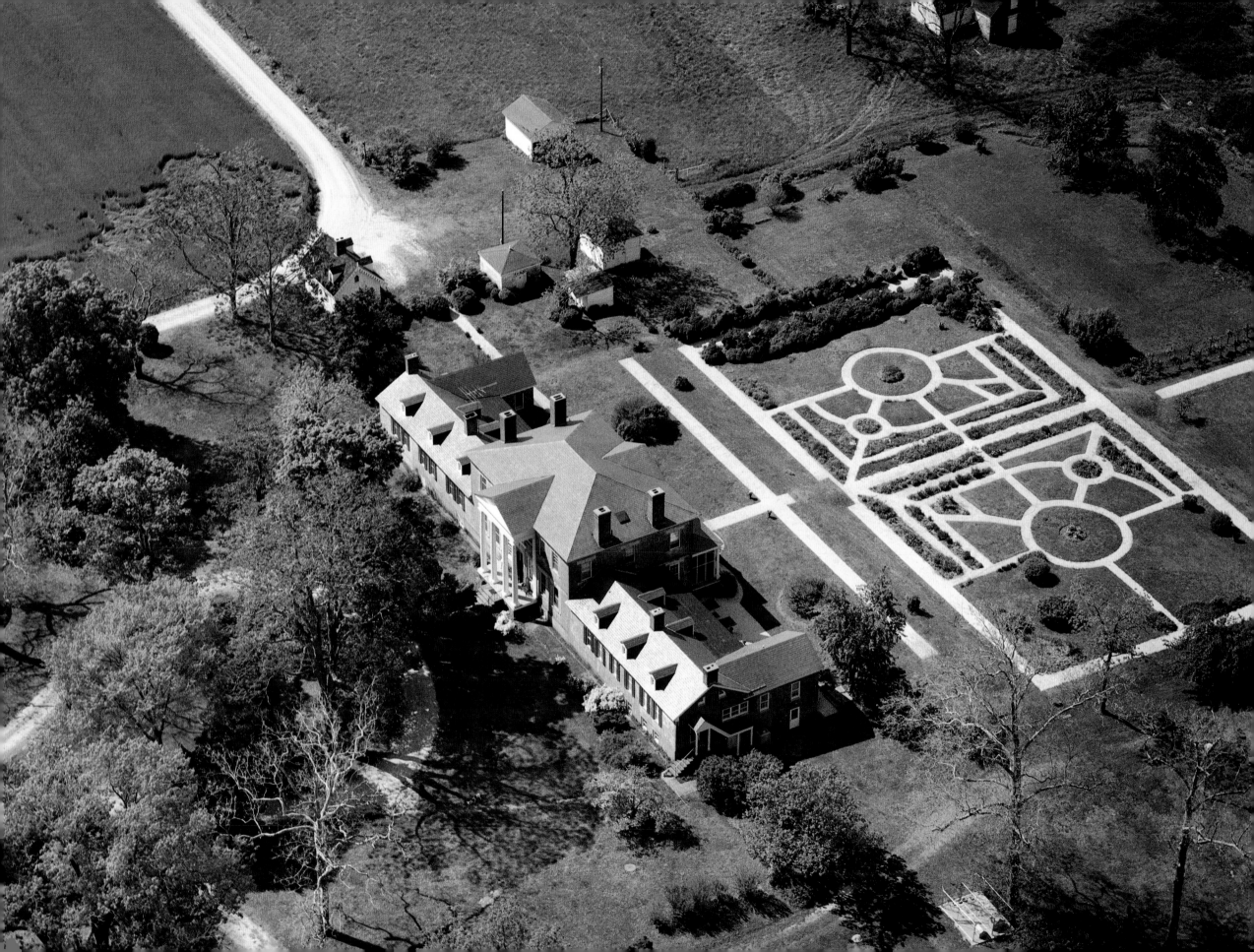

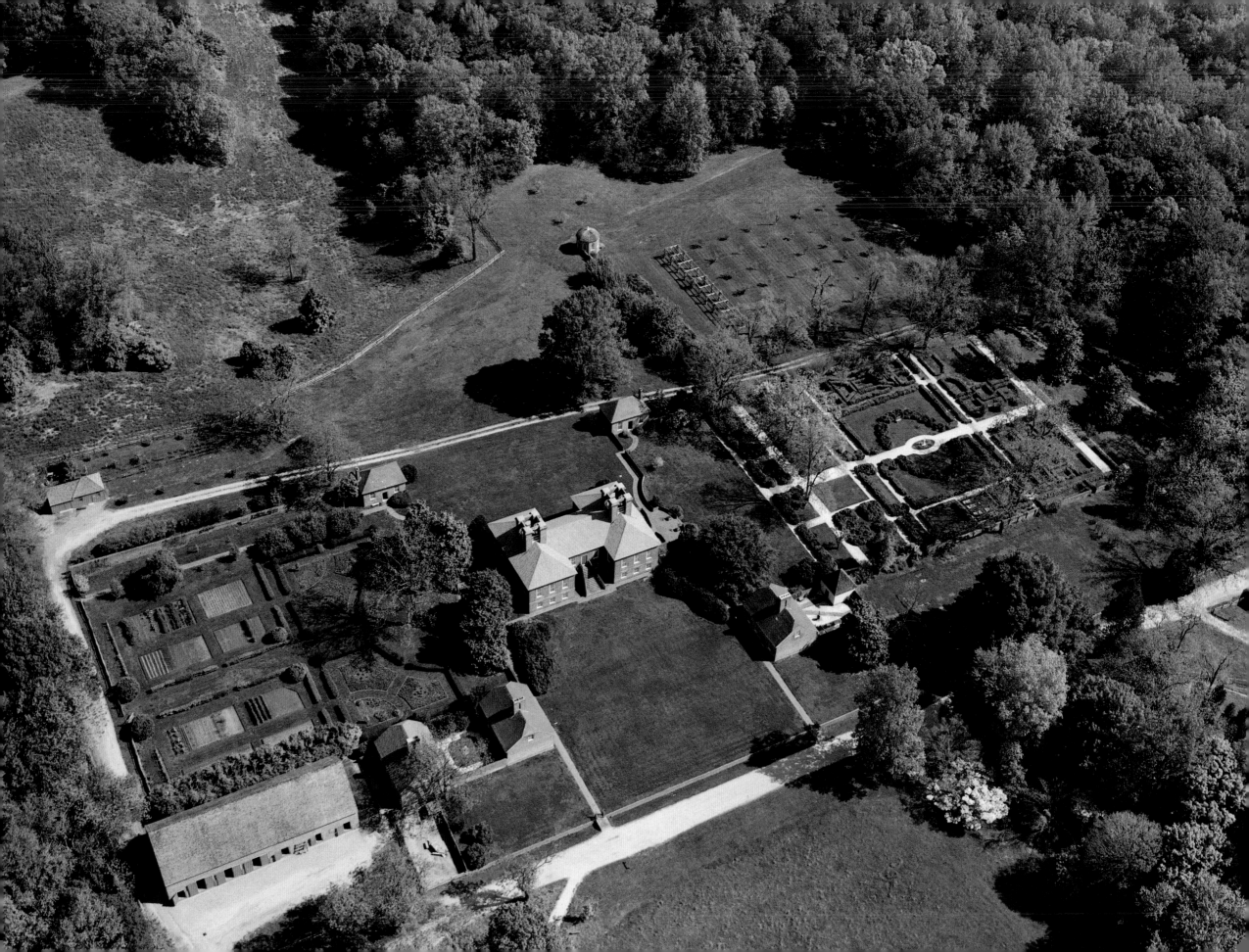

Stratford Hall, *ca.* 1738

Westmoreland County

Overlooking the broad reaches of the Potomac River about forty miles east of Fredericksburg is one of the great houses of American history, Stratford Hall, built by Thomas Lee in the late 1730s.

The cliffs in the foreground, a "Miocene compaction," similar to the chalk cliffs of Dover, England, are a landmark of Stratford Hall plantation, which was called The Cliffs when its 1,400-acre tract was purchased by Thomas Lee in 1730.

Home of Richard Henry and Francis Lightfoot Lee, signers of the Declaration of Independence, and birthplace of Robert E. Lee, general-in-chief of the Confederate armies, the H-shaped manor house is distinguished by the Great Hall (29 feet square, with a 17-foot tray ceiling) in the center of the house. Two clusters of massive chimney stacks were once connected by a promenade deck straddling the roof ridge. The site plan is formal, with the house in the center of a square with a brick dependency at each corner.

The Potomac is to the north of the manor house, with an avenue cut through the trees to see the river. On the eastern side is a formal garden with boxwood-bordered beds, and at the west is the kitchen garden.

The Lee family lost ownership of Stratford in the 1820s. A hundred years later, in 1929, the Robert E. Lee Memorial Association bought 1,600 acres of the original 30,000-acre tract and began a continuing program of study, preservation, and restoration of the plantation.

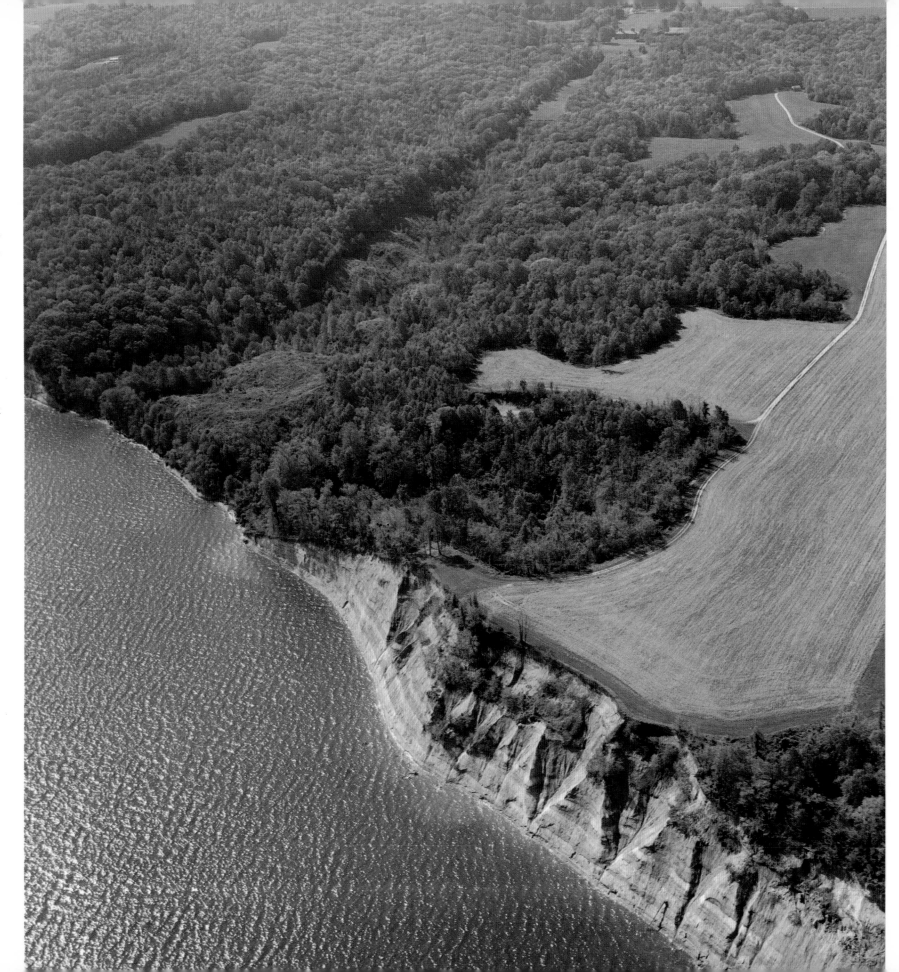

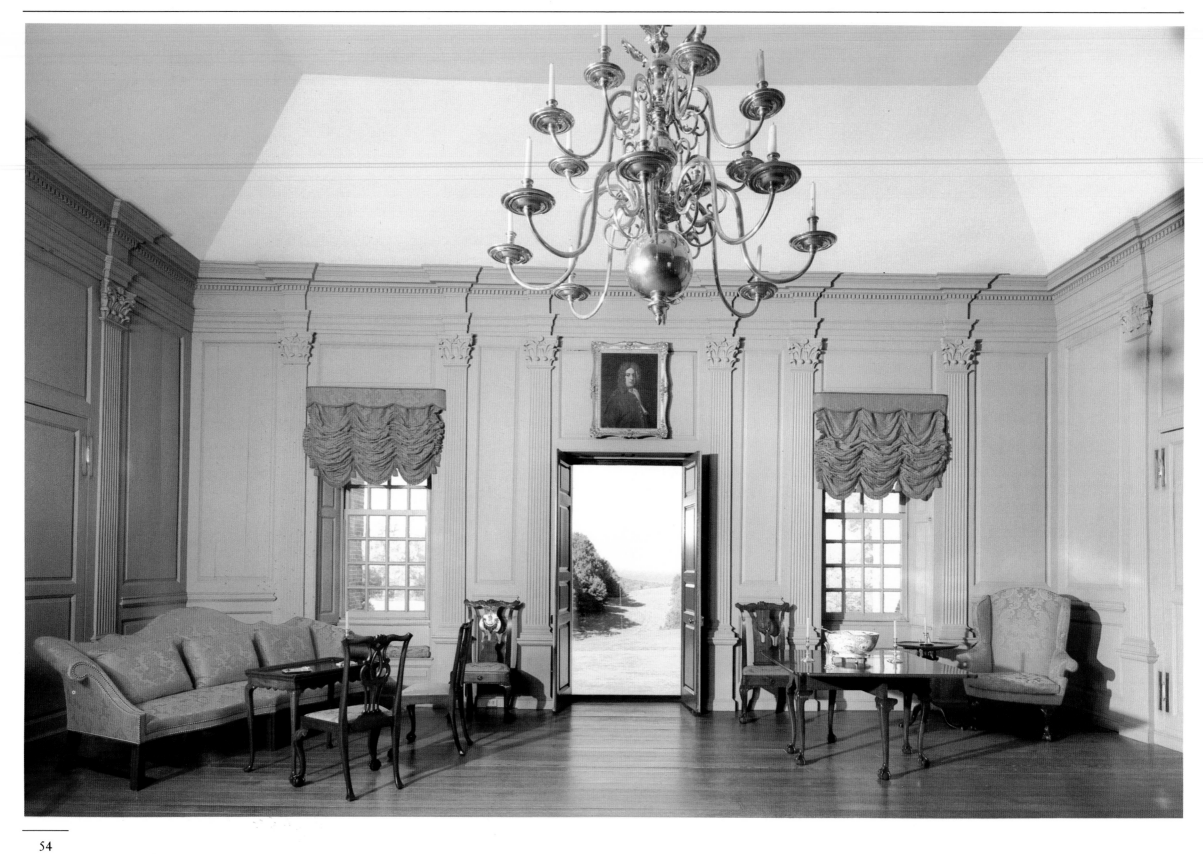

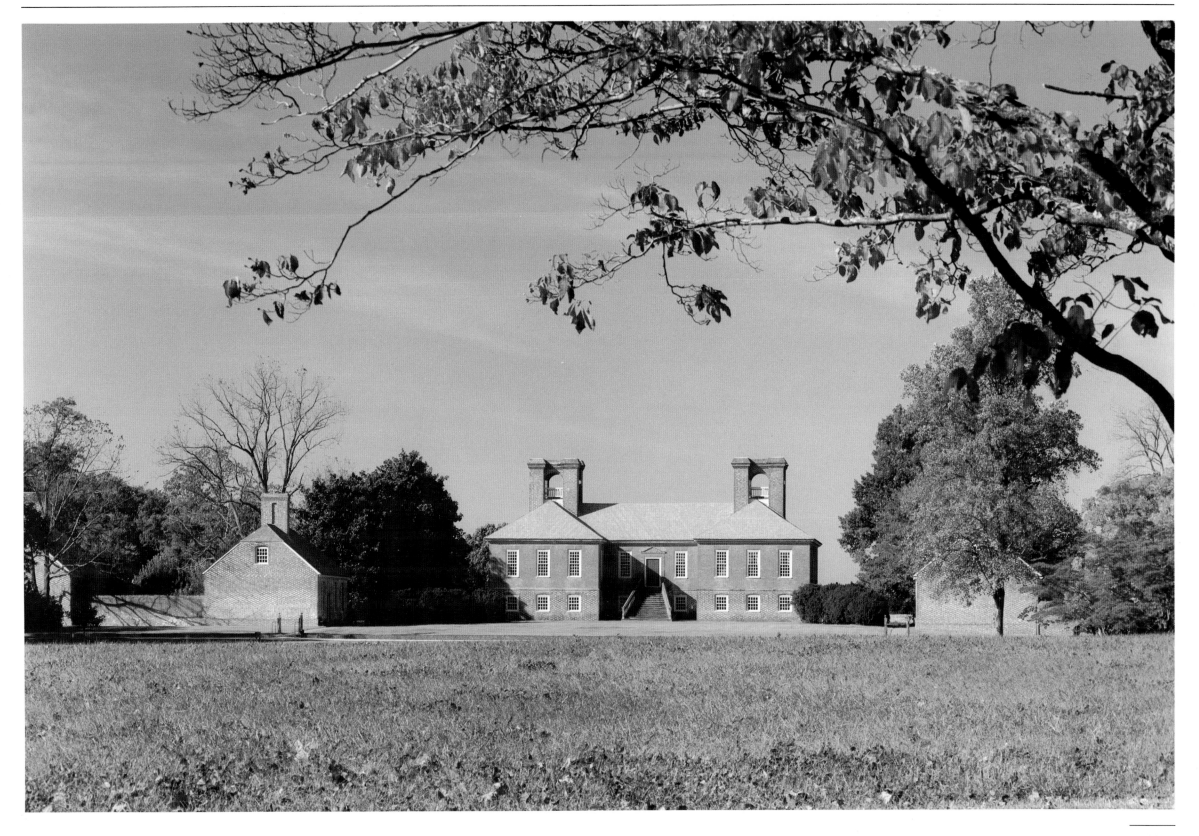

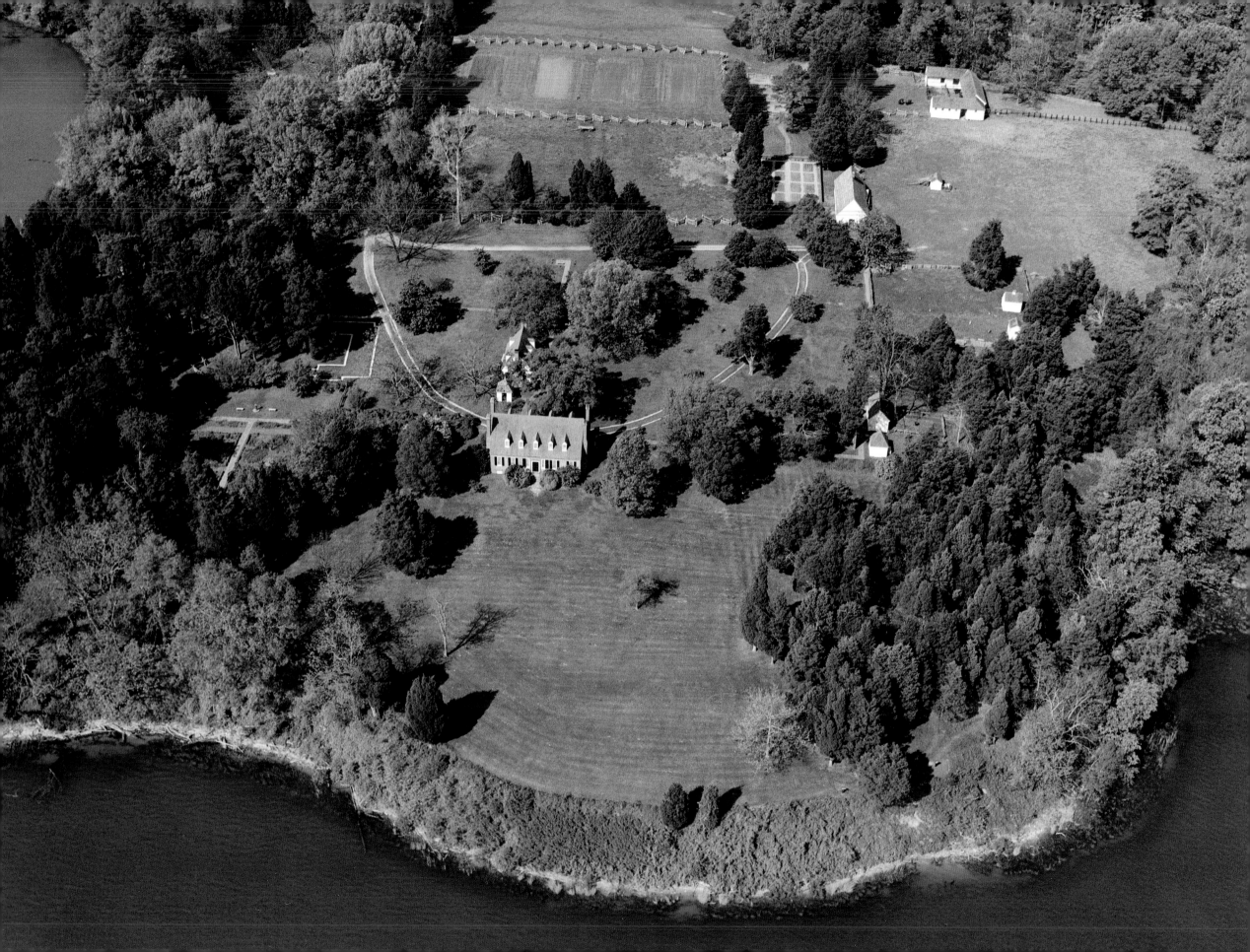

George Washington Birthplace National Monument (Wakefield)

(left)

Westmoreland County

Four miles west of Stratford, on Pope's Creek near the Potomac River, is the birthplace of George Washington, whose father, Augustine, bought the property in 1719. Young George spent only his first three years there, but returned to study surveying when he was eleven. The house, named Wakefield at the time, burned in 1779 and was not rebuilt.

In 1923 the Wakefield National Memorial Association acquired the property and built the present memorial house, representing a typical home of a planter of the late colonial period. The house and farm were transferred to the National Park Service in 1932.

Wirtland, 1850

Westmoreland County

After his wife, the former Elizabeth Payne, inherited extensive acreage in Westmoreland County, Dr. William Wirt, Jr., bought 110 acres from Walnut Hill plantation as the site for a 28-room Gothic Revival mansion to be placed in an English park setting.

Although there is no documentation of its architect, the three-story mansion conforms to the ideal of the American villa of Andrew Jackson Downing, one of the foremost architects of mid-nineteenth-century America and a leading proponent of the Gothic revival.

Wirtland became a "female academy" following Dr. Wirt's death in 1898, and later was incorporated into Ingleside Nurseries. Now restored, it is the residence of a member of the Flemer family.

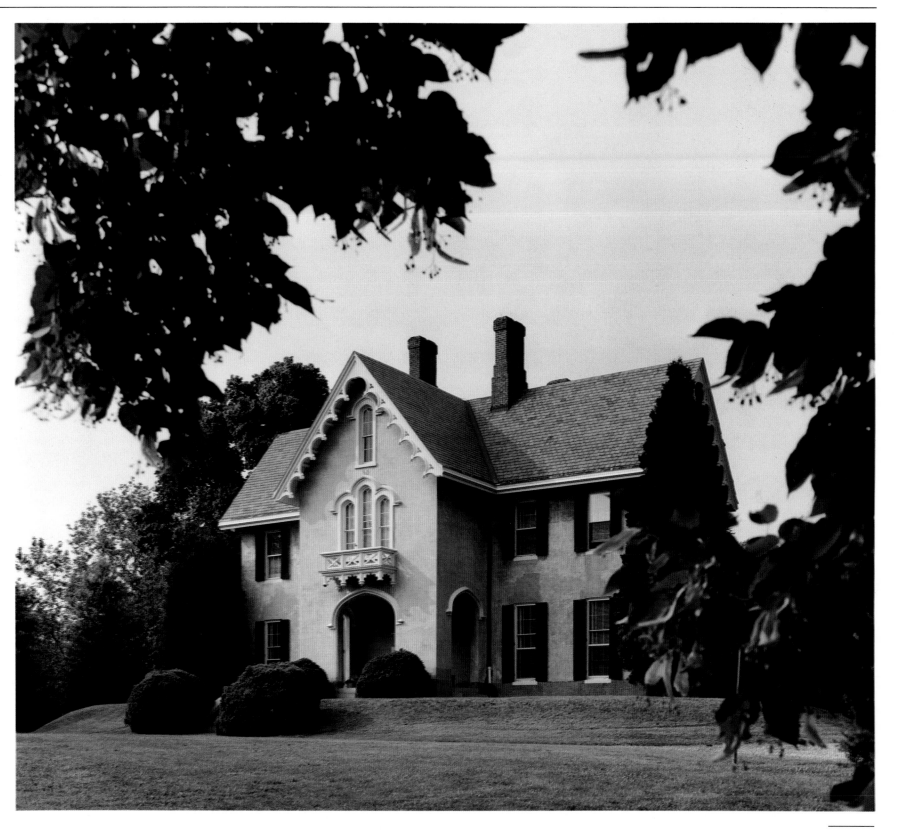

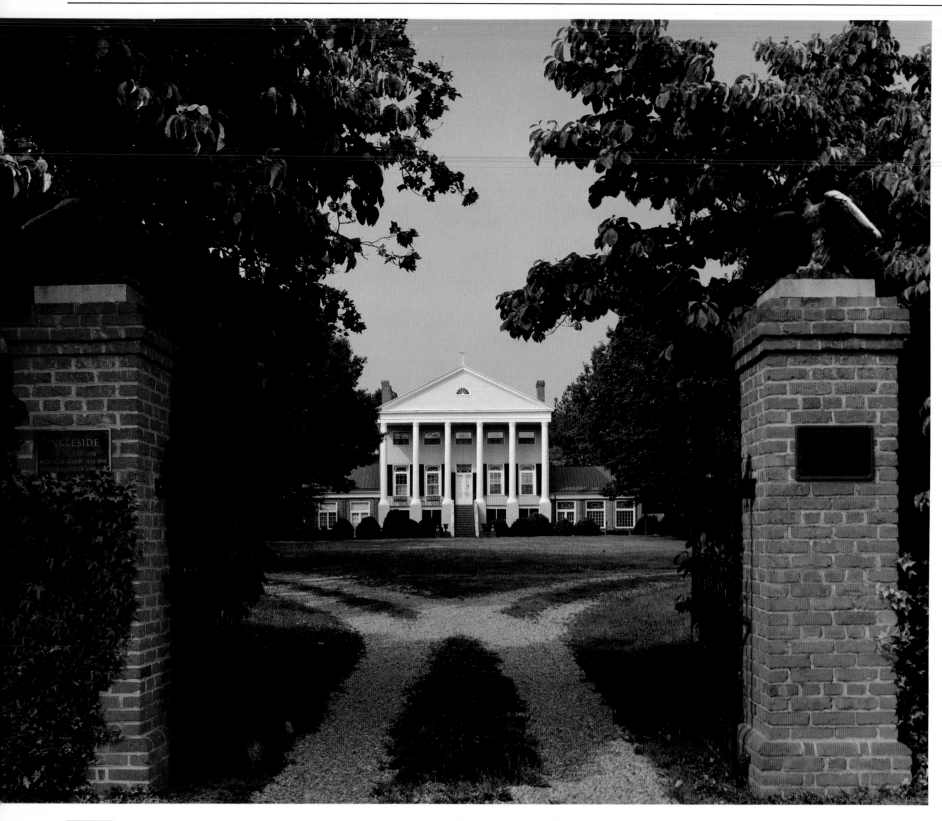

Ingleside, 1834
Westmoreland County

On the highest ground of the Northern Neck, midway between the Potomac and Rappahannock rivers, is Ingleside plantation, now part of a 2,500-acre agricultural enterprise comprising one of the largest nurseries on the eastern seaboard and an award-winning winery.

The manor house was built in 1834 as a private school, Washington Academy, patterned (according to local tradition) along the lines of the state capitol in Richmond, designed by Thomas Jefferson.

Washington Academy closed after about ten years, and James L. Cox bought the building and 47 acres for $900. Ingleside was the site of a Union garrison during the Civil War, a district courthouse during Reconstruction, and later a dairy.

In 1890, Charles Henry Flemer bought the house and 404 acres adjoining Walnut Hill plantation, owned by his sons. Carl Flemer planted his first grapevines in 1960, and Ingleside continues to be owned and operated by the Flemer family.

Northern Virginia and the Shenandoah

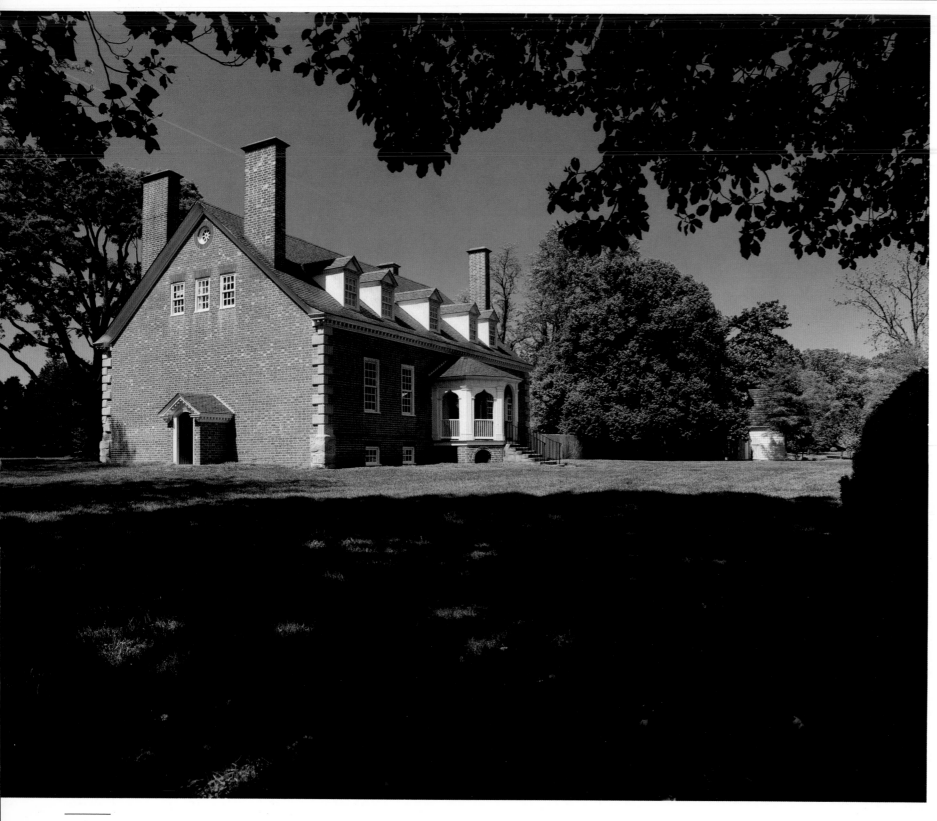

Gunston Hall, *ca.* 1755

Fairfax County

George Mason, father of the Bill of Rights of the U.S. Constitution, built his elegant home on an inherited plantation bordering the Potomac River below Alexandria in about 1755. To complete his design, Mason brought over from England an indentured worker, the talented young architect-builder William Buckland, to design and execute his interiors and porches in the latest fashions of London.

Between the house and the river Mason placed formal gardens, now painstakingly restored by the Garden Club of Virginia. A boxwood allée in the center of the garden was planted by Mason himself.

Gunston Hall remained in the family until 1866. The house and grounds gradually declined until Louis Hertle bought the property in 1912 and began restoration. As his wife wished, Hertle deeded Gunston Hall to the Commonwealth of Virginia, to be administered by the National Society of the Colonial Dames of America. Restoration continues, and many of the architectural elements removed from the interior in the late nineteenth century have now been replaced.

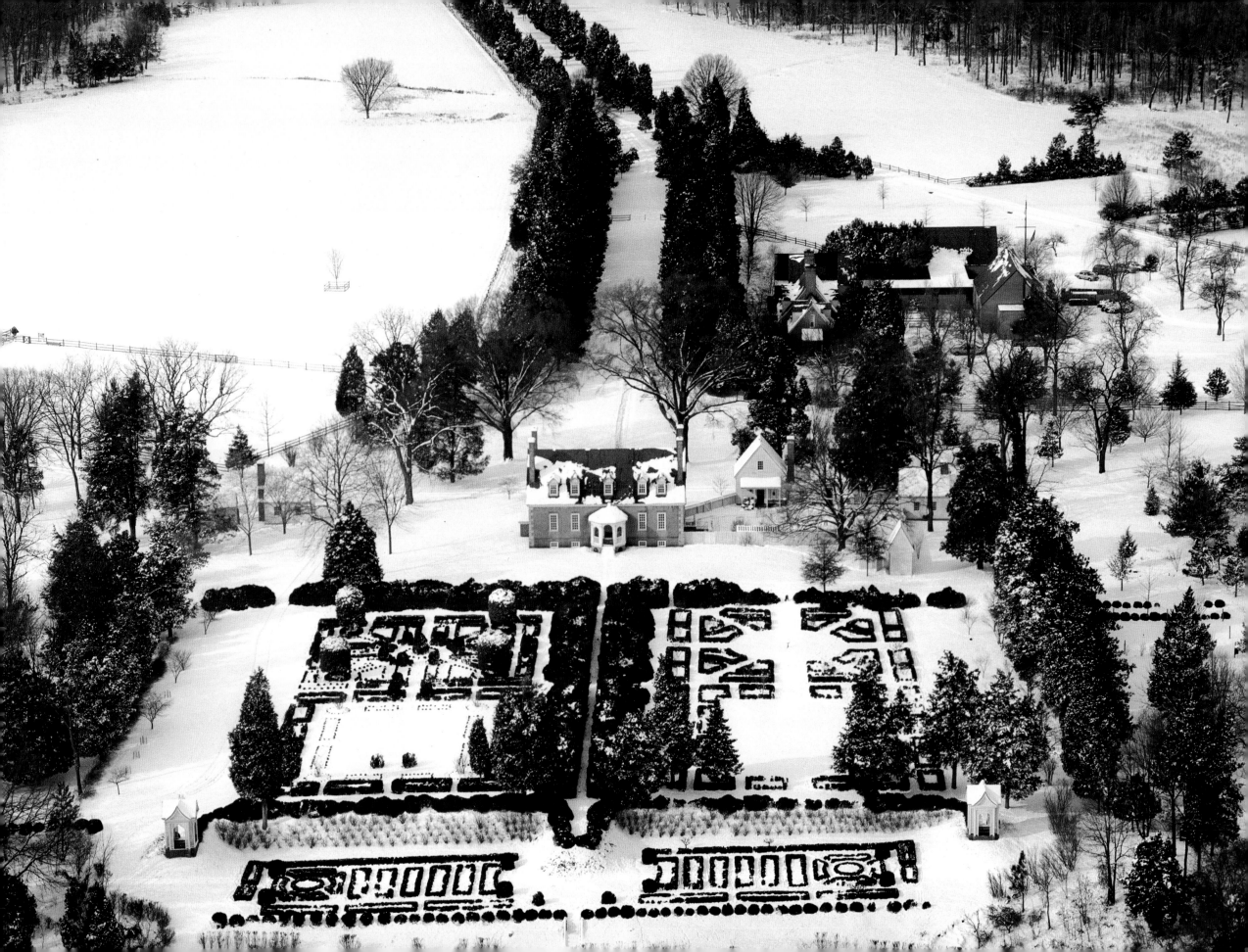

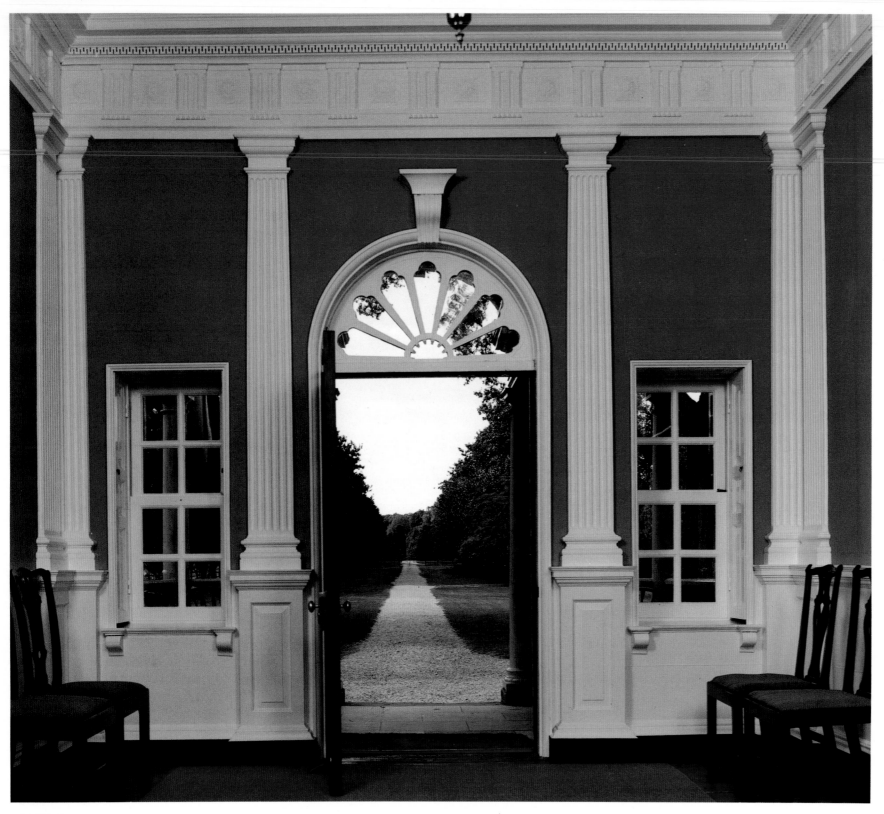

Two views of the newly restored entrance hallway at Gunston Hall. At left is the carriage entrance toward the west, and at right are the stairway and door to the formal gardens on the east (river) side.

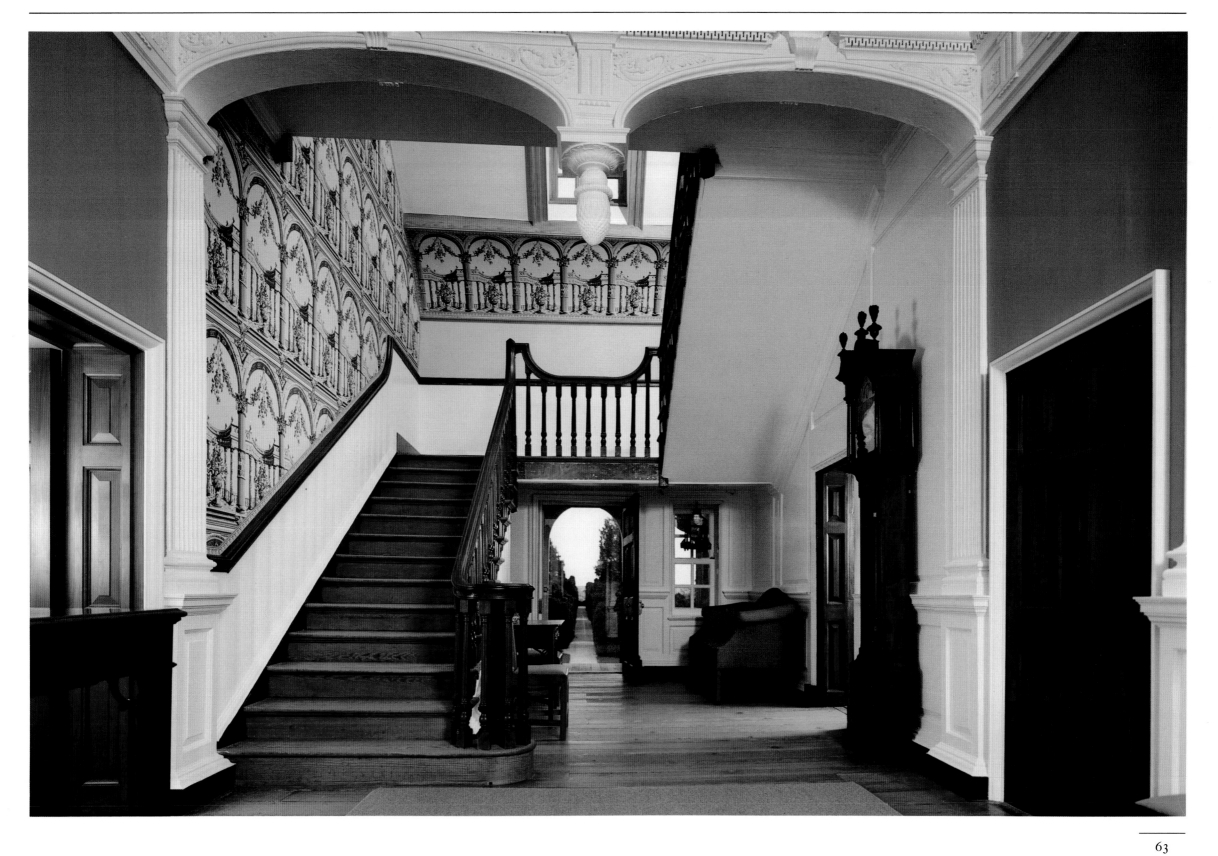

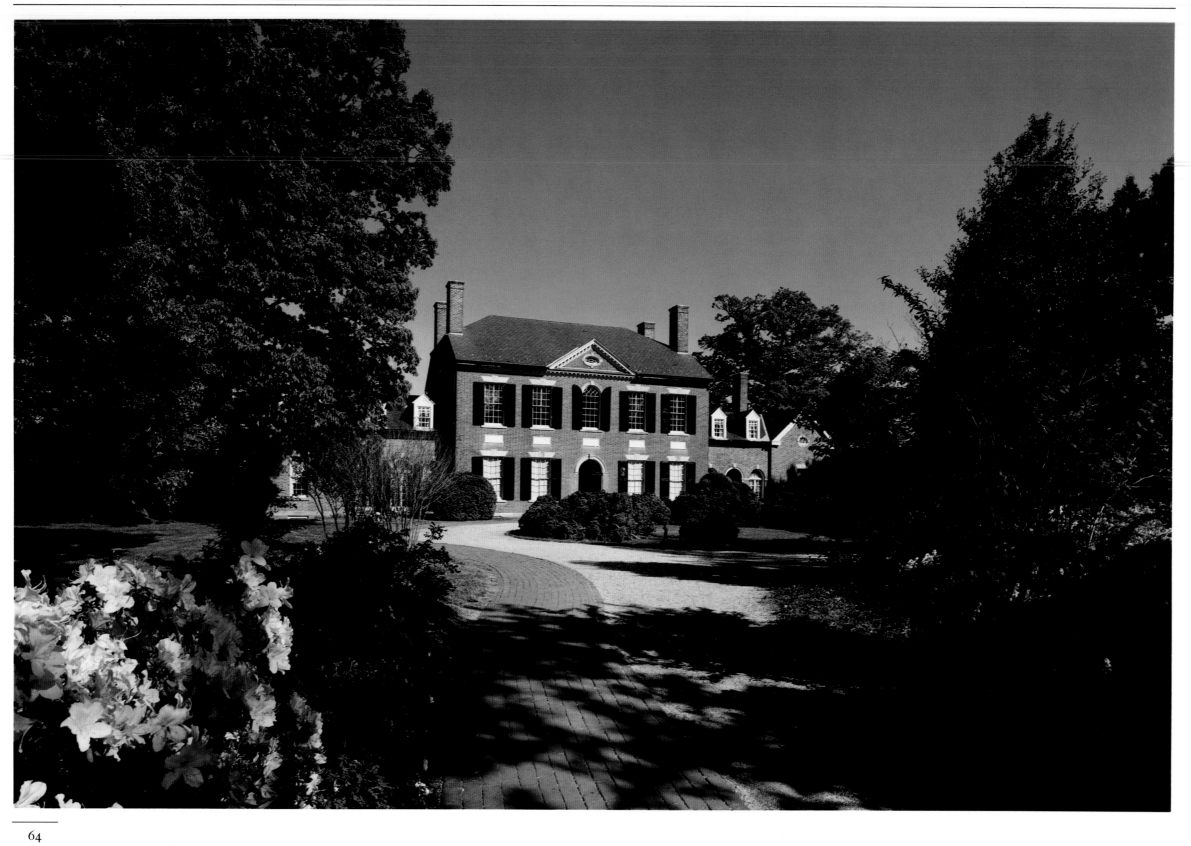

Woodlawn, 1800–1806

Fairfax County

When his ward, Eleanor Parke Custis, and his nephew, Lawrence Lewis, married at Mount Vernon in 1799, retired president George Washington gave the young couple 2,000 acres of his Fairfax County holdings. Dr. William Thornton, the first architect of the United States Capitol and a friend of Washington, designed the mansion, and construction began in 1800. The Lewises moved from Mount Vernon to Woodlawn when the wings were completed in 1803, and furnished the center block with Mount Vernon pieces following its completion in 1806.

Woodlawn stood vacant for seven years after Lawrence Lewis' death in 1839. At a public sale, four Quakers acquired the house and 2,030 acres. They subdivided the land into small farms to create a Quaker community that opposed slavery and Virginia's secession ordinance.

Later owners included the New York playwright Paul Kester and Miss Elizabeth Sharpe, who bought the property in 1905 and, over a 20-year period, spent $100,000 restoring Woodlawn. Two years after her death in 1925, Senate majority leader Oscar Underwood of Alabama bought the estate and made it his home.

In 1948 the Woodlawn Public Foundation bought the estate, and two years later it turned management over to the National Trust for Historic Preservation, which acquired title to Woodlawn in 1957. Woodlawn was the trust's first house museum to be opened to the public.

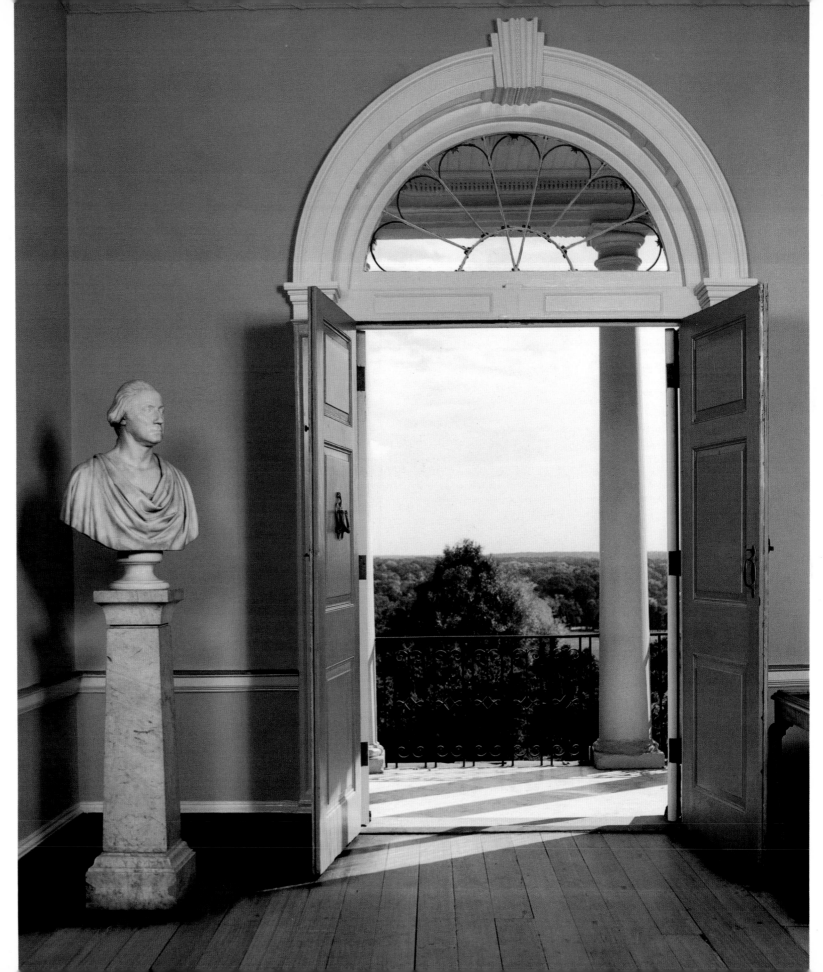

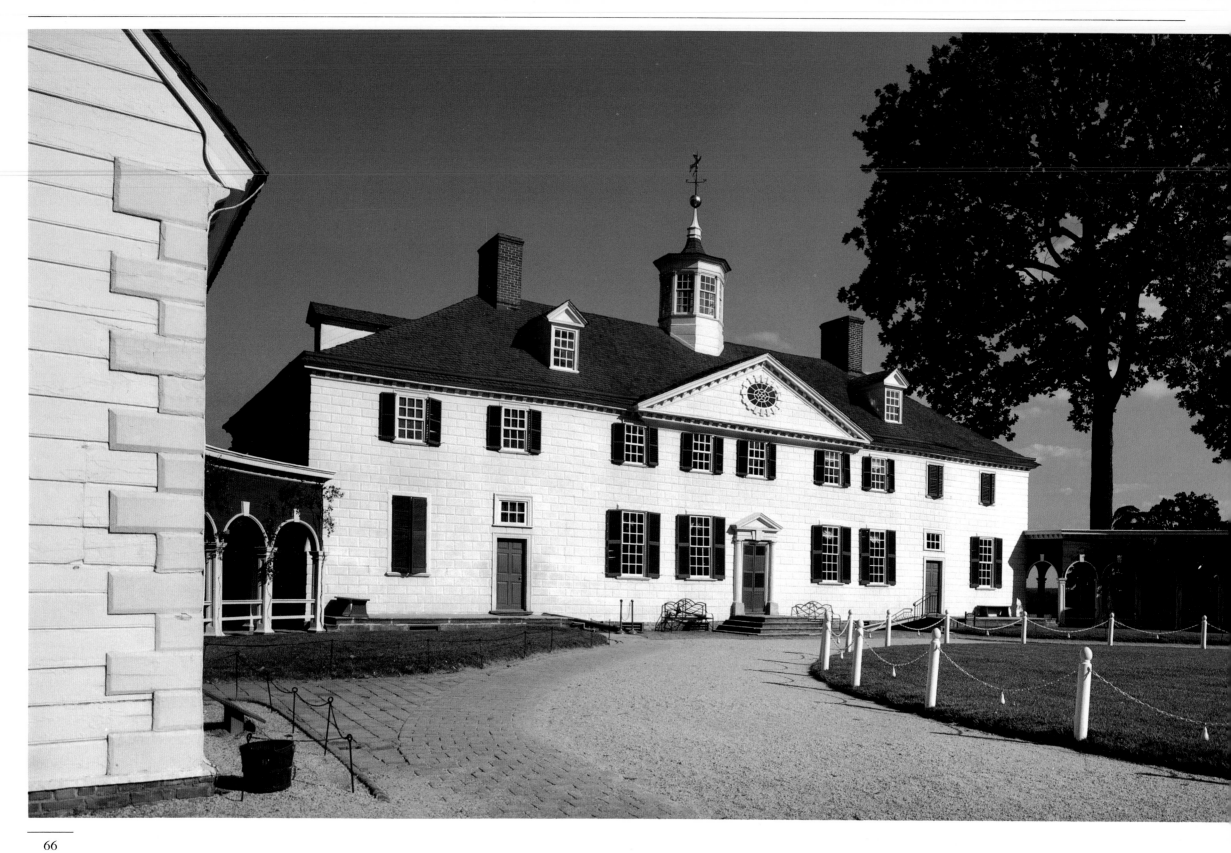

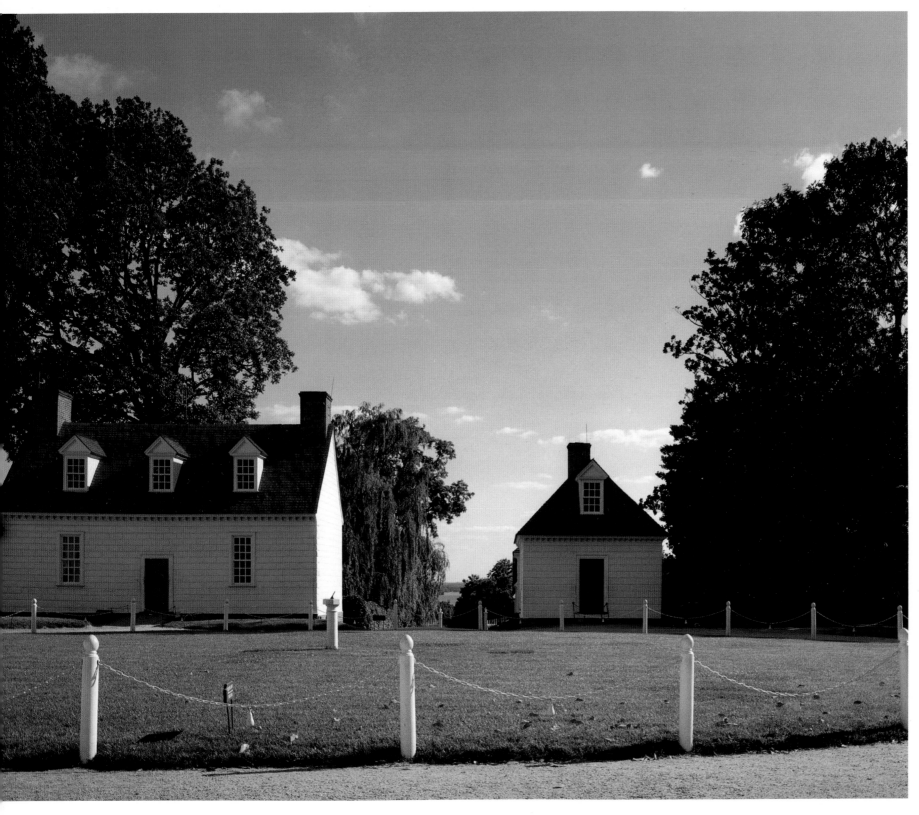

Mount Vernon, 1735–1787

Fairfax County

George Washington's father, Augustine, completed the nucleus of America's most famous house by about 1735. It stands on land granted in 1674 to John Washington, George's great-grandfather. In 1754, George Washington, then twenty-two, leased Mount Vernon from the widow of his half-brother Lawrence, and inherited the estate upon her death seven years later.

Over the next thirty years, Washington expanded the plantation holdings to 8,000 acres and enlarged and embellished the simple farmhouse, changing it into a country gentleman's estate with extensive gardens and outbuildings. The distinctive portico and cupola are among Washington's most familiar additions to the house.

By 1853, the fortunes of the Washington heirs had sagged. After both the federal government and the state of Virginia had turned down an offer for the property, Miss Ann Pamela Cunningham of South Carolina founded the Mount Vernon Ladies Association, which bought the house and 200 acres in 1858. The association restored and continues to operate the nation's most visited historic home without federal or state funding.

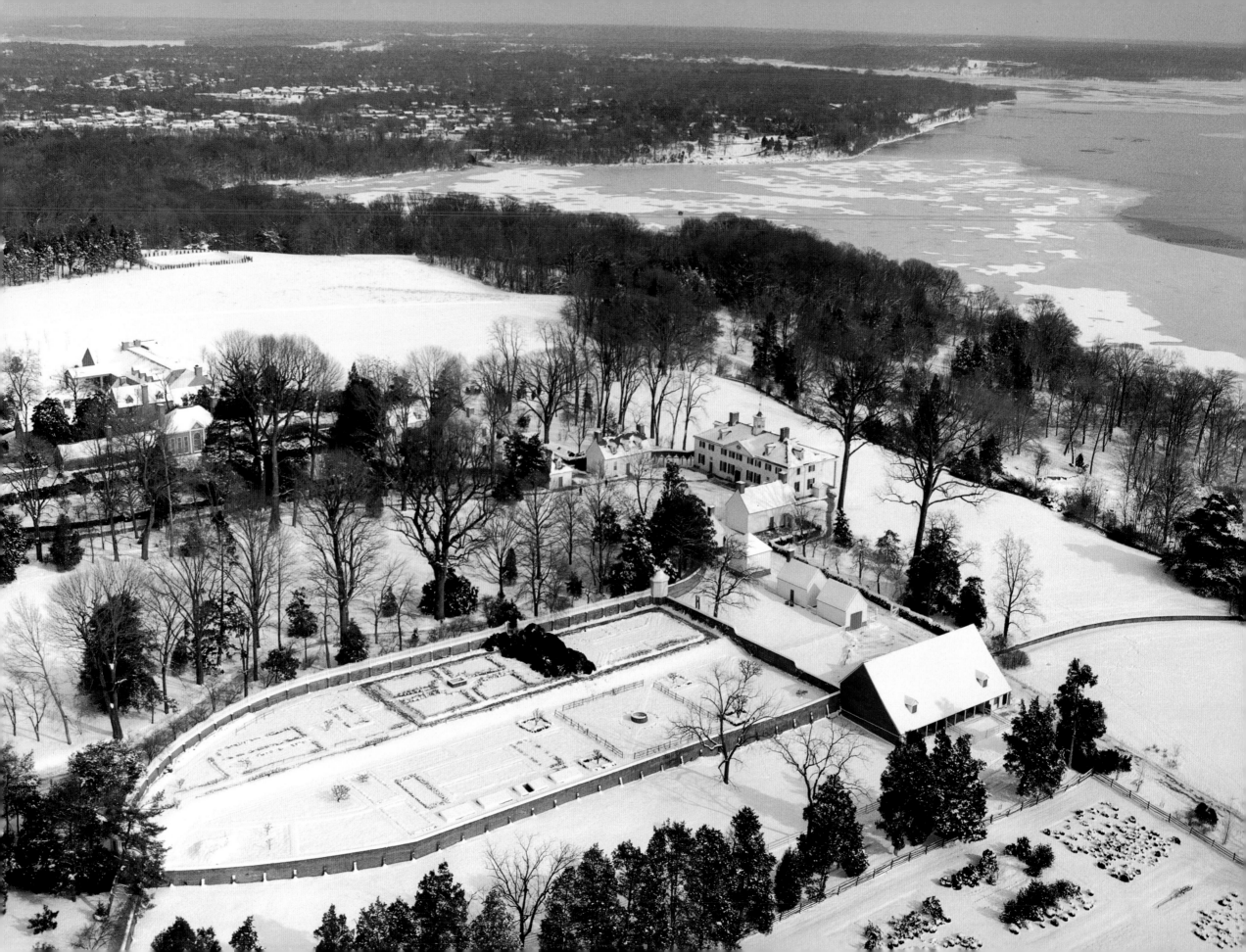

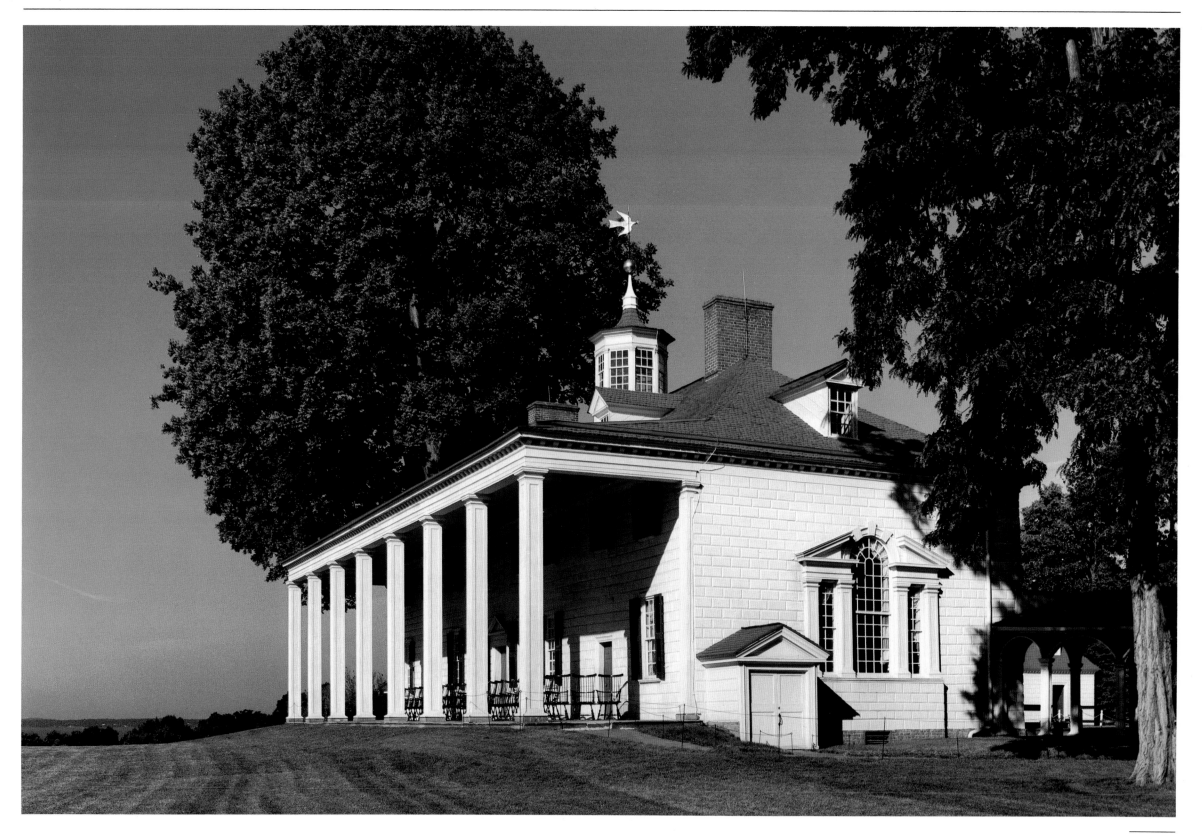

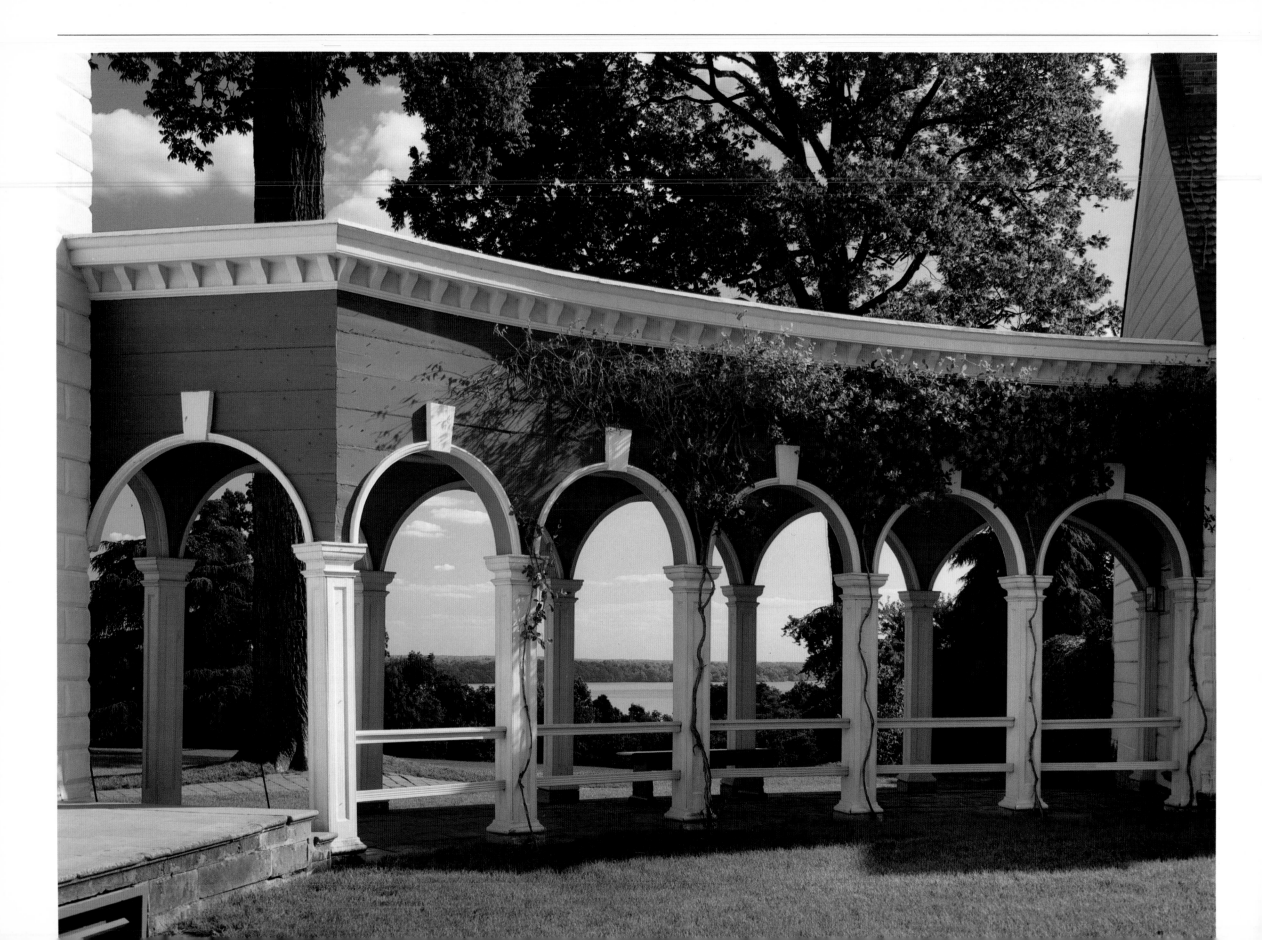

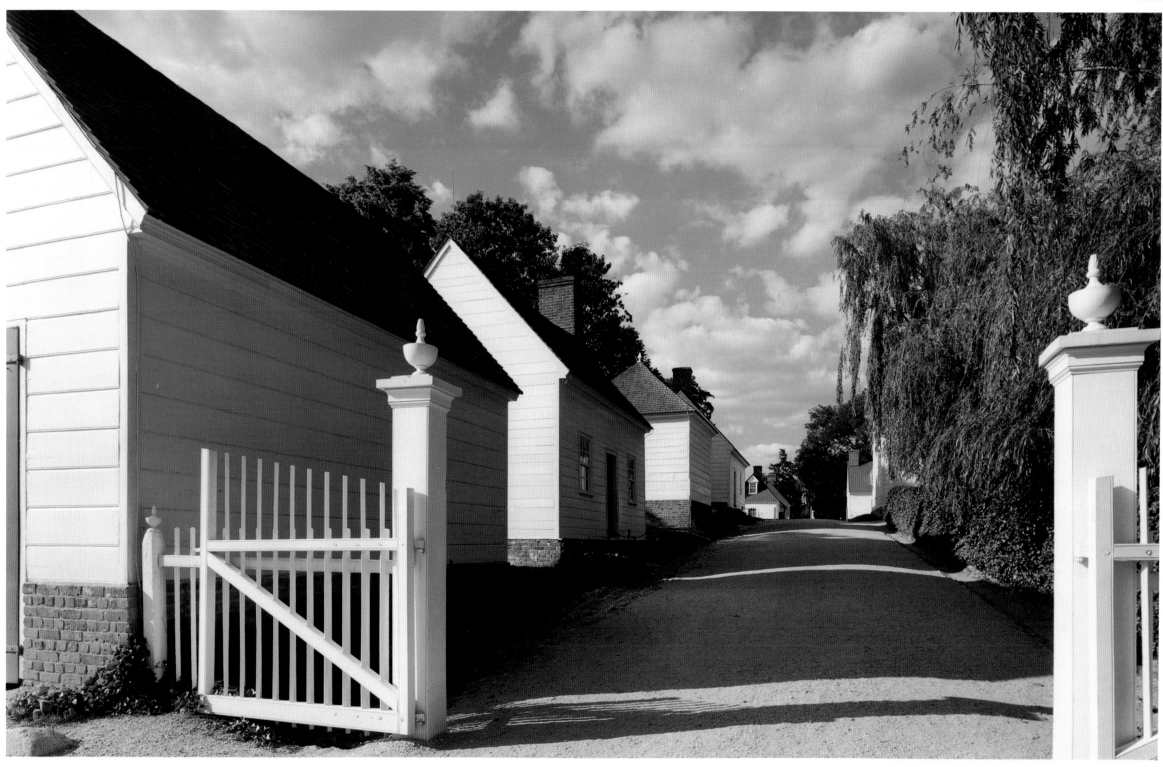

(left) *One of Mount Vernon's hyphens and* (above)
its plantation street

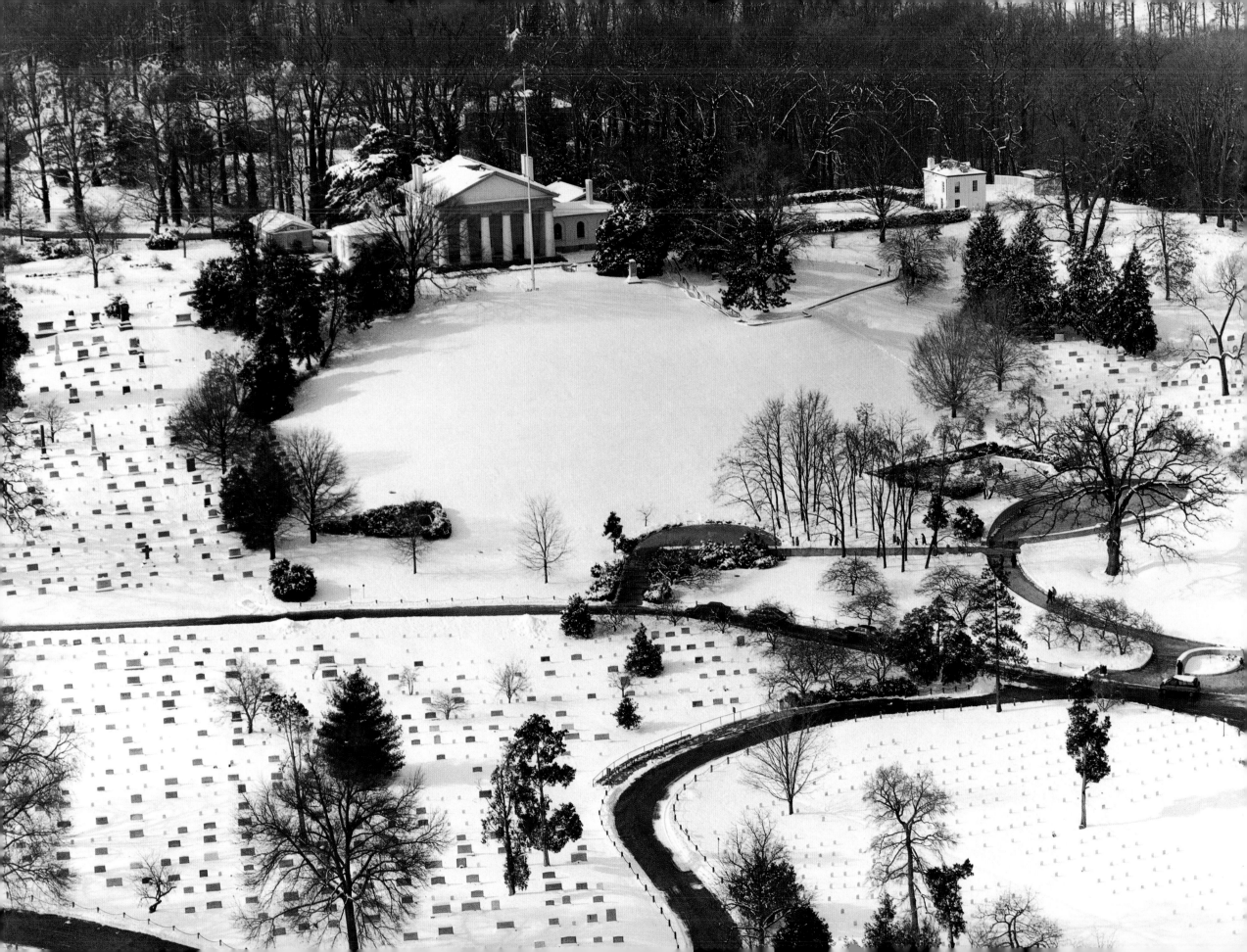

Arlington House, 1802–1817

Arlington County

Begun in 1802 and completed in 1817, Arlington House was built by the grandson of Martha Washington, George Washington Parke Custis, who, after the death of his father, was raised by his grandmother and her second husband, George Washington.

Designed by George Hadfield, an English architect who had supervised part of the construction of the United States Capitol across the Potomac River, the house dominated an 1,100-acre plantation. Its 5-foot-thick columns and east exterior walls were covered with a "hydraulic cement" of fossil shells that were streaked and scored to resemble blocks of stone.

In 1804, while his house was under construction, Custis married Mary Lee Fitzhugh. Their daughter Mary wed Robert E. Lee at Arlington in 1831. For the next thirty years, Arlington was home to the Robert E. Lee family, shared with Mary's parents.

During the Civil War, Federal troops occupied Arlington. The plantation was confiscated in 1864, with a 200-acre plot set aside as the beginning of Arlington National Cemetery.

Arlington House is now a property of the National Park Service, restored to its pre–Civil War state and preserved as a memorial to Robert E. Lee and George Washington Parke Custis.

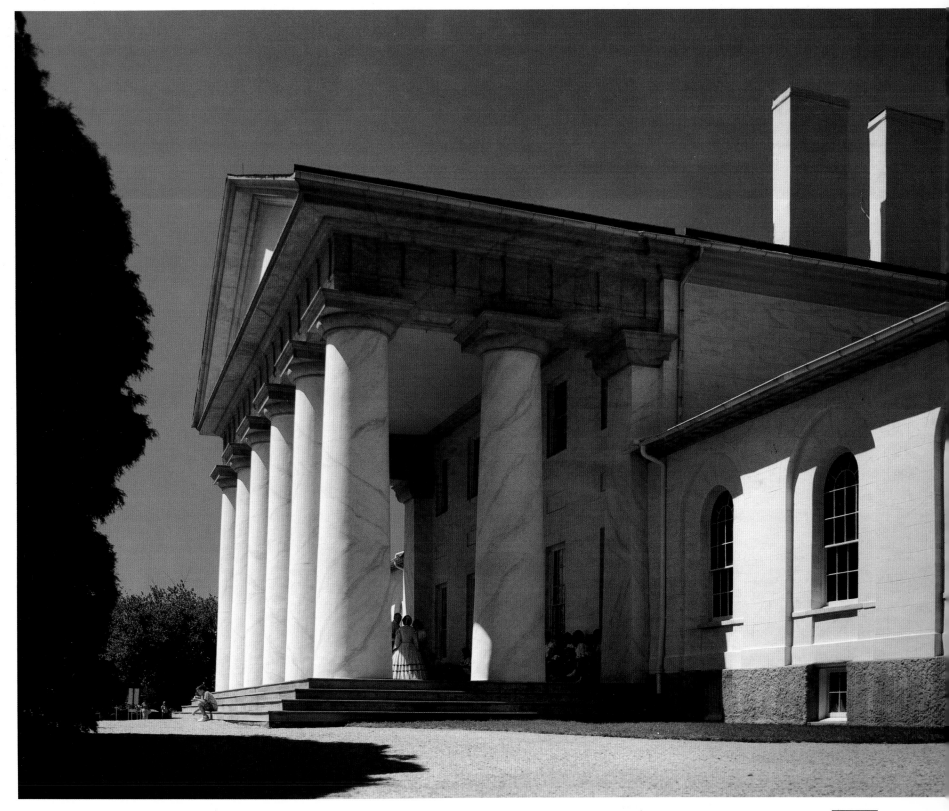

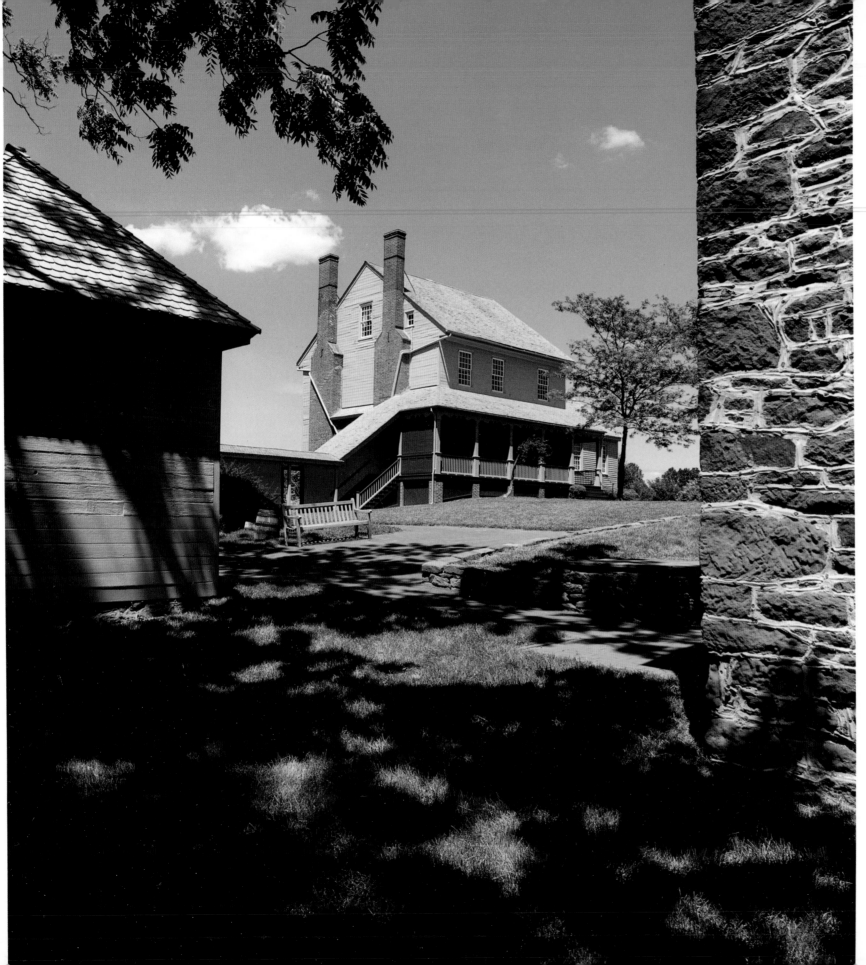

Sully, 1794
Fairfax County

Henry Lee bought over 3,000 acres of land about twenty miles northwest of Alexandria in 1725, but the first Lee to live on the property was his grandson, Richard Bland Lee, who inherited his share in 1787. Richard Lee was the brother of Light-Horse Harry Lee and the uncle of Robert E. Lee.

Richard Lee, a founder of Phi Beta Kappa, represented northern Virginia in Congress in 1789 in Philadelphia, where he met and wed Elizabeth Collins, daughter of a Quaker merchant.

Lee and his bride planned Sully to resemble Philadelphia's town houses more than the manorial homes of Virginia's planters. Sully's furnishings were elegant, brought from Philadelphia, and included "every article of silver plate, mahogany, Wilton carpeting, and glassware that can be conceived," according to kinsman Thomas Shippen in 1794.

Later owners included Jacob and May Haight, Quaker farmers from New York State who bought Sully in 1842. Their children, Alexander and Maria, owned the property during the Civil War, with Maria and her sister-in-law remaining on the farm while their husbands, northern sympathizers, were behind Union lines.

In 1958 Sully was threatened by the construction of Dulles International Airport. Putting a bill through Congress saved the house. Now restored by the Fairfax County Park Authority, the complex of Sully's manor house and outbuildings recalls its earlier days of 1794 to 1842.

Melrose, ca. 1856–1860 (right)
Fauquier County

Completed just before the Civil War, this castellated manor house was inspired by the romantic literature of Sir Walter Scott, author of *The Lay of the Last Minstrel, Kenilworth, Waverley, Rokeby,* and *Ivanhoe,* among many other works written between 1805 and 1831.

Two brothers from Scotland, Edward and Dr. James H. Murray, retained the Baltimore architect Edmund George Lind, born and educated in

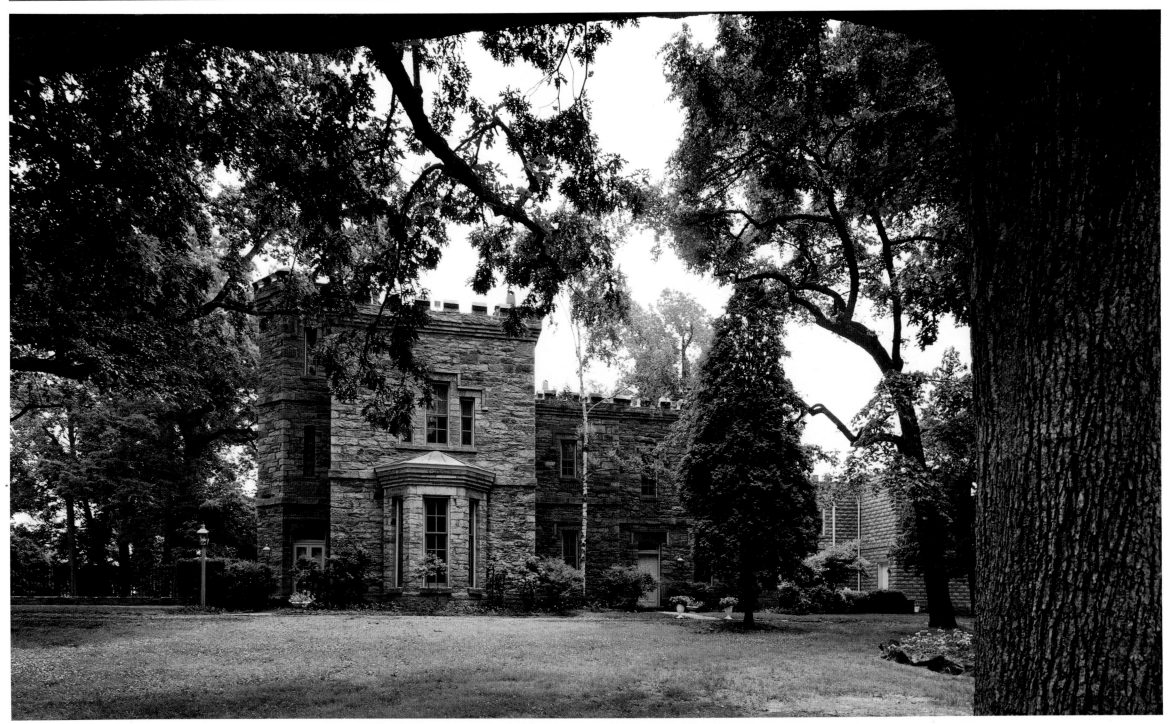

England, to design this romantic castle in the wooded countryside of Fauquier County. The local builder was George Washington Holtzclaw.

Both brothers joined the Confederate army during the Civil War, and Melrose was occupied by Union troops, who pitched their tents about the house.

Melrose was also known as Murray's Castle, and features walls of stone quarried on the property, topped by battlements, with a winding stair in a tower that was an inspiration for *The Circular Staircase,* by Mary Roberts Rinehart.

Mr. and Mrs. James and Louise Wemyss bought the property as a summer home in August, 1987, and have since restored the house and grounds.

Oakley, 1857

Fauquier County

Built in the style of an Italian villa, Oakley was originally the home of one of the foremost horsemen of Virginia's Hunt Country, Richard Henry Dulany, founder of the Upperville Colt and Horse Show, the country's oldest.

During the Civil War, Oakley saw a number of cavalry engagements and bore the marks of both northern and southern troops who made the house their temporary headquarters.

Oakley, shaded on the south and west sides with dramatic Italianate galleries, continues to preside over a great Virginia horse farm, owned by Mrs. Archibald Cary Randolph.

Oak Hill, early 1820s, 1920s

Loudoun County

Two miles south of Oatlands on the old Carolina Road (now Route 15) is Oak Hill, the summer home where President James Monroe drafted his famous Monroe Doctrine and entertained the Marquis de Lafayette on his triumphal tour. Monroe had begun construction about 1820.

Both Thomas Jefferson and James Hoban were involved in the design of the house, distinguished by its unusual five-columned portico that surveys the formal garden.

Oak Hill left the Monroe family in the years following the president's death in 1831. Colonel John W. Fairfax bought the estate in 1854, and while he served on the staff of General Longstreet during the Civil War, his wife remained at Oak Hill to manage the plantation. During the Battle of Manassas, she was an unwilling hostess to Union general George G. Meade, who made the house his headquarters.

Like many southern plantations, Oak Hill entered a period of decline following the war. Frank C. Littletown added the east and west wings in the 1920s, and the present owners, Mr. and Mrs. Joseph Prendergast, maintain the house and gardens as the centerpiece of a working farm.

Oatlands, 1804–1830s

Loudoun County

In 1776, Robert Carter, one of "King" Carter's grandsons, bought a 63,093-acre tract in northern Virginia from Lord Fairfax. As a coming-of-age gift in 1798, he gave his youngest son, George, the 3,000-acre Oatlands estate taken from that tract.

George Carter designed his home himself, completing it in 1804, but making additions in the late 1820s and 1830s. The stately three-story mansion, with half-octagonal staircase wings on either end, was occupied by Confederate troops during the Civil War, but sustained little damage. The Carter family continued to own the estate until the house and 60 acres were sold in 1897 to Stilson Hutchins, founder of the Washington *Post*.

Six years later, Oatlands was purchased by Mr. and Mrs. William Corcoran Eustis, who restored the house and terraced gardens, making Oatlands once again a center of northern-Virginia hospitality.

In 1965, the Eustises' daughters, Mrs. David E. Finley and Mrs. Eustis Emmett, presented Oatlands and 265 acres to the National Trust for Historic Preservation. Oatlands was named a National Historic Landmark in 1972.

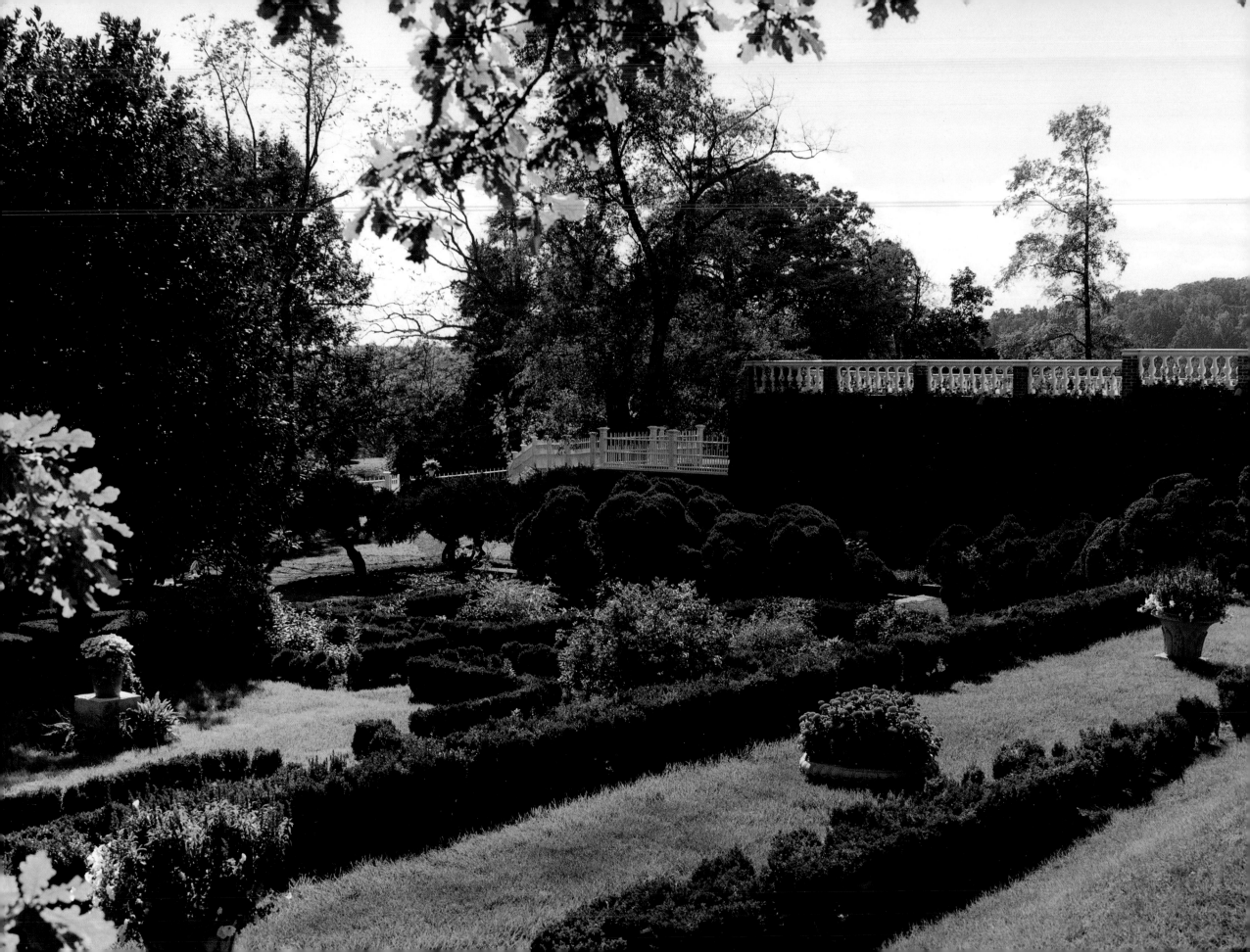

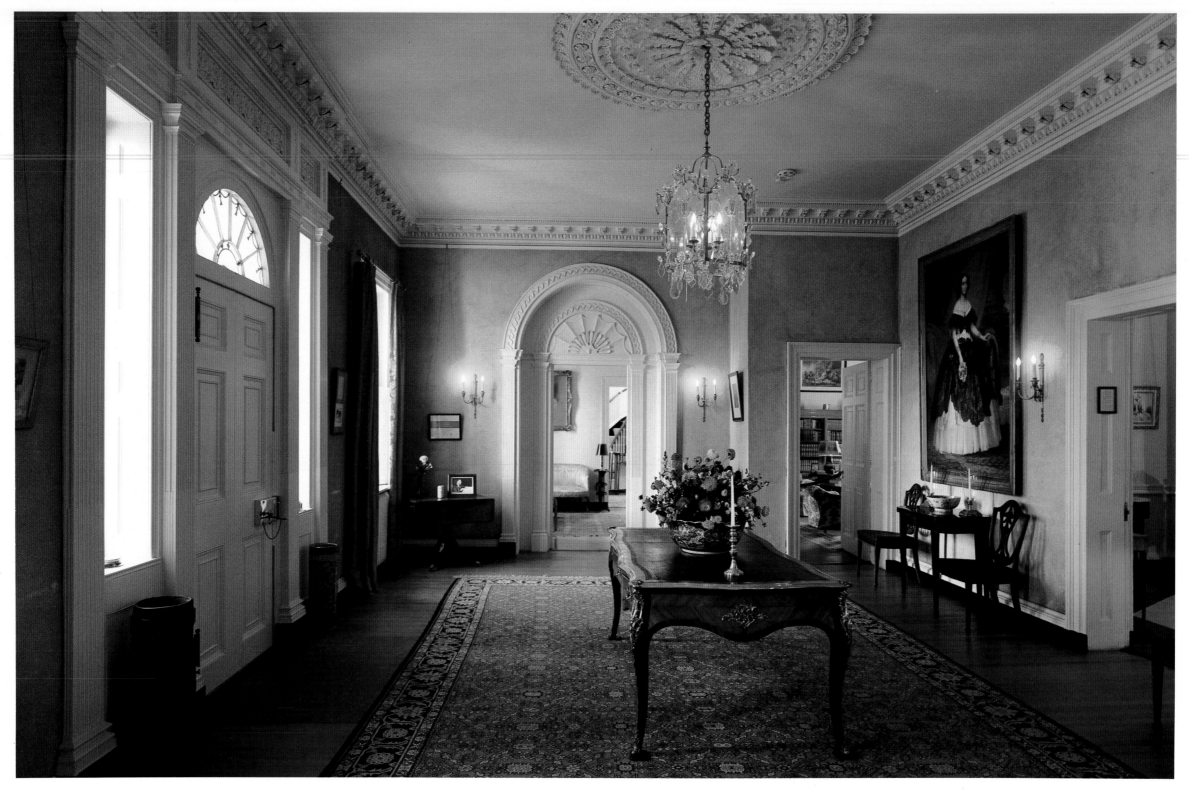

The entrance parlor at Oatlands

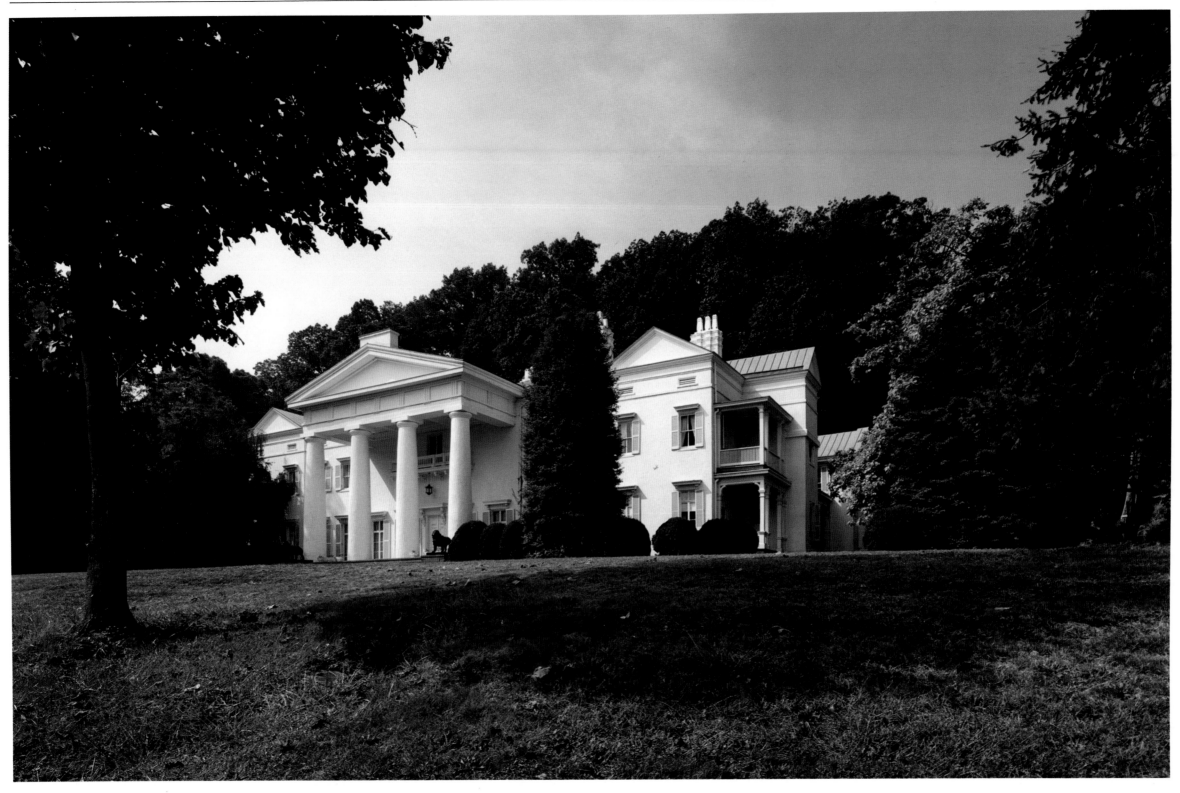

Morven Park

Morven Park, 1780s, 1808, 1840s
Loudoun County

Dominating a 1,200-acre estate near Leesburg, Morven Park was originally a much smaller fieldstone house owned by Wilson Cary Selden. Judge Thomas Swann bought the property in 1808 and enlarged the house soon thereafter. His son, Thomas Swann, Jr., became a Maryland banker and later was elected governor of that state, but continued to maintain Morven Park as a summer home.

In the 1840s the younger Swann retained the Baltimore architect Edmund George Lind, who had designed Melrose (Murray's Castle) in neighboring Fauquier County, to remodel Morven Park into an extravagant Italianate villa. Not all of Lind's suggestions were incorporated (four great towers, for example, were never built), but Lind presided over an extensive enlargement of the house, including the addition of a bold Doric portico.

A later owner was Virginia governor Westmoreland Davis, whose wife, the former Marguerite Inman, created the extensive gardens. Following his death, she established the Westmoreland Davis Foundation, which operates Morven Park as a working farm, equestrian center, and museum.

Carter Hall, late 1790s, 1814, 1830s

Clarke County

Colonel Nathaniel Burwell, of Carter's Grove near Williamsburg, built his country mansion on 8,000 acres in the lower Shenandoah valley. The two dependencies, East House and West House, were built about the same time, the latter serving as a school for the colonel's sons and a few neighboring children, and the former as the kitchen. Colonel Burwell's son George Harrison Burwell later altered the limestone-walled house, adding the Ionic portico.

Both armies occupied Carter Hall at different times during the Civil War. Stonewall Jackson's troops camped in the surrounding park while the general made the house his headquarters in 1862.

In 1929, Gerald Lambert bought the mansion and grounds from J. Townsend Burwell and completely modernized Carter Hall, replacing the staircase and removing a cupola from the roof. The People-to-People Health Foundation, Inc., parent organization for Project Hope, acquired the property in 1977, adding new buildings and renovating older ones. Carter Hall is now the headquarters for Project Hope's worldwide health-sciences education and training programs.

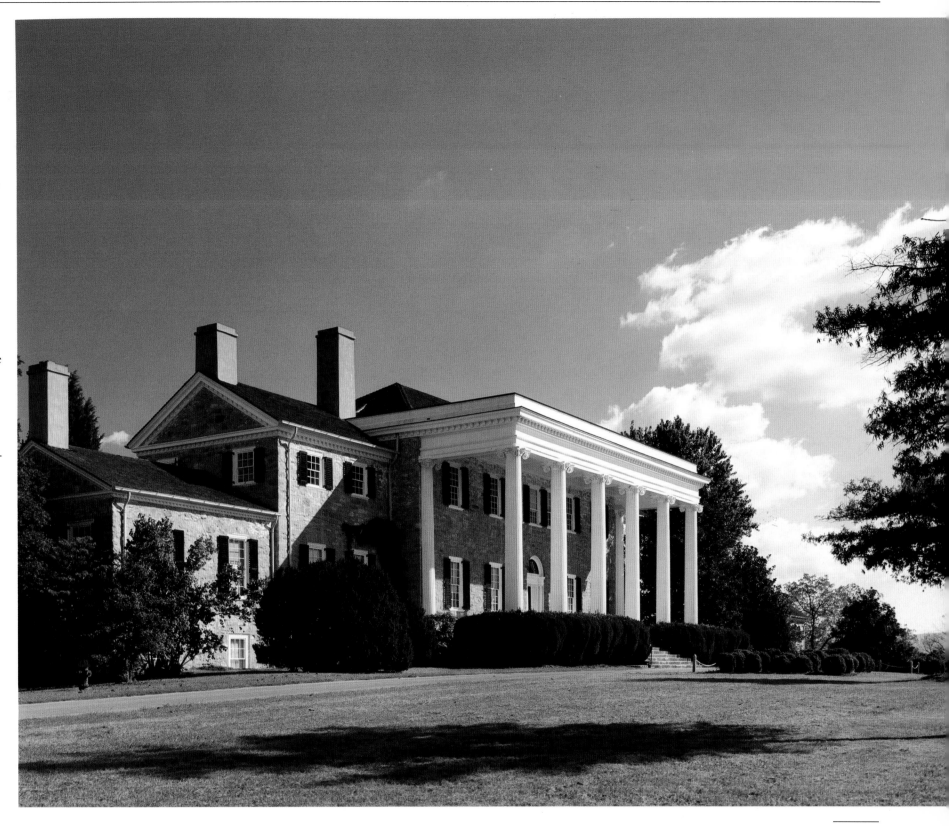

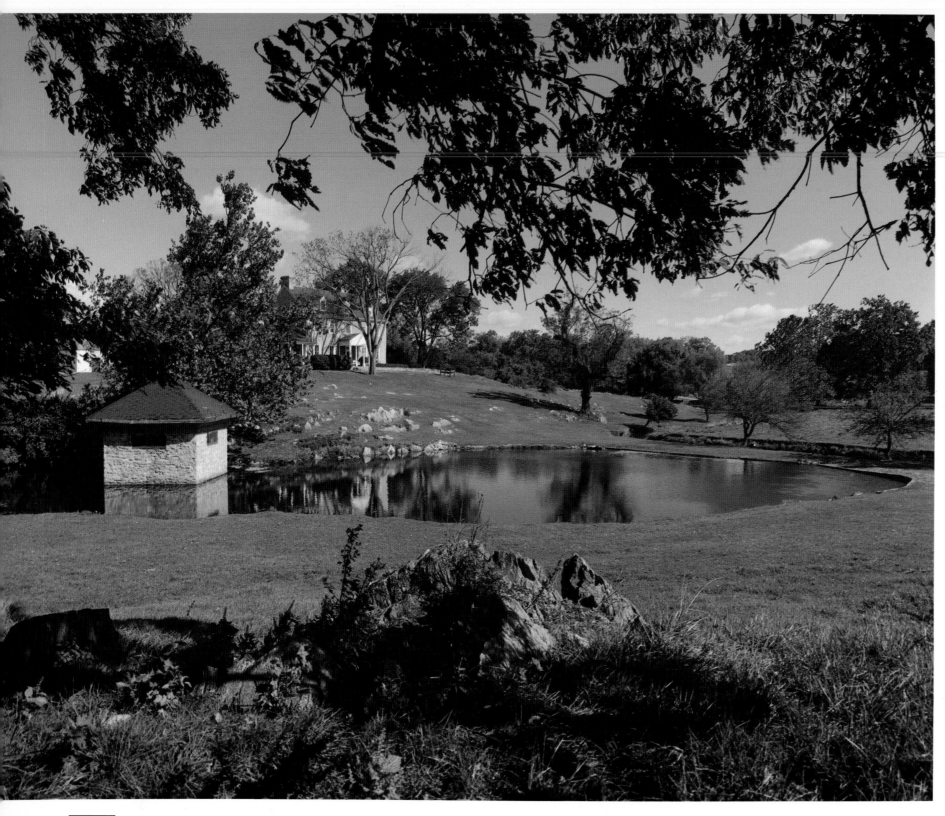

Saratoga, 1779
Clarke County

Big Daniel Morgan distinguished himself leading his riflemen at the Battle of Saratoga in New York State in the fall of 1777. That victory, which resulted in the capture of over 5,000 British troops, many of whom were Hessian mercenaries, was to encourage France to openly aid the fledgling United States.

A number of those Hessian prisoners were ultimately imprisoned near Morgan's property in the lower Shenandoah valley not far from Winchester. Tradition holds that the house with its finely carved woodwork was built by some of those prisoners, many of whom elected to stay in the United States.

Later named a brigadier general, Morgan claimed a signal victory over British general Banastre Tarleton in South Carolina at the Battle of Cowpens in January, 1781, and was awarded a gold medal by Congress.

Owned later by antebellum writers Philip Pendelton Cooke and his brother John Esten Cooke, Saratoga is still a working farm. The house overlooks a gemlike pond and its original stone springhouse.

Belle Grove, 1794

Frederick County

"Doubtless the most splendid building west of the Blue Ridge" according to a writer in the early 1800s, Belle Grove was built by Major Isaac Hite, Jr., grandson of one of the first settlers in the Shenandoah valley, Jost Hite.

Major Hite married James Madison's sister Nelly Conway Madison in 1783, and in 1794 Madison and his bride Dolley visited the Hites during their honeymoon. In October of that year, Madison wrote his friend Thomas Jefferson at Monticello, introducing the builder who was to construct the limestone-walled Belle Grove for Major Hite, and requested Jefferson's advice on plans for the house.

In the last year of the Civil War, Confederate general Jubal Early attacked the Union forces of General Philip Sheridan, who had established his headquarters at Belle Grove. The resulting battle of Cedar Creek, with much of the fighting taking place on Belle Grove property, established Union dominance of the Shenandoah valley for the balance of the war.

A hundred years later, through a bequest of Francis Welles Hunnewell, the National Trust for Historic Preservation became the owner of Belle Grove.

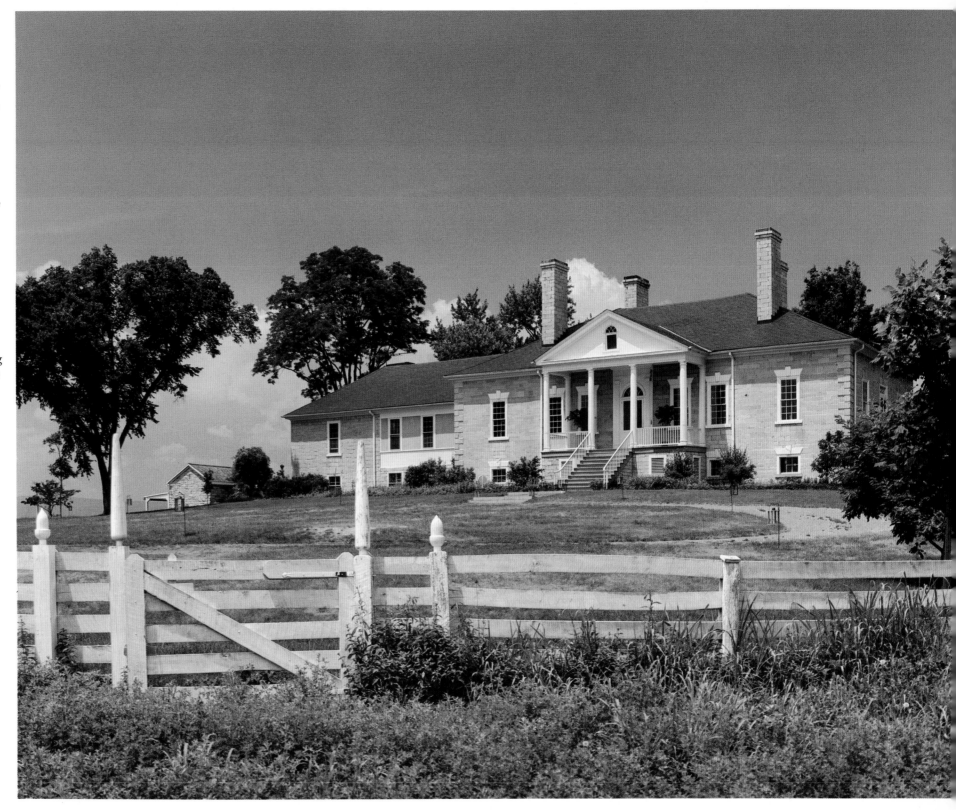

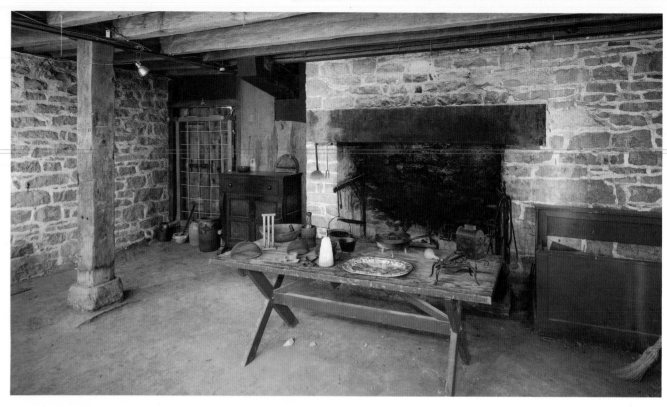

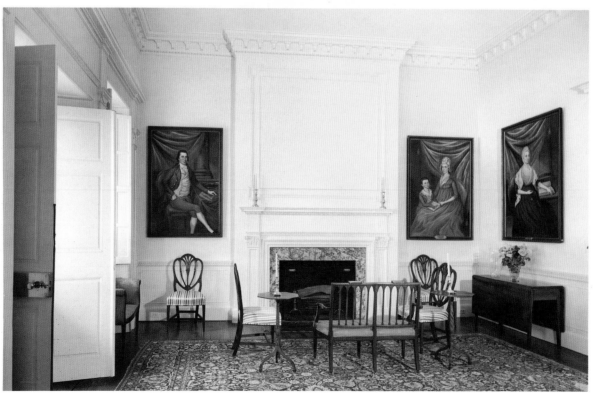

(above) *The winter kitchen in the basement of Belle Grove, and* (left) *the parlor overlooking the gardens to the rear of the house.*

Smithfield, 1774
Montgomery County

In the New River valley near present-day Blacksburg, William Preston completed his house in an area of southwest Virginia where only nineteen years earlier a Shawnee Indian massacre had wiped out most of the pioneer settlers. Preston, visiting in the valley at the time, had survived the attack to become a member of the House of Burgesses, and later served as a colonel in the Virginia militia in the Revolution. His son, James Patton Preston, and grandson, John Buchanan Floyd, were both born at Smithfield, and each became governor of the Old Dominion.

Smithfield is surprisingly sophisticated for its far-southwestern, frontier location, and would probably appear quite at home in colonial Williamsburg. Its outbuildings include a summer kitchen, smokehouse, and law office.

The Association for the Preservation of Virginia Antiquities acquired the house in the early 1960s, restored it, and continues to operate Smithfield as a house museum, depicting life on an early plantation in southwest Virginia.

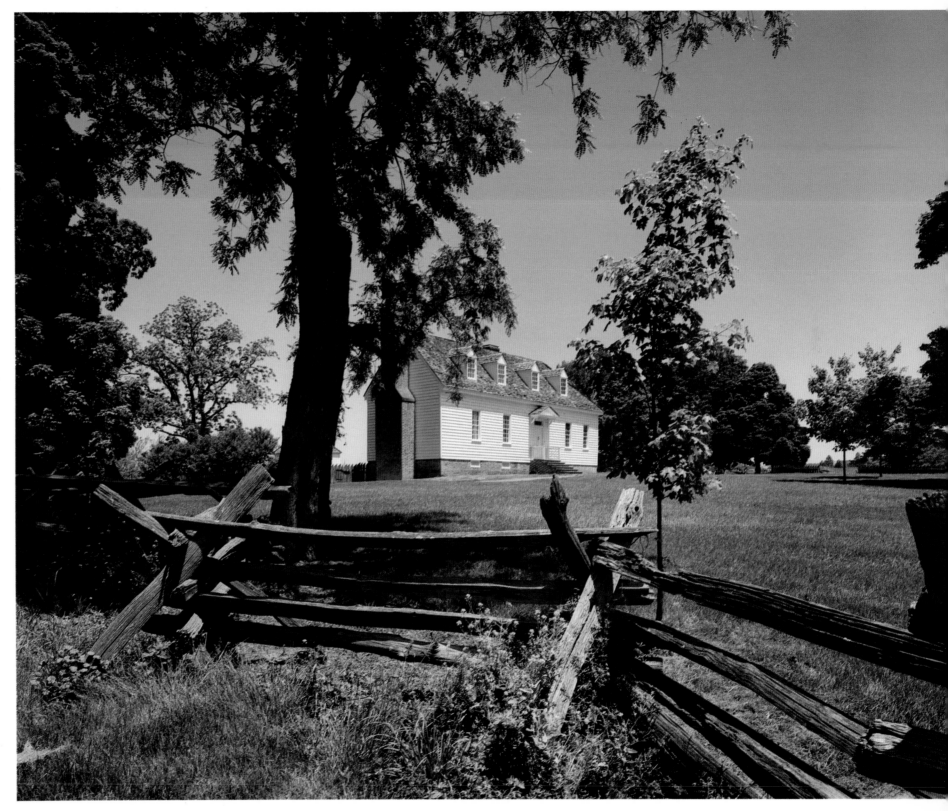

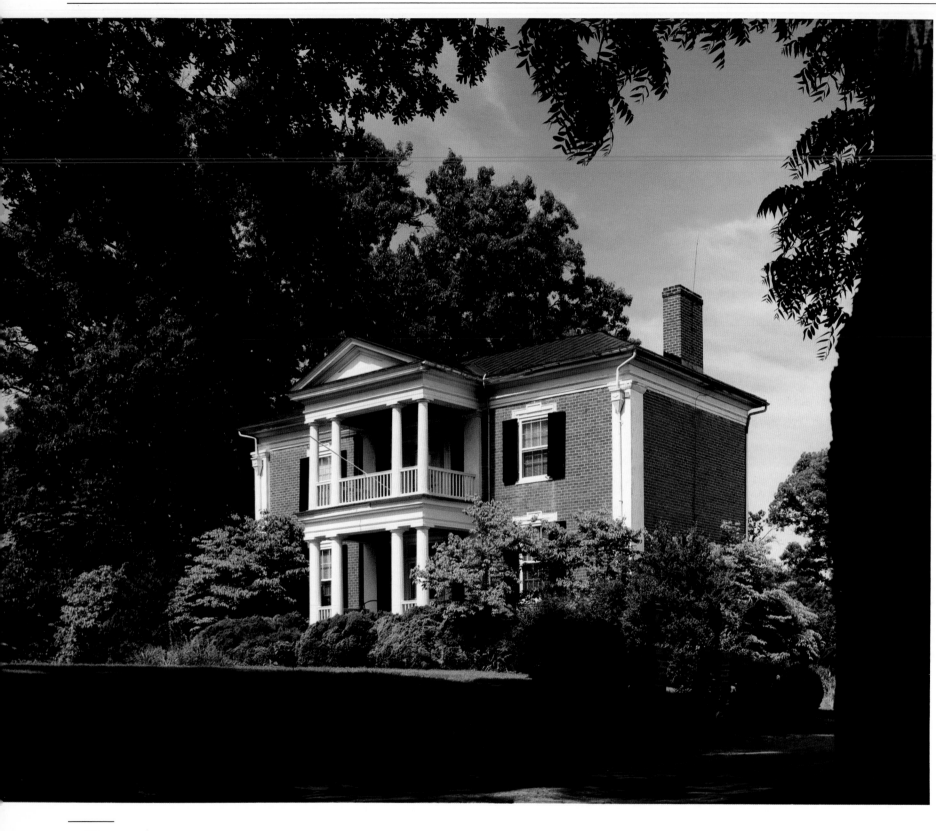

Belle Aire, 1849

Roanoke

Asher Benjamin, a Massachusetts housewright and architect, published *The American Builder's Companion* in 1806. Other books followed through 1833, and his designs were widely copied across the young country. A large part of the detailing on Belle Aire was adapted from Benjamin's books, on which the master builder, Gustavus Sedon, relied greatly. The mansion originally surveyed extensive lands owned by Madison Pitzer but now is the dominant house on Belle Aire Circle in Roanoke. It is presently owned by Mr. and Mrs. R. S. Whitney who have made Belle Aire their home.

Fotheringay, *ca.* 1796

Montgomery County

During the Revolutionary War, Colonel George Hancock was aide-de-camp for Count Casimir Pulaski and represented his region of the Roanoke valley in the Virginia House of Delegates and the United States Congress. Shortly after he acquired land overlooking the South Fork of the Roanoke River in 1796, Colonel Hancock began construction of one of the most elegant Federal houses in the valley, with carefully executed hand-carved doorways and chimneypieces.

The house was intended to be symmetrical with a central portico and two bays on either side. However, Colonel Hancock built only the center and north end. In the 1950s, Robert L. Nutt, Jr., a descendant of the Edmundson family, which has owned Fotheringay since about 1810, added two matching bays on the south end, creating a symmetrical façade.

Edmundson heirs, Dr. Robert L. Nutt III and his sister Mrs. Robert Dalton, Jr., continue to own and care for Fotheringay.

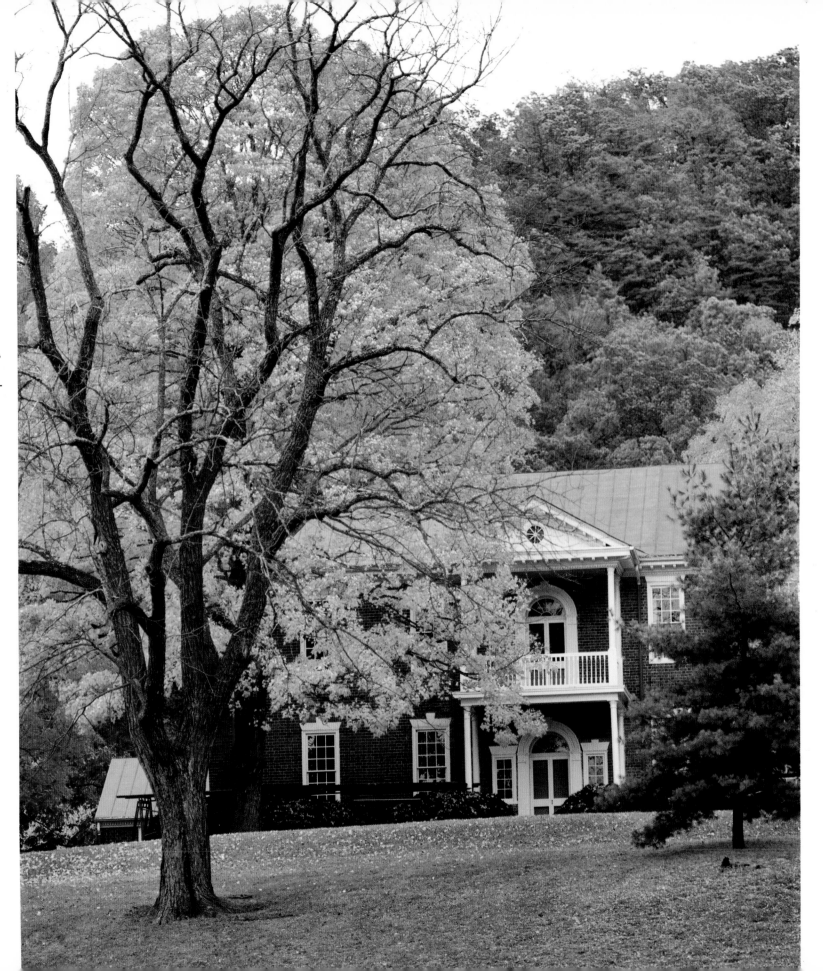

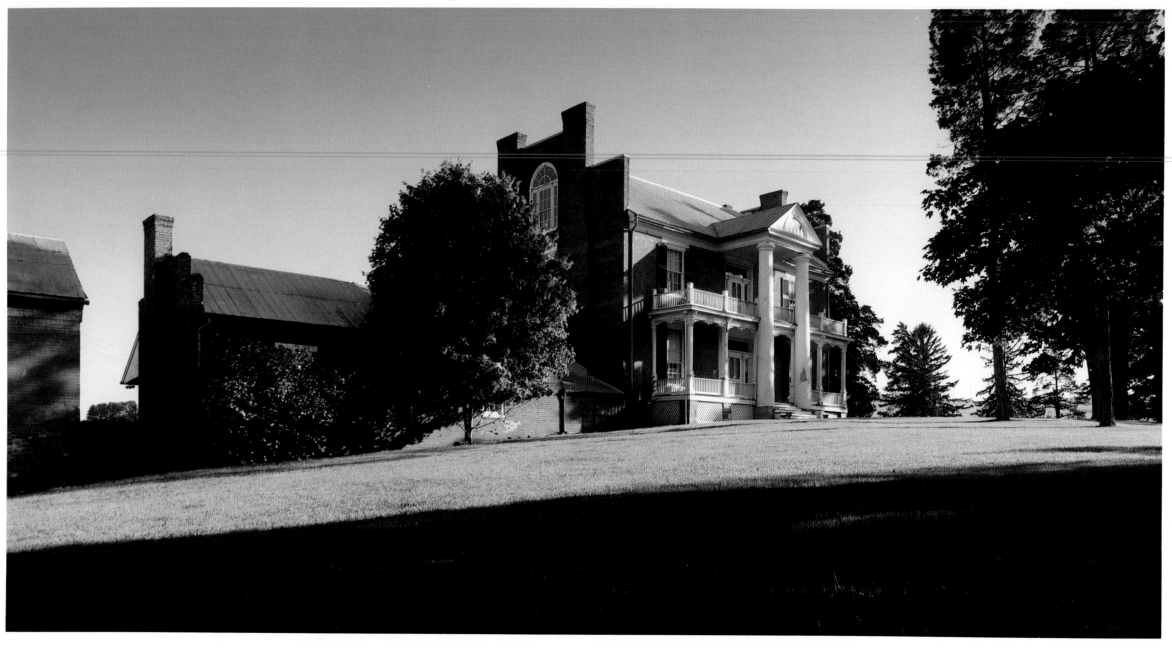

Fort Chiswell Mansion, 1839

Wythe County

Stephen and Joseph McGavock, brothers, were among the first settlers in the Wythe County area of southwest Virginia. They built their home at Fort Chiswell, on the Great Wilderness Road, and became quite prosperous landowners and merchants. In 1839 the brothers contracted with

Lorain Thorn and James Johnson to build an imposing Greek Revival mansion on a ridge overlooking their older house, which has long since vanished.

In a line on the eastern end of the house are the original brick service buildings, including the kitchen and a smokehouse still containing the

huge, squared-off, dug-out tree trunks that formed nailless vats for salting meat.

Little has changed at Fort Chiswell Mansion, except for the addition of one-story Victorian front and west side porches. Interstate Highway 81, which the house now overlooks, follows the approximate trace of the Great Wilderness Road.

Southside and the Piedmont

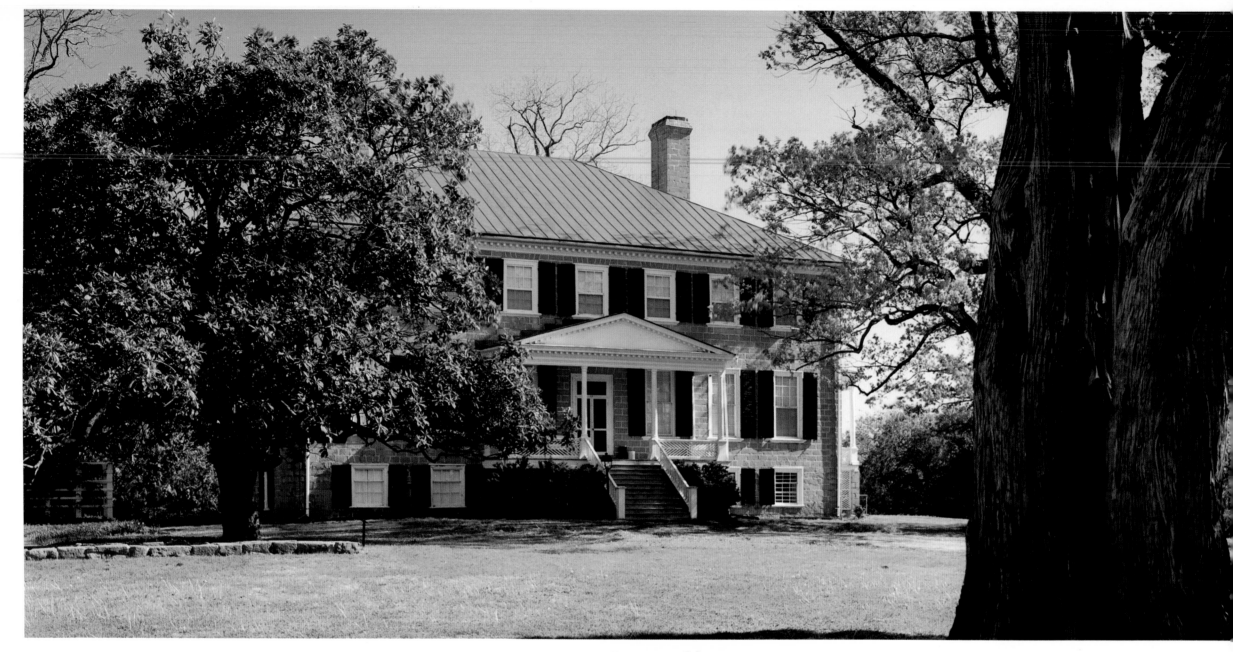

Prestwould, 1790–1795

Mecklenburg County

The only American-born baronet, Sir Peyton Skipwith, placed his Georgian mansion on a bluff overlooking the Roanoke River not far from the North Carolina border.

Begun in 1790, two years after Sir Peyton's marriage to his second wife, Jean Miller, the house, built of stone quarried on the plantation, still retains its original woodwork and numerous panels of Zuber scenic wallpaper. Original out-buildings include the plantation office, smoke-house, and two-family slave house. Between the house and the river are gardens that were super-vised by Lady Skipwith herself and an octagonal summer house.

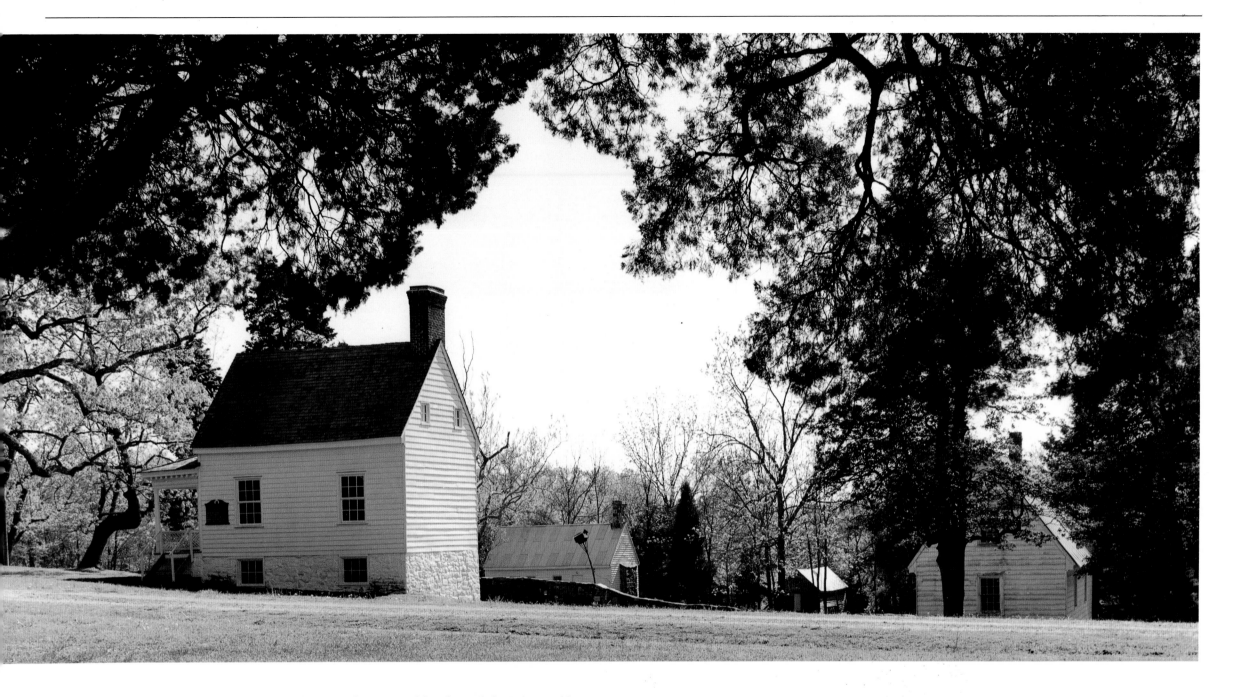

Following Sir Peyton's death, Lady Skipwith managed the 10,000-acre plantation, kept a garden journal (which the Colonial Williamsburg Foundation used in planning their restorations), and assembled one of the largest libraries in Virginia.

The Skipwith family continued to own the plantation until 1914, when it passed through other owners' hands until the Prestwould Foundation acquired the majestic house in 1963. The foundation continues a careful program of preservation and restoration.

Berry Hill, 1844

Halifax County

Considered "the noblest model of its kind," Berry Hill is the preeminent example of a Greek Revival plantation home in Virginia. Its architect was a West Point graduate and Halifax County planter, John Evans Johnson. Berry Hill's owner, James Coles Bruce, asked him to create a columned mansion similar to Philadelphia banker Nicholas Biddle's home on the Delaware River, Andalusia.

Befitting Bruce's considerable wealth, Berry Hill was richly appointed, with silver doorknobs and plate-glass windowpanes. Bruce's fortune at the start of the Civil War was estimated at six million dollars, not only in slaves and tobacco land in the South, but in thousands of acres of frontier land in Wisconsin, Iowa, and Nebraska.

Although Bruce opposed Virginia's secession, he equipped two Confederate companies after the onset of hostilities, and he lost his son Charles at the Battle of Malvern Hill. Bruce himself died just a fortnight before General Lee's surrender at Appomattox in 1865.

Berry Hill, a National Historic Landmark, remained in the Bruce family until 1950, and continues to be privately owned.

(right) *Staunton Hill*

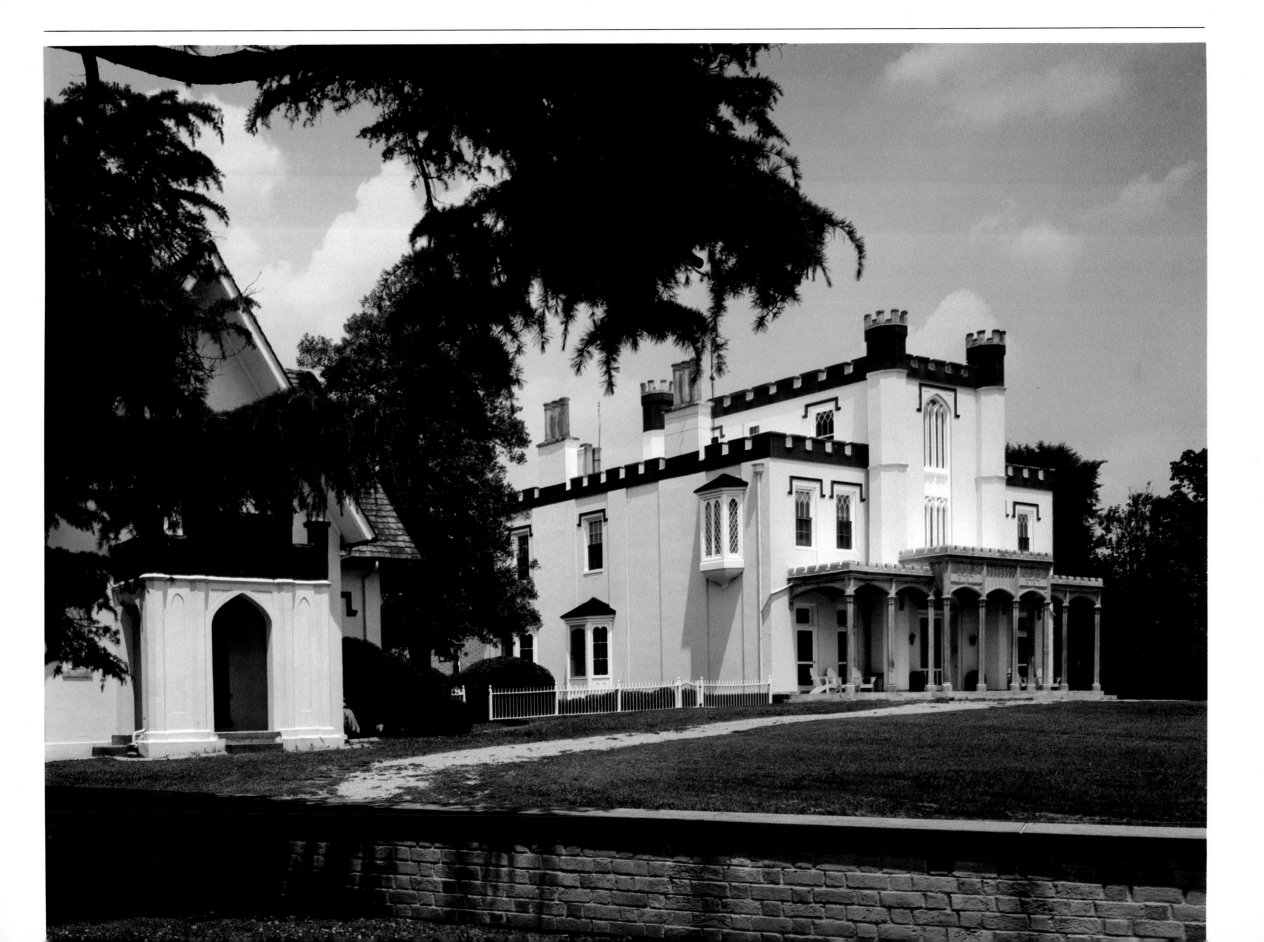

Staunton Hill, 1847

Charlotte County

Said to be the third-richest man in America in the early 1800s, James Bruce made much of his fortune in tobacco grown on the 5,000 acres of Staunton Hill plantation. His son Charles, half-brother to James Coles Bruce, owner of Berry Hill, commissioned John Evans Johnson to build the Gothic Revival mansion in 1847. Italian marble was barged up the Roanoke and Staunton rivers from North Carolina for the mantels and portico.

The plantation is said to have produced 5,000 barrels of corn annually, as well as a million "hills" of tobacco and substantial harvests of oats and hay.

In 1861, Charles Bruce organized and equipped a battery of Confederate artillery, and in the fading days of the war, Staunton Hill was the locale for one of the last meetings of the Confederate cabinet.

David K. E. Bruce restored Staunton Hill in 1933 and, ten years later in World War II, became the head of the Office of Strategic Services in Europe. After the war, he became a prominent diplomat, serving as United States ambassador in Paris, Bonn, London, and Beijing. His son, David S. Bruce, further restored the house and created a unique conference center at Staunton Hill plantation.

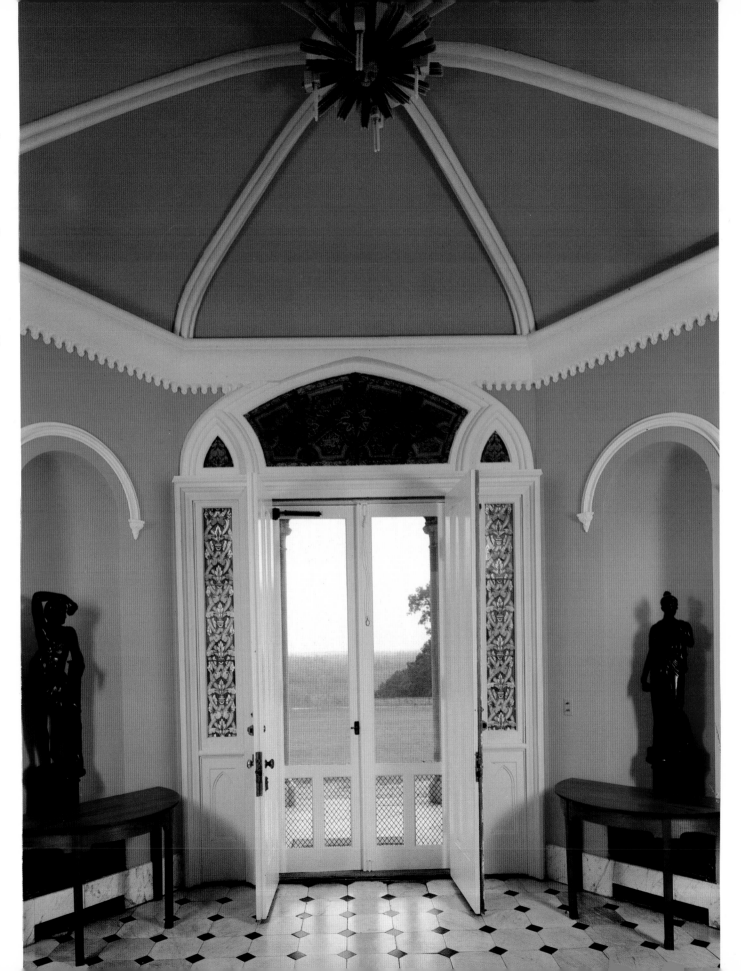

Red Hill, 1770s, 1795, 1957

Charlotte County

Patrick Henry's last home and final resting place was the focal point of a tobacco plantation of 2,920 acres, expanded from his first purchase of 700 acres. Henry moved to Red Hill in 1794 and retired from public service. He had been a member of the Virginia House of Burgesses, the Con-

tinental Congress, and the Virginia House of Delegates ("Give me liberty, or give me death"), and was the first nonroyal governor of Virginia.

The Red Hill complex includes a separate kitchen near the house, an ancient osage orange tree, 350 to 400 years old, and the law office that the "Voice of the Revolution" converted from an existing overseer's house.

Red Hill continued to be occupied by Henry's descendants following his death in 1799, and was expanded in the early 1900s to an 18-room mansion by two great-granddaughters. It burned in 1919.

When the Patrick Henry Memorial Foundation reconstructed the house on its original foundations in 1957, the organization was fortunate in secur-

ing the assistance of architect Stanhope Johnson, who had directed the last expansion of the house and still had his blueprints of the eighteenth-century structure.

Poplar Forest, 1809–1823 (left)

Bedford County

Monticello's continuous round of visitors, well-wishers, and guests placed a heavy demand on the time and attention of its owner, Thomas Jefferson. To meet his need for solitude, Jefferson began construction of a secluded retreat on property about ninety miles west of Monticello in 1809. He was occupying the house periodically by 1811, but interior work proceeded until 1823.

An octagonal building, with four octagonal rooms framing a square dining room, Poplar Forest also has two octagonal privies at either end of the grounds, screened by mounds of earth left over from the excavation of the foundation.

A fire gutted Jefferson's retreat in 1845. When it was rebuilt, the skylight over the dining room, a roof deck, and a balustrade were omitted.

In 1947 Mr. and Mrs. James O. Watts undertook an extensive restoration, and the house remained in private hands until the Corporation for Jefferson's Poplar Forest acquired the estate for preservation and further restoration.

Point of Honor, ca. 1815

Lynchburg

Overlooking the James River and its approach to downtown Lynchburg is Point of Honor, a Federal-style mansion with polygonal bays. Dr. George Cabell, who counted Patrick Henry among his friends and patients, built Point of Honor as the manor house of his 900-acre plantation on the outskirts of town.

According to a local story, existing in several versions, a duel was fought on the grounds of the plantation home, thus giving it its name. The point of land that the house and grounds occupy was originally outside Lynchburg, where local law forbade dueling. A number of "points of honor" may have been satisfied on this location before Dr. Cabell acquired the property.

Now a Virginia Historic Landmark and a house museum, Point of Honor is undergoing a long-term restoration to the period of 1815–1830. It is administered by the Lynchburg museum system.

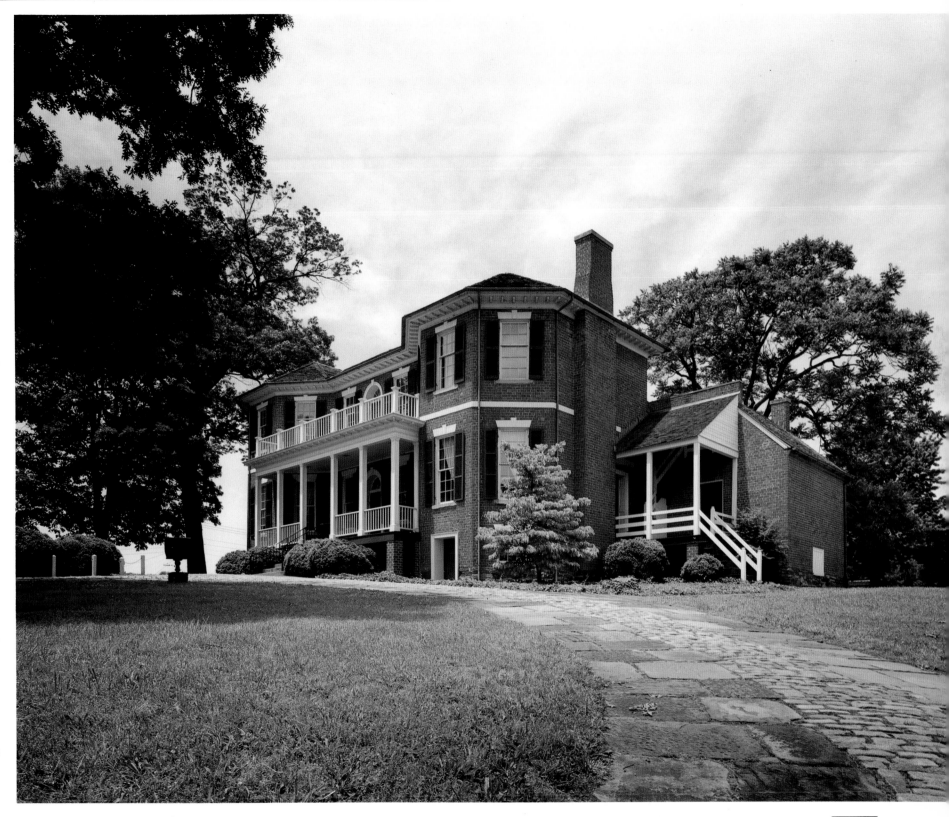

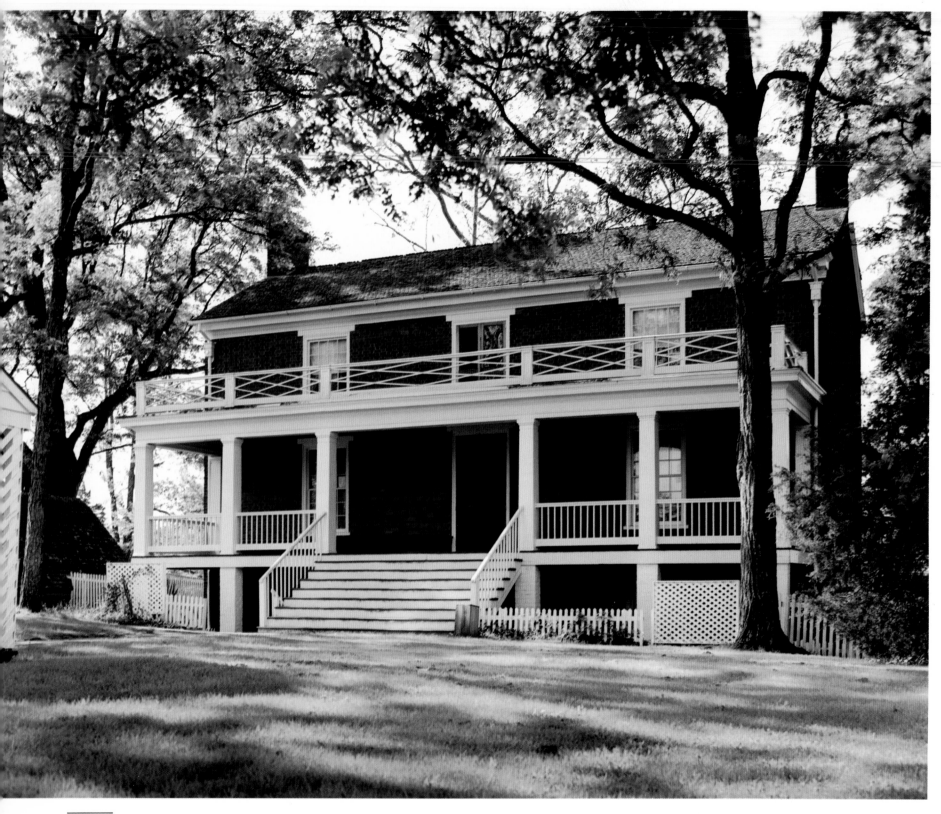

McLean House, 1848

Appomattox County

Wilmer McLean owned a home in northern Virginia near a small creek named Bull Run, which flows close to the town of Manassas. After the first battle of Manassas threatened his property, McLean in 1863 pulled up stakes and moved to quieter country in south-central Virginia east of Lynchburg, to a little settlement surrounding the Appomattox County courthouse.

In April, 1865, the escape of a battered, retreating Confederate army commanded by General Robert E. Lee was blocked by the Union army of General Ulysses S. Grant near the village of Appomattox Court House. In McLean's parlor, Lee agreed to the surrender of his beloved Army of Northern Virginia. McLean's farmhouse was virtually stripped by Union followers seeking a memento of that historic occasion.

The McLean House was dismantled in 1893 with plans to reconstruct it in Washington, D.C., as a war museum, but the dream was never realized. The lumber and bricks lay in a crumbling pile until 1935, when the National Park Service began to restore and rebuild the village of Appomattox Court House. It is today a National Historical Park, with the McLean House reconstructed to the year 1865.

Upper Bremo, 1820

Fluvanna County

On his Piedmont plantation on the upper James River, General John Hartwell Cocke built a classic Palladian villa on land owned by his family since 1714. A friend and associate of Thomas Jefferson, General Cocke asked the Master of Monticello for his advice in designing the house, but Jefferson declined to draw the plans, saying all his architectural books had been sold to the Library of Congress. However, his influence is evident throughout the house. Jefferson recommended Bremo's master carpenters, John Neilson and James Dinsmore, who had done much work at Monticello.

Upper Bremo is part of the Bremo Historic District, still owned by Cocke's descendants. Two other plantation houses, Lower Bremo (1723, 1802–1805) and Bremo Recess (1809, 1836), a great-columned stone barn, stone stables, and other plantation outbuildings combine with Upper Bremo to create a unique historic complex.

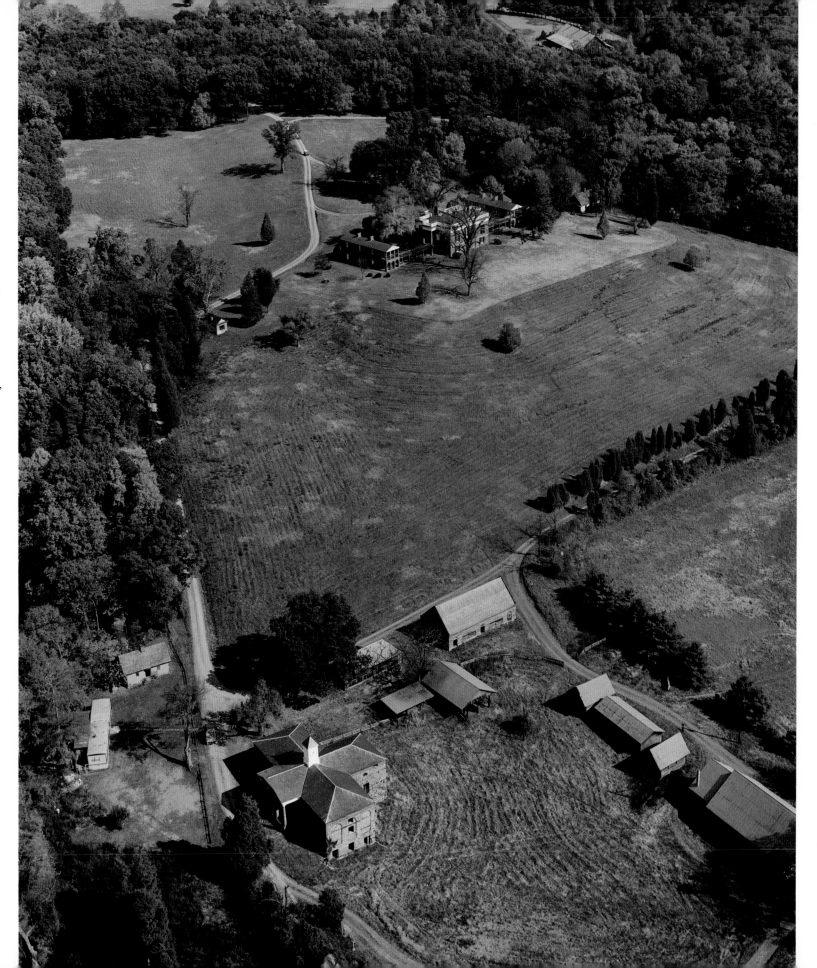

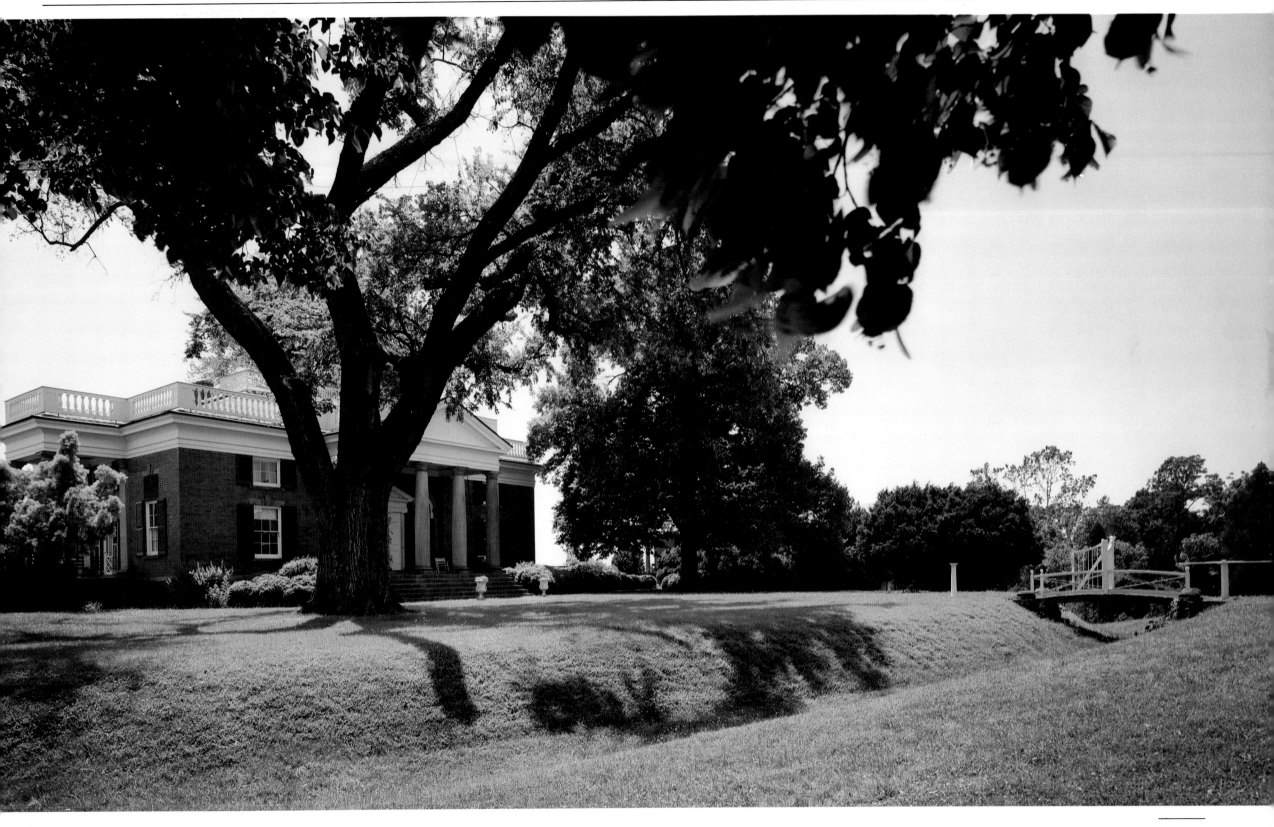

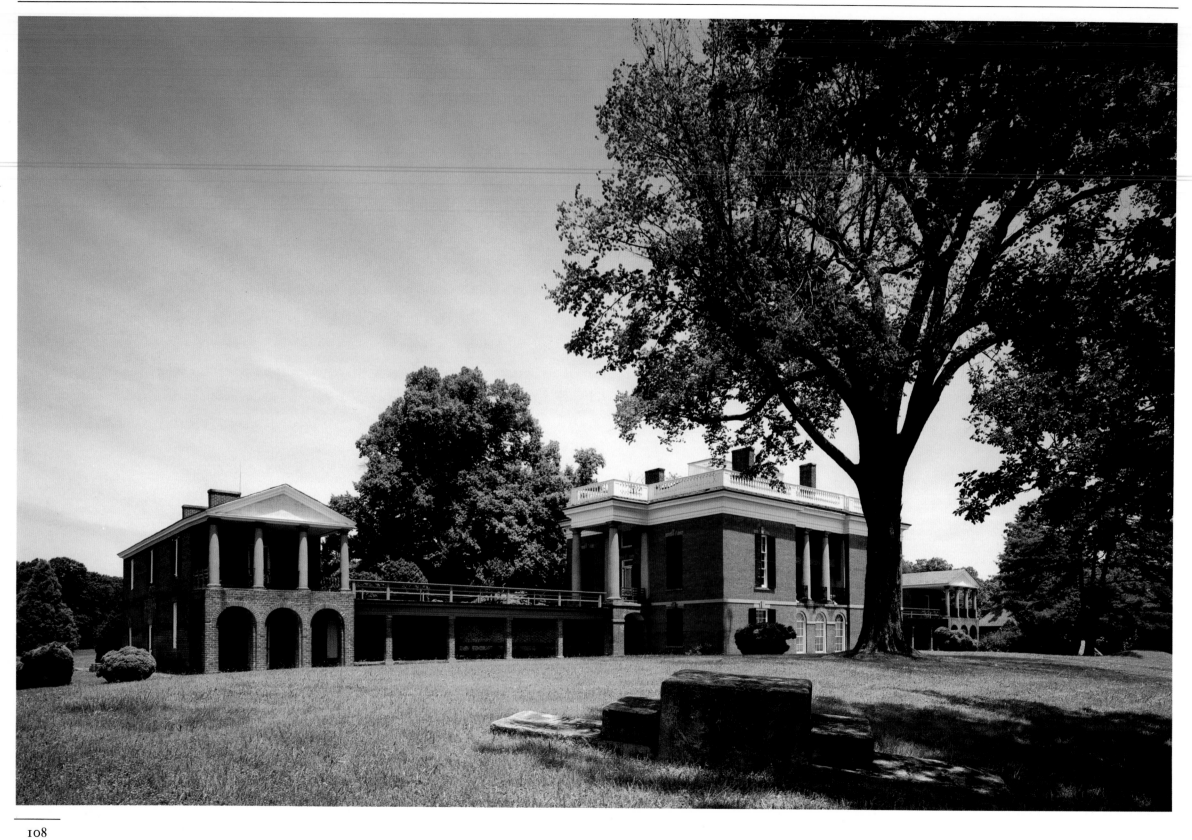

The oldest part of Lower Bremo (right) is a stone hunting lodge built about 1723, used by General Cocke and his family when they began coming to Bremo in the early 1800s. The general remodeled Lower Bremo and Bremo Recess in a neo-Jacobean style similar to that of Bacon's Castle in Surry County. Lower Bremo was further expanded in 1917.

At left is the river elevation of Upper Bremo.

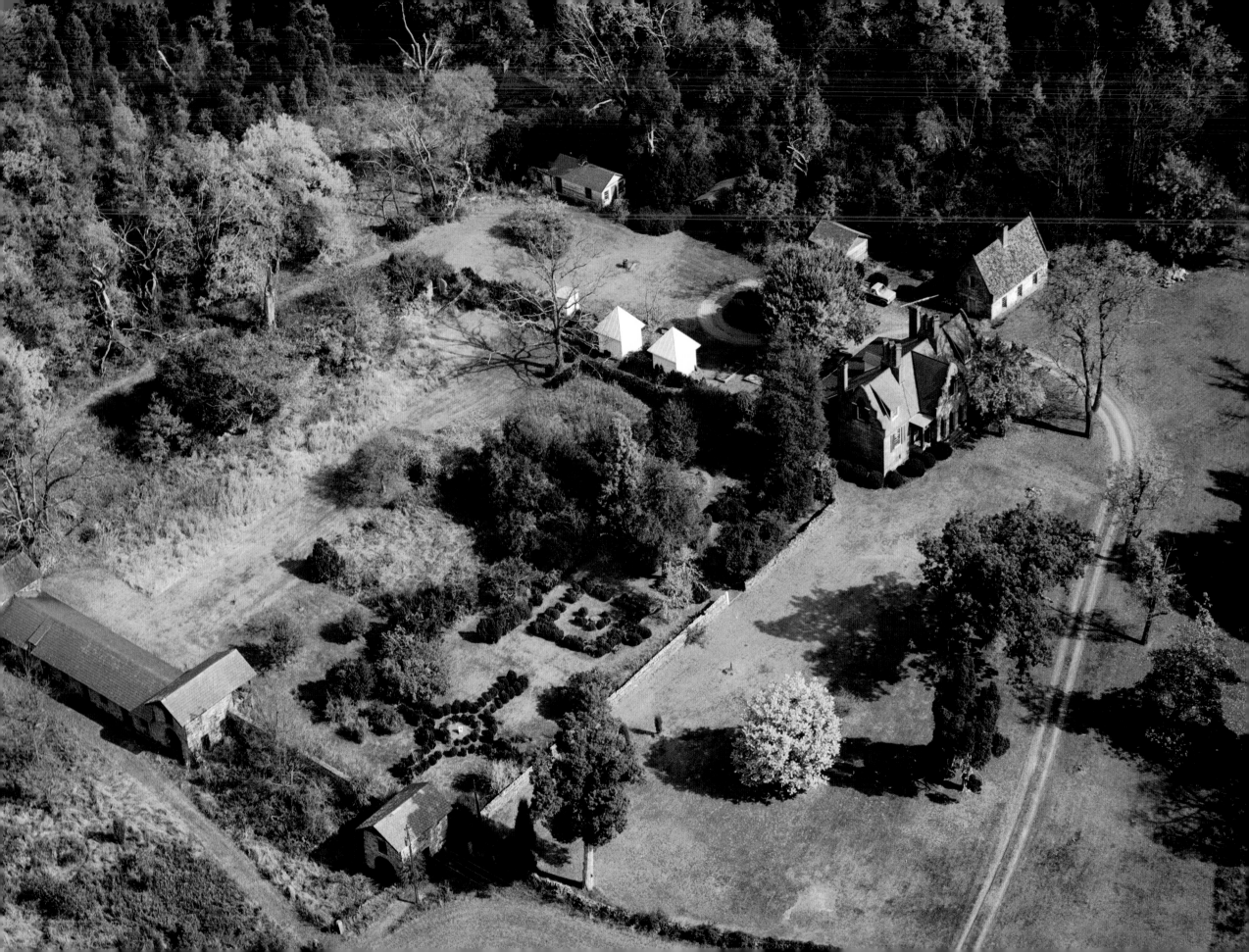

Bremo Recess, 1809, 1836

Fluvanna County

The Cocke family lived at Bremo Recess from 1809 to 1820, when Upper Bremo became ready for occupancy. General Cocke remodeled Bremo Recess for his son John in 1836.

Original outbuildings still stand behind and at either side of the house. Its formal garden, to the rear of which vegetables were grown, also remains. On the far side of the garden from the house are stone stables, part of which have been removed, and on the opposite side of the house is a four-room, two-story guest cottage. Where the external kitchen was located is unsure. The two square white buildings to the rear of Bremo Recess are the smokehouse and dairy.

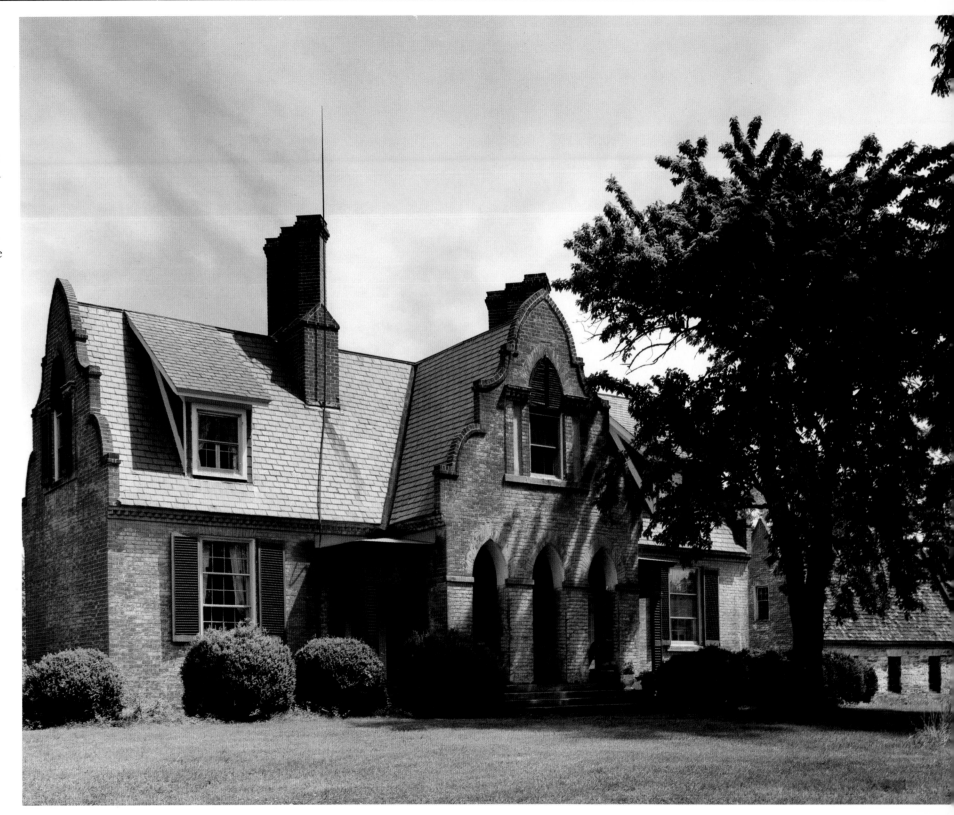

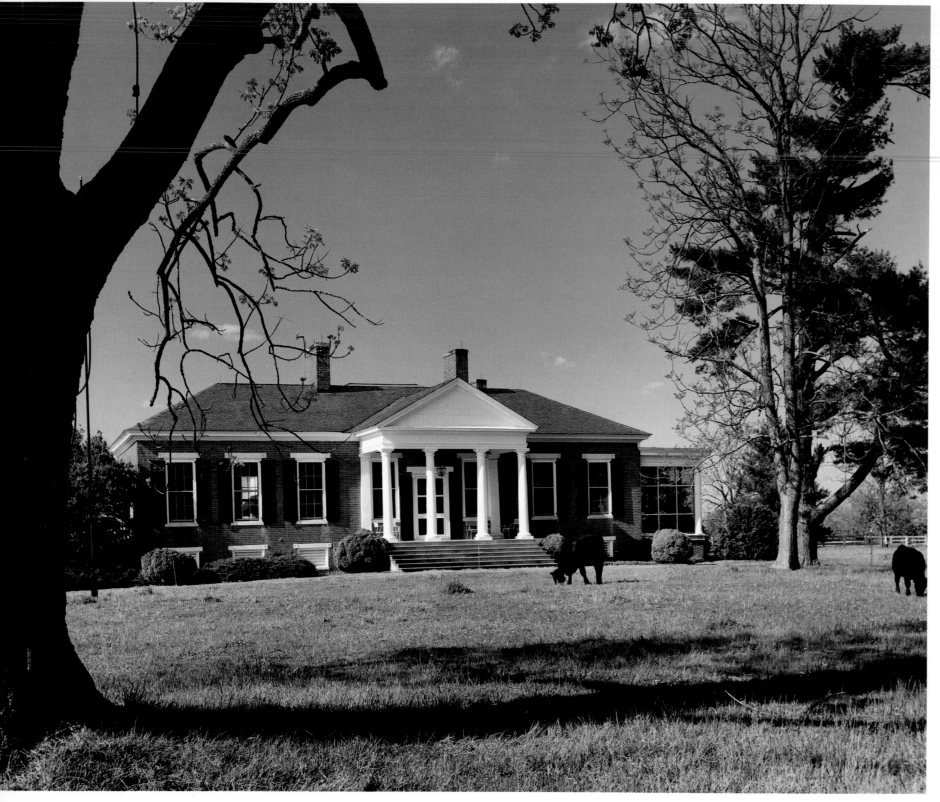

Ampthill, *ca.* 1835
Cumberland County

Originally part of Clifton plantation, Ampthill was patented by Thomas Randolph in 1723, and occupies a large loop of the upper James River west of Richmond.

In 1815, Ampthill's owner, Randolph Harrison, asked Thomas Jefferson for his help in designing a new brick structure that would double the square footage of the existing eighteenth-century wooden house. Jefferson sent him the plans, but construction did not begin until twenty years later and may not have followed Jefferson's original design. However, the gracefully proportioned new addition is believed to reflect Jefferson's architectural ideals.

Still a working plantation, Ampthill was restored by Mr. and Mrs. James Rea, who acquired the then run-down estate in 1953.

Bolling Island, late 1700s, early 1800s, 1836 (right)
Goochland County

In 1717, John Bolling patented a 300-acre island in the upper James River above Richmond and bought 200 acres of adjacent bottomland on the north bank to form Bolling Island plantation. His grandson William Bolling built a small frame house on a hill for his overseer, and this became the first part of the existing house. In the early 1800s, the brick center portion was added.

The enlarged house was occupied successively by William Bolling's daughter Anne and her husband, and by his son Thomas and Thomas' wife, Mary Louisa Morris. Thomas ultimately was deeded the plantation. He further expanded the house in 1836 by adding another floor to the brick center section and by building the columned portico.

The Bollings continued to operate the plantation until 1870, when a series of owners followed. In 1962, Richard Couture, the present owner, bought the house, its fourteen dependencies, and fifty acres and made Bolling Island his home.

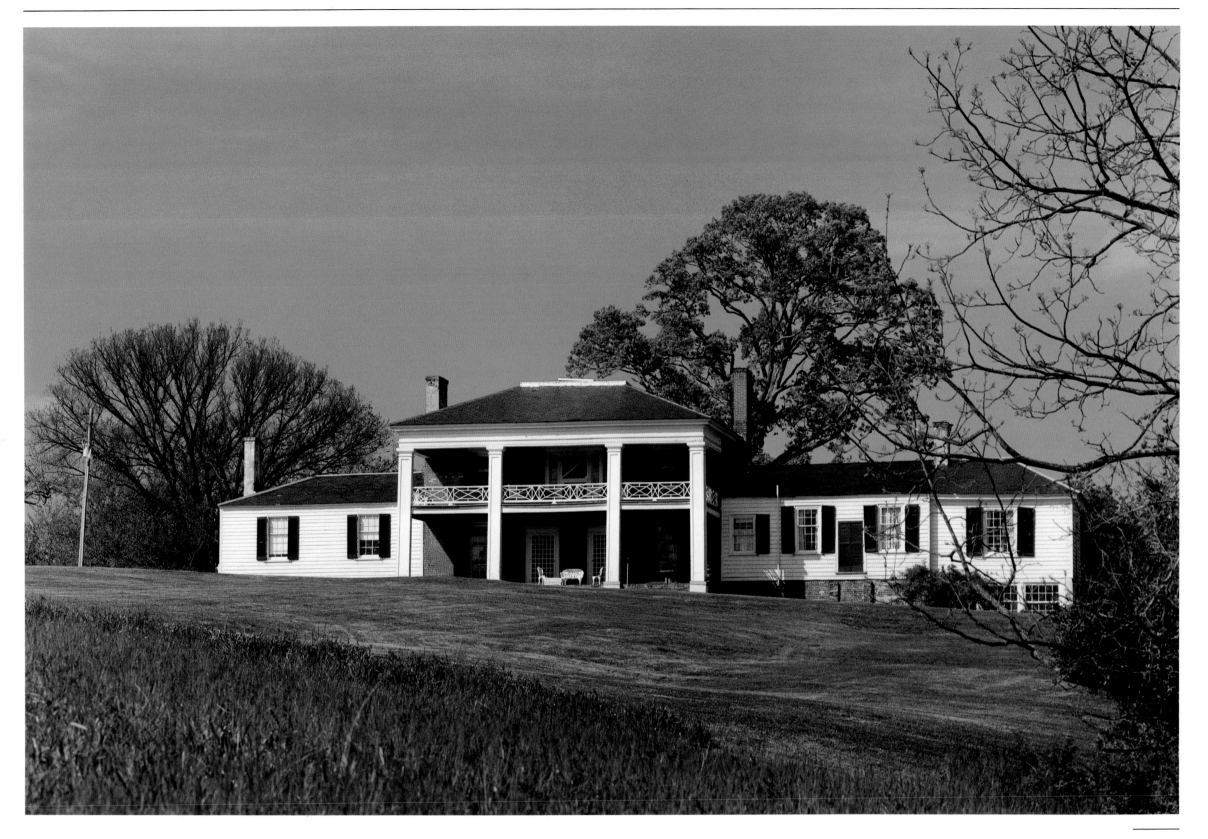

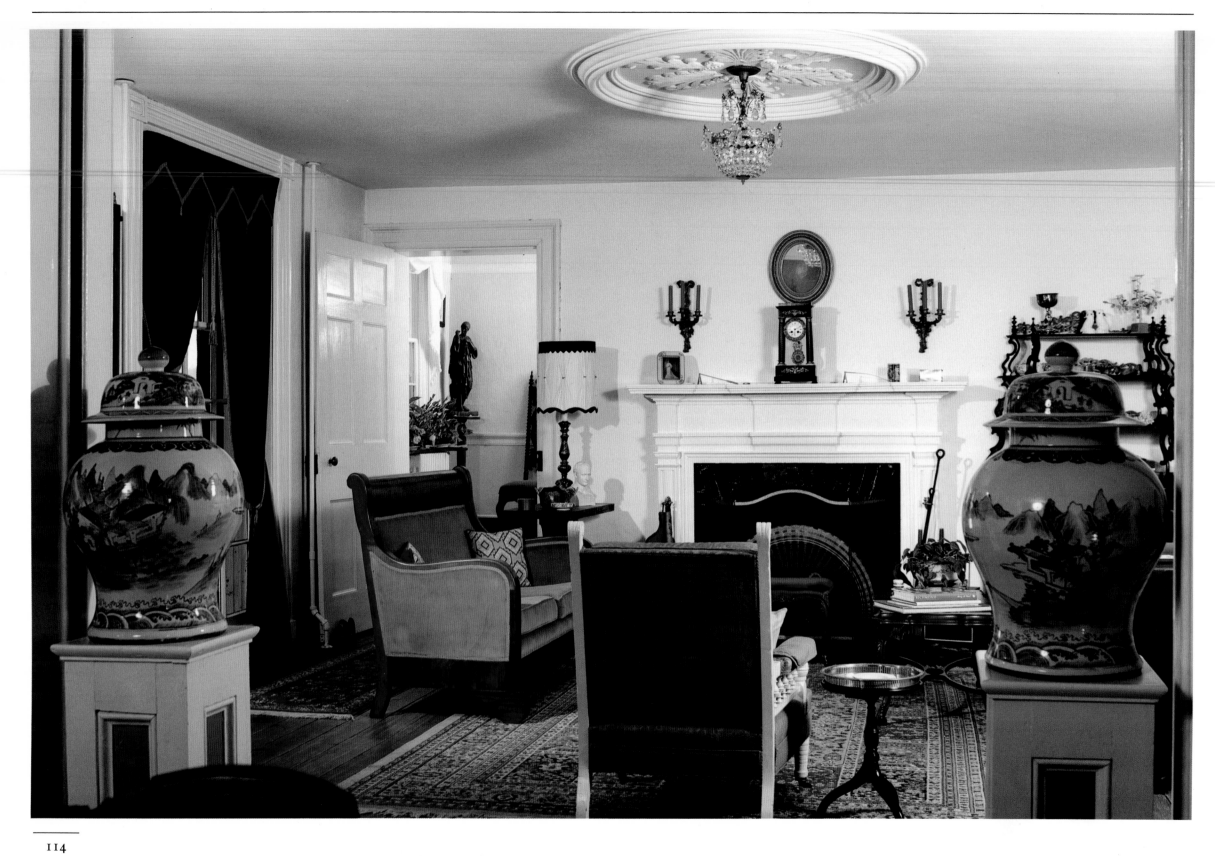

Muddy Creek Mill, *ca.* 1792

Cumberland County

Near the James River in Cumberland County is a unique mill with most of its water-powered machinery still intact. The upper part of the building was built before 1792, when its owners raised it above a new main floor and crowned the new roof with two levels of dormers to create the present mill.

Muddy Creek Mill served the neighboring plantations, grinding their wheat and corn until the 1950s. Nearby is the miller's house and a small brick store built about 1800.

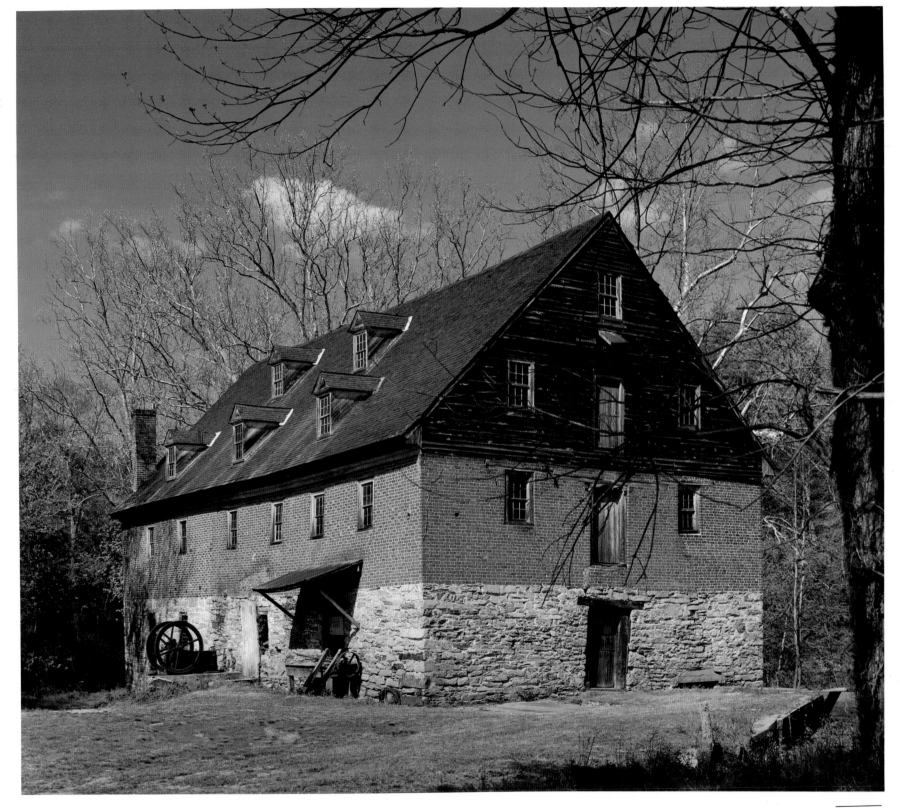

(left) *The parlor at Bolling Island*

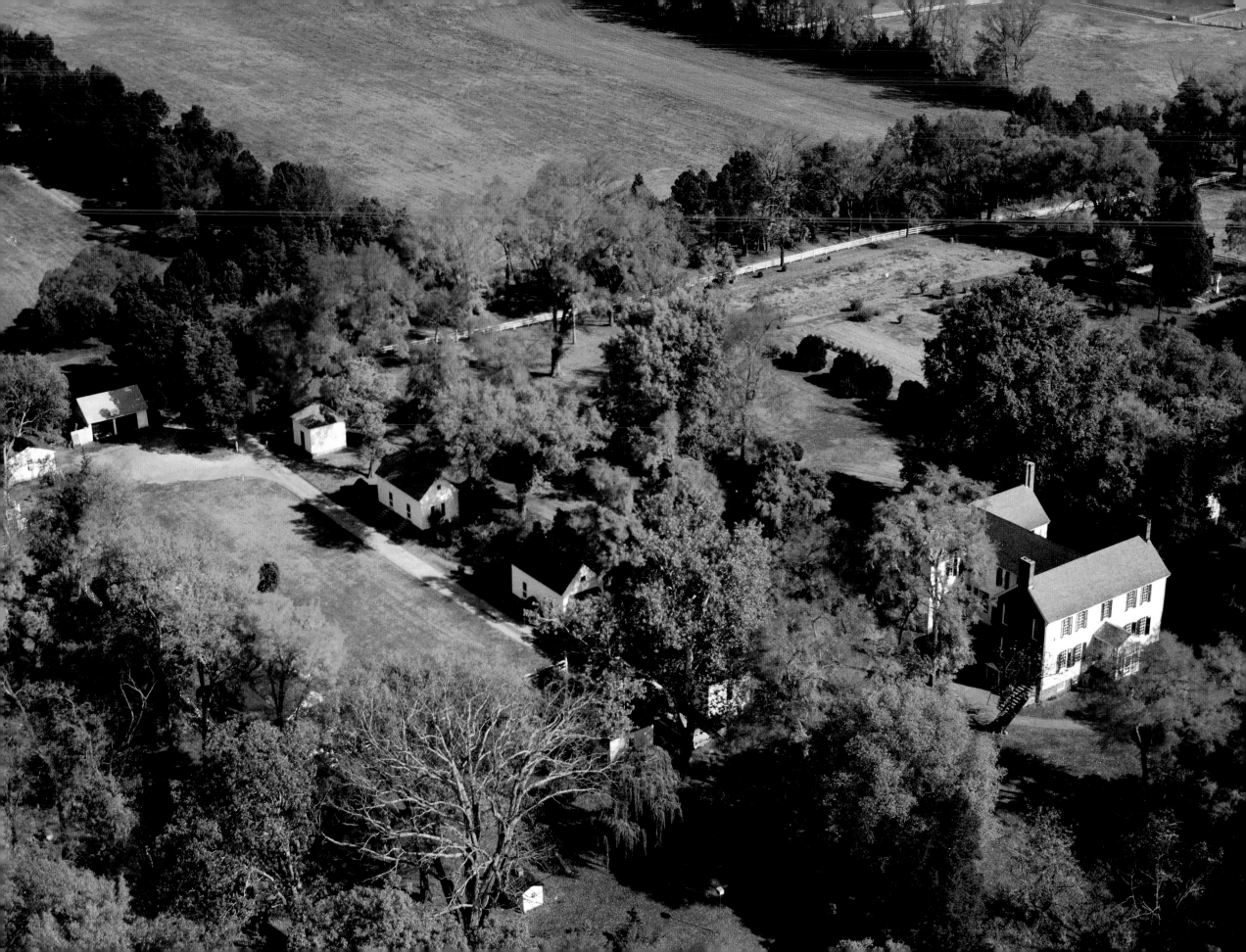

Tuckahoe, *ca.* 1723, 1735

Goochland County

"On a rising ground, having a most beautiful and commanding prospect of the James River" stands Tuckahoe, nucleus of one of the best-preserved colonial plantation complexes in Virginia. According to Thomas Anburey, an eighteenth-century visitor, the house "seems to be built solely to answer the purposes of hospitality."

Of the large plantations established by the sons of William Randolph of Turkey Island (1651–1711), Tuckahoe, begun by Thomas Randolph in the early 1720s, is the only one remaining. The H-shaped house is noted for its elaborate carved staircases and paneled walls. The rare street of outbuildings on the western side of the house includes the plantation office, brick kitchen, slave quarters, and smokehouse. On the eastern side is a diminutive schoolhouse where young Thomas Jefferson was first taught. His family moved to Tuckahoe when he was two, remaining there for seven years.

The oldest part of the house (*ca.* 1723), farthest from the bluff, is connected to the brick-ended south wing (*ca.* 1735) by a large hyphen, containing the fully paneled great hall. Each wing contains two rooms downstairs and two above, with a center hall.

The Randolphs continued to own Tuckahoe until the 1830s. In 1898 it was bought at auction by Harold Jefferson Coolidge of Boston, a descendant of the Randolphs and Thomas Jefferson. Mr. and Mrs. N. Addison Baker bought Tuckahoe in 1935 and restored the great house, aided by architect Duncan Lee. A National Historic Landmark, Tuckahoe is still a country home, now in the stewardship of third-generation descendants of the Bakers.

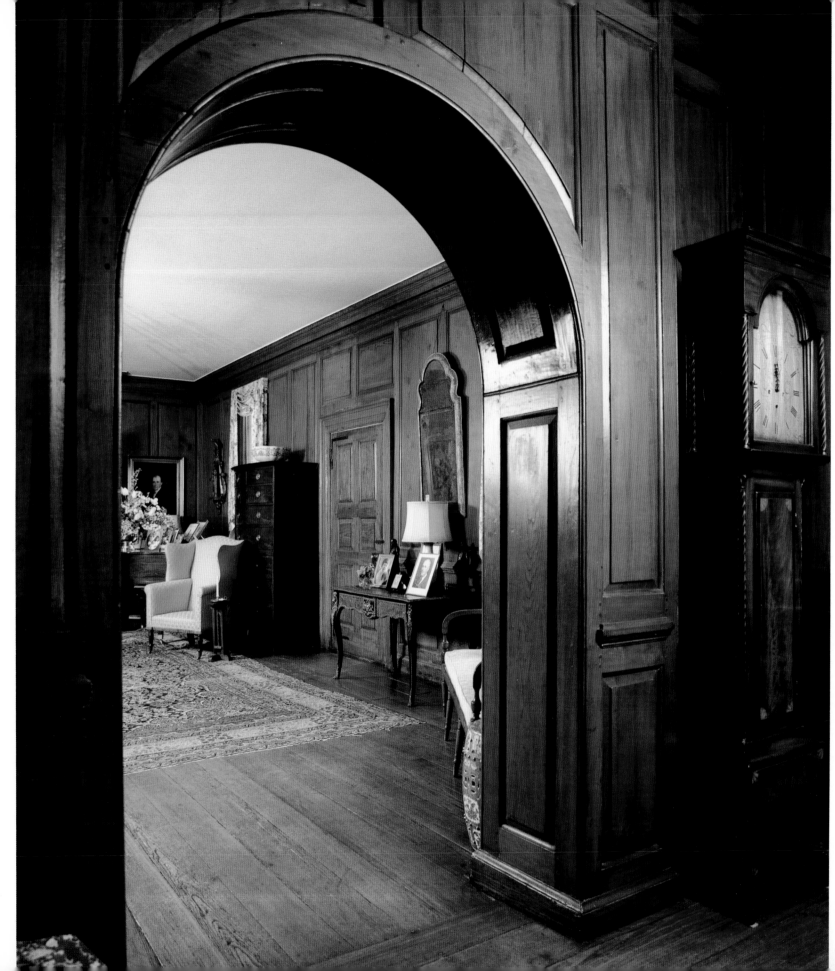

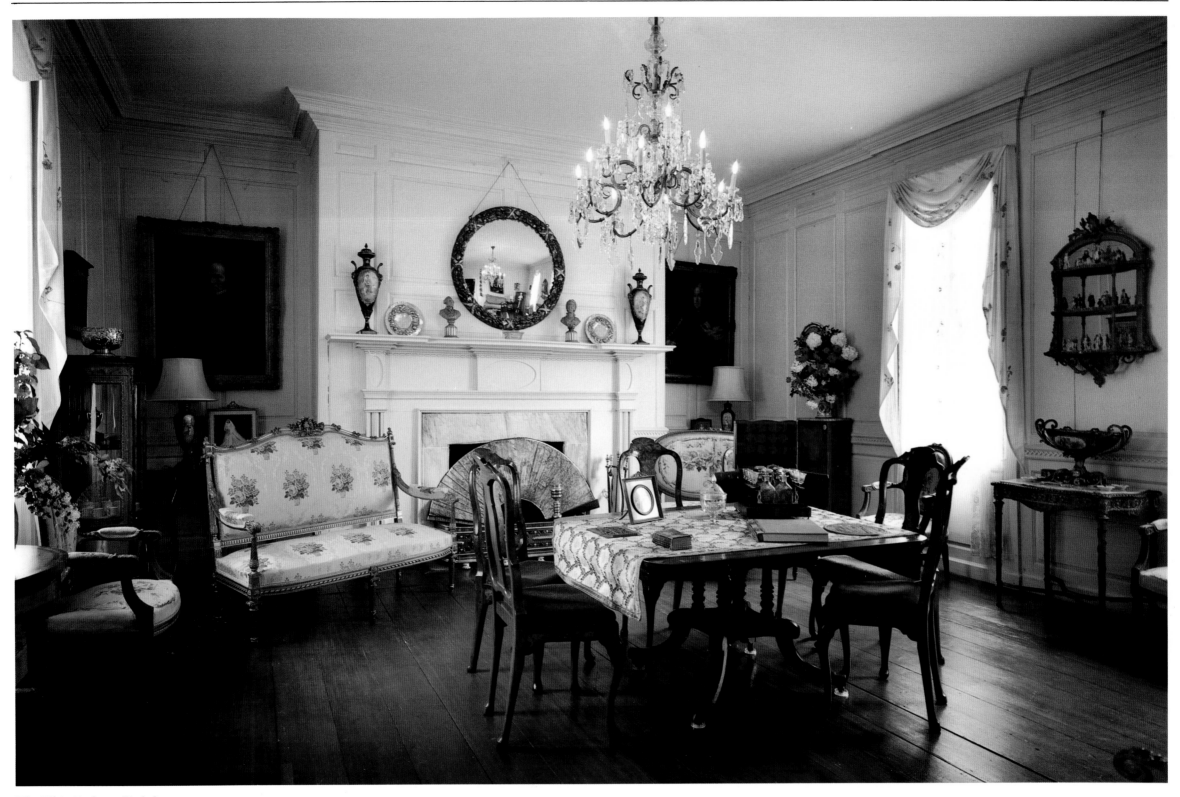

The White Parlor at Tuckahoe

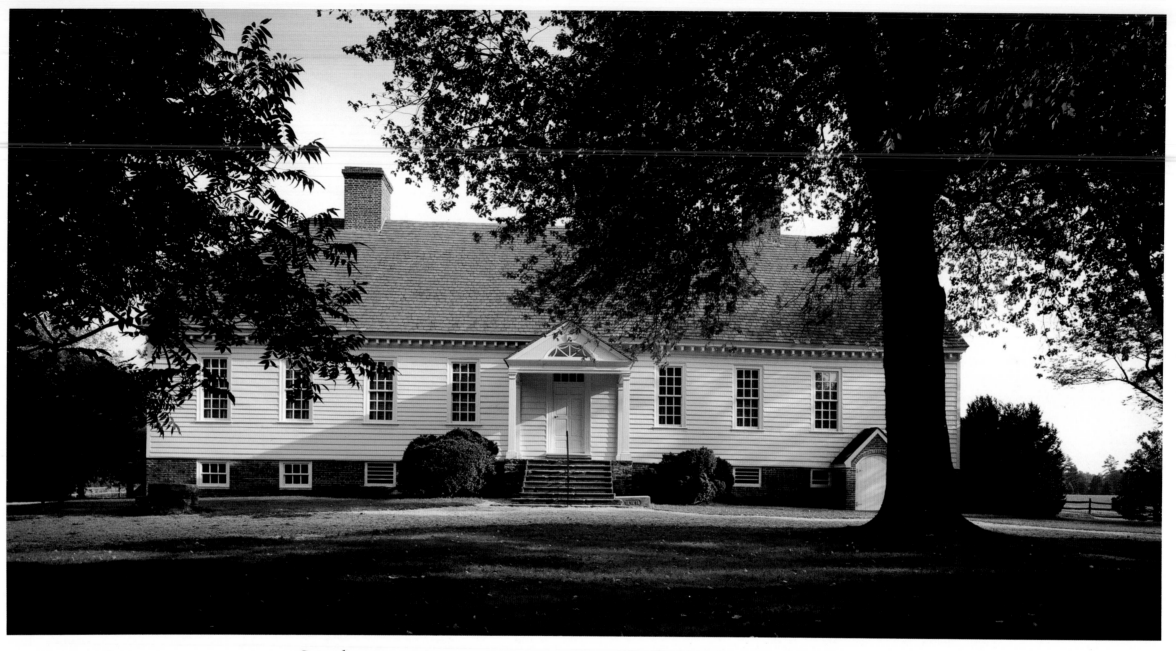

Scotchtown, *ca.* 1719

Hanover County

Patrick Henry made Scotchtown his home from 1771 to 1778, when he was a leading lawyer in the Old Dominion and was gaining fame as the "Voice of the Revolution." In 1776, he was elected the first governor of the Commonwealth of Virginia.

Charles Chiswell built the one-story house, with eight large rooms and a center passage, about 1719 as his country seat on a 9,976-acre tract on which he raised tobacco and wheat. Fifty-two years later, Patrick Henry bought the house and 960 acres and made it home for his first wife, Sarah Shelton Henry, and six children. A later owner, in the 1780s, was John Payne, whose

daughter Dolley grew up at Scotchtown and later married James Madison.

In 1958, the abandoned, run-down house was saved by the Hanover branch of the Association for the Preservation of Virginia Antiquities, which carefully restored Scotchtown and opened it to the public.

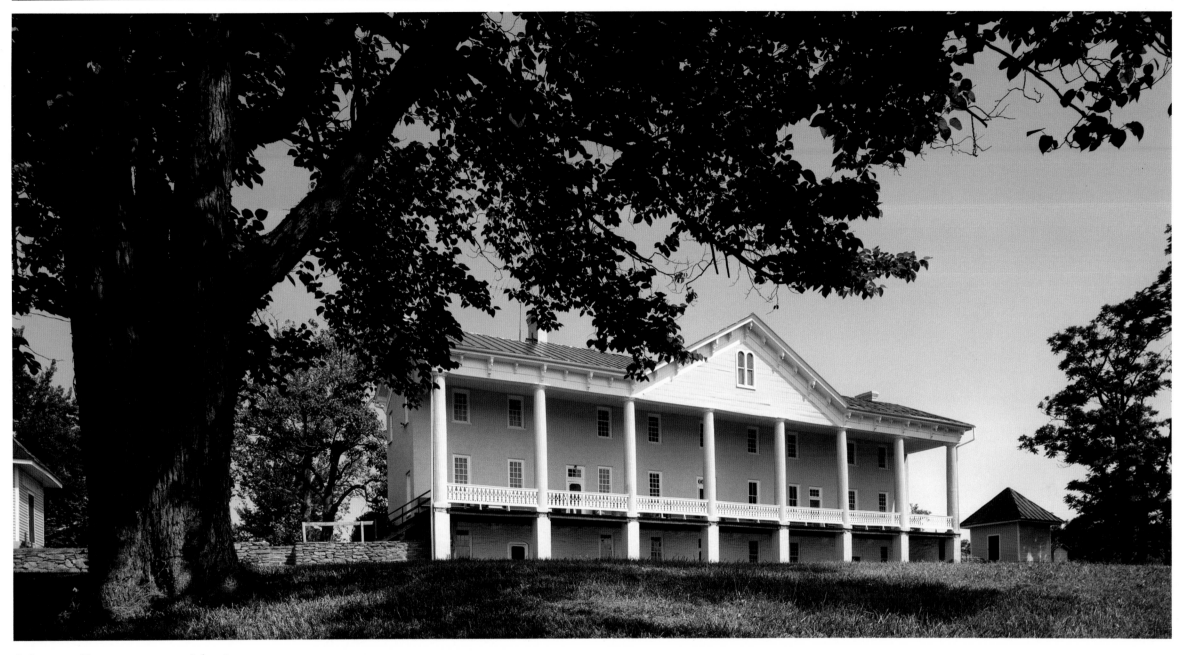

Montpelier, 1740s, mid-1800s

Rappahannock County

In the southern part of Rappahannock County is an imposing two-story house with full "English" basement (open at ground level on one side) begun by Francis Thornton in the 1740s and owned by his son William near the end of the eighteenth century. Later generations of Thorntons made alterations resulting in a unique house with a great-columned veranda on the south side.

Montpelier was first used as a summer home to escape the malaria that plagued the Tidewater lands owned by the Thorntons. Designed to catch the summer breezes, the house is but one room wide, with a center hall and stair, and stairs in rooms at either end. Each of the rooms downstairs (the main floor) has its own door to the veranda.

The Thornton family owned the estate until the widow of Francis Thornton's grandson, Dr. Philip Thornton, died in 1876. Recently restored, Montpelier is now owned by James W. Fletcher, whose wife is a Thornton descendant.

Ben Venue, 1844

Rappahannock County

Near the Blue Ridge Mountains, on the Old
Stage Road from Richmond to Winchester, are
three carefully detailed brick slave cabins of Ben
Venue plantation, west of Warrenton. The manor
house and cabins were designed and built by
James Leake Powers, who had worked under
Thomas Jefferson's direction on his "academical
village" of the University of Virginia.

Ben Venue was established in the early 1800s
and remained in the family of the original owner,
M. V. Fletcher, for over 150 years. It is now
owned by the Eastham family, and continues as a
working plantation.

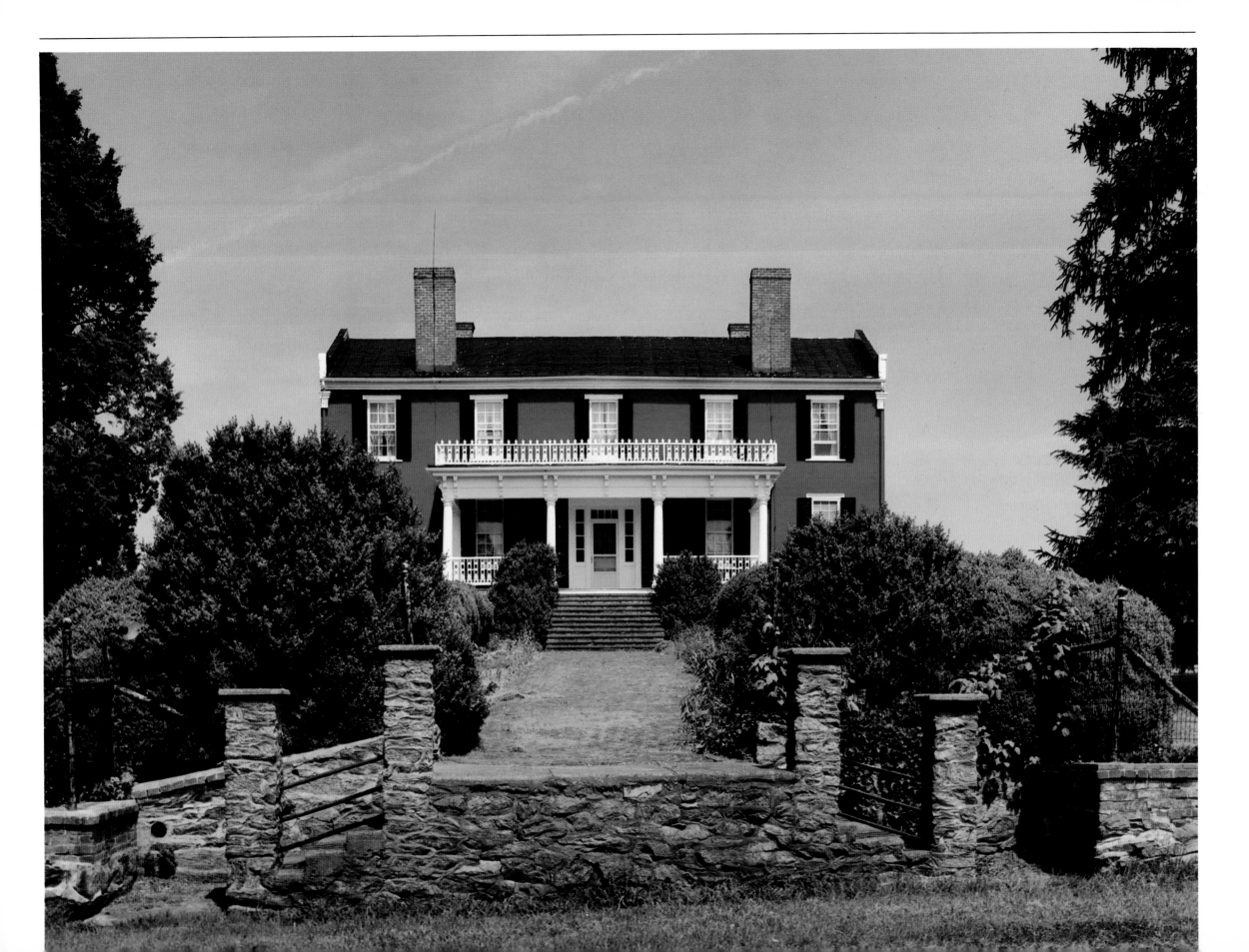

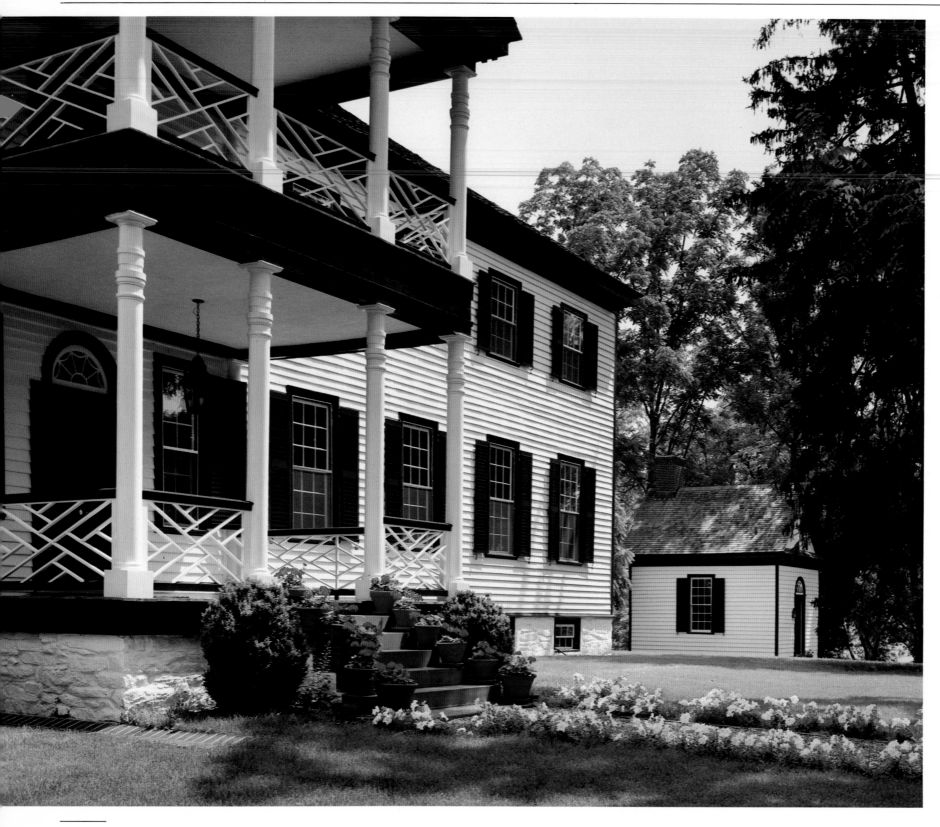

Farley, 1803
Culpeper County

In 1801 William Champe Carter of Albemarle County, near Charlottesville, bought nearly 2,000 acres of land on the upper Rappahannock River, part of a tract named Sans Souci by its first owners, the Beverley family.

Carter renamed the land after his wife, the former Maria Byrd Farley, and shortly began construction of an imposing late-Georgian frame house, essentially one room wide, with a downstairs center hall and twin galleries upstairs and down, which run the length of the 96-foot-long house to stairs at either end.

Farley was headquarters for Union general John Sedgwick during the nearby battle of Brandy Station, the largest cavalry engagement of the Civil War.

Following the war, Farley saw a gradual decline until it was purchased by Mr. and Mrs. C. D. Ward of Washington, D.C., in the 1980s, and given an extensive and careful restoration. Farley still has a few of its original outbuildings, including a classic one-room schoolhouse.

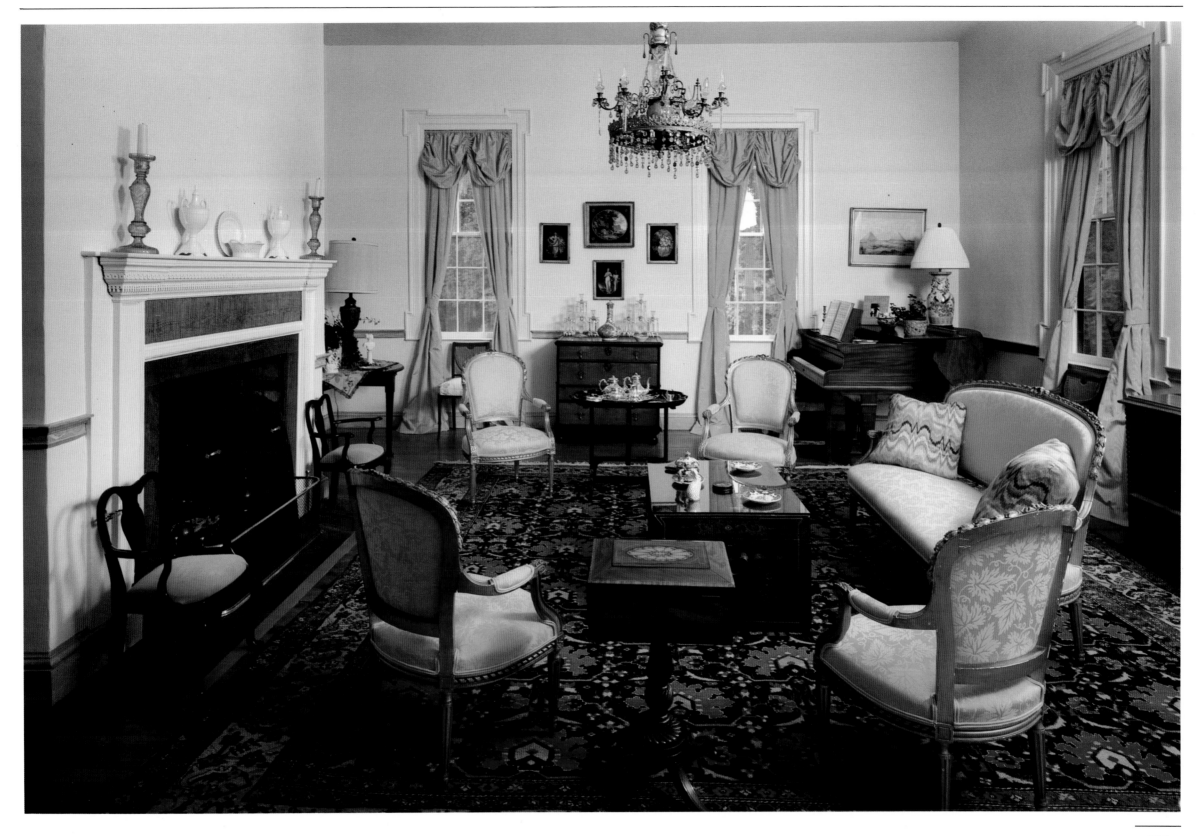

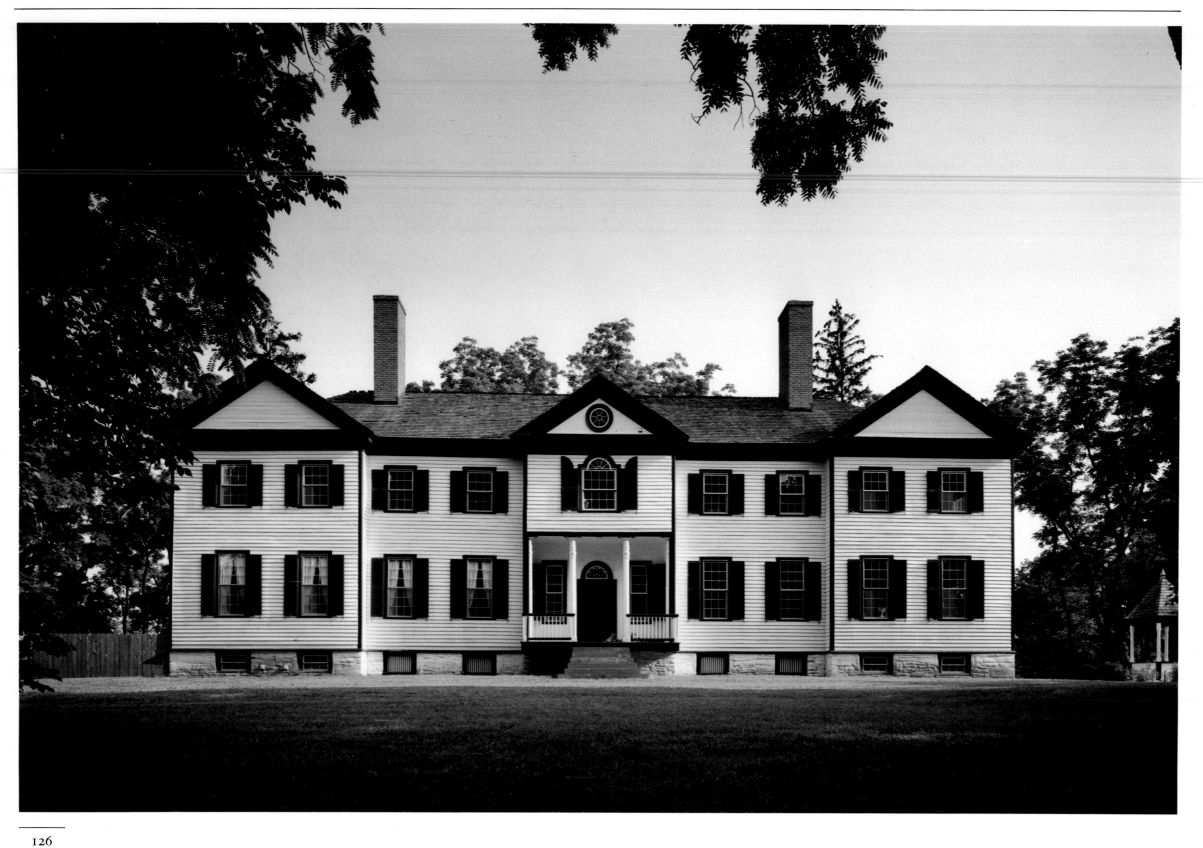

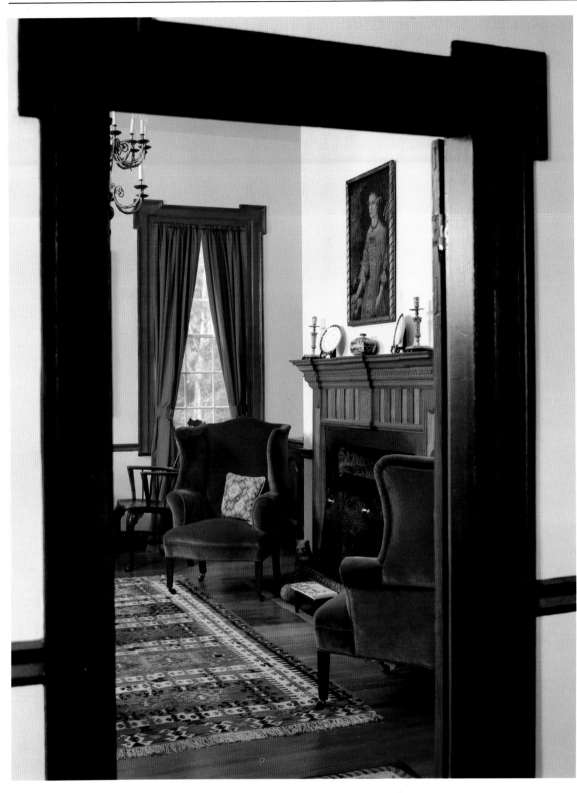

The fireplace in the library at Farley, and its two galleries with twin stairs at either end.

Greenville, 1847–1854

Culpeper County

Philip Pendleton Nalle began construction of a monumental country seat for his estate of more than 2,000 acres in 1847. His designer was a Culpeper County physician, Jeremiah Morton, who created a three-story Classical Revival mansion with four large Doric columns supporting a heavy Italianate cornice behind which is an unusual W-shaped roof.

The interior of Greenville is connected by a spiral stair rising from the ground level to the top level. The second floor, originally entered via a porch behind the columns, has higher ceilings and more elaborate woodwork than the first, and at one time contained double parlors with sliding doors. The brick kitchen behind the house is still equipped with its antebellum hardware.

During the Civil War campaigns of 1863 and 1864, the fighting near Greenville was so heavy that a nearby pasture was called the "cannonball field" for years afterward. The house itself escaped damage.

The Thomas C. Queen and Charles W. Parker families bought Greenville in 1931 and occupied the house jointly for about forty years. It has not been inhabited since 1974.

Willow Grove, 1770s, 1848

Orange County

In the 1770s, Joseph Clark built a tall frame house overlooking the rolling pastures of his Piedmont farm, just south of Madison Mills, near James Madison's Montpelier.

In 1848, Clark's son William, who had inherited the estate several years earlier, added a brick section and Tuscan portico ornamented with "Chinese Chippendale" lattice railings. Essentially unchanged, the house still has a number of its original outbuildings and its formal gardens.

The mansion and 37 acres were purchased in the late 1980s by Dick and Angela Brown, who restored the house and opened it to the public as a country inn.

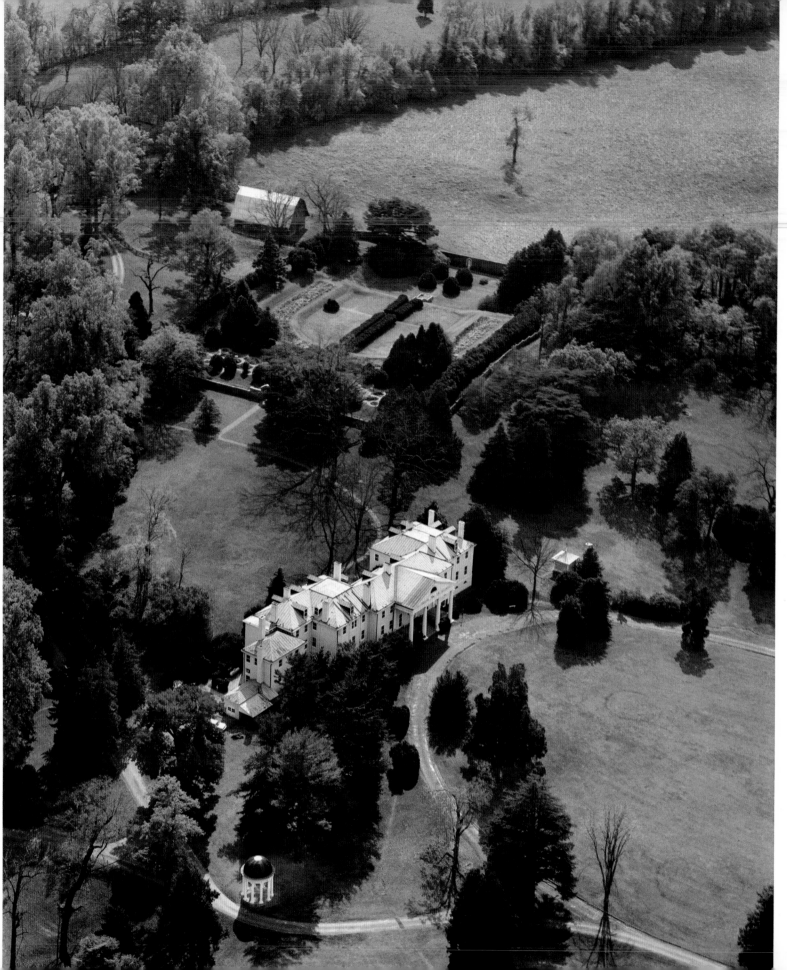

Montpelier, 1755, 1798, 1812
Orange County

The home of James Madison for seventy-six years, Montpelier plantation was established in 1723 by Madison's grandparents, and the earliest part of the 55-room mansion was built by his father in 1755.

Considered the Father of the Constitution, James Madison was Thomas Jefferson's secretary of state, and president for two terms. He expanded Montpelier in 1798 and 1812, using Jefferson's master builders, James Dinsmore and John Neilson.

Madison's widow Dolley sold Montpelier in 1844, and the property changed hands a half dozen times before William du Pont, Sr., bought the 2,700-acre estate. He and daughter Marion du Pont Scott further enlarged the house and created a great equestrian center with its own steeplechase and flat race courses, a 2½-acre formal garden, and a complex of blacksmith shop, dairy, sawmill, stables, bowling alley, and scores of farm and maintenance buildings.

Now owned by the National Trust for Historic Preservation, which has opened the great estate to the public, Montpelier has entered a long-term period of carefully researched restoration.

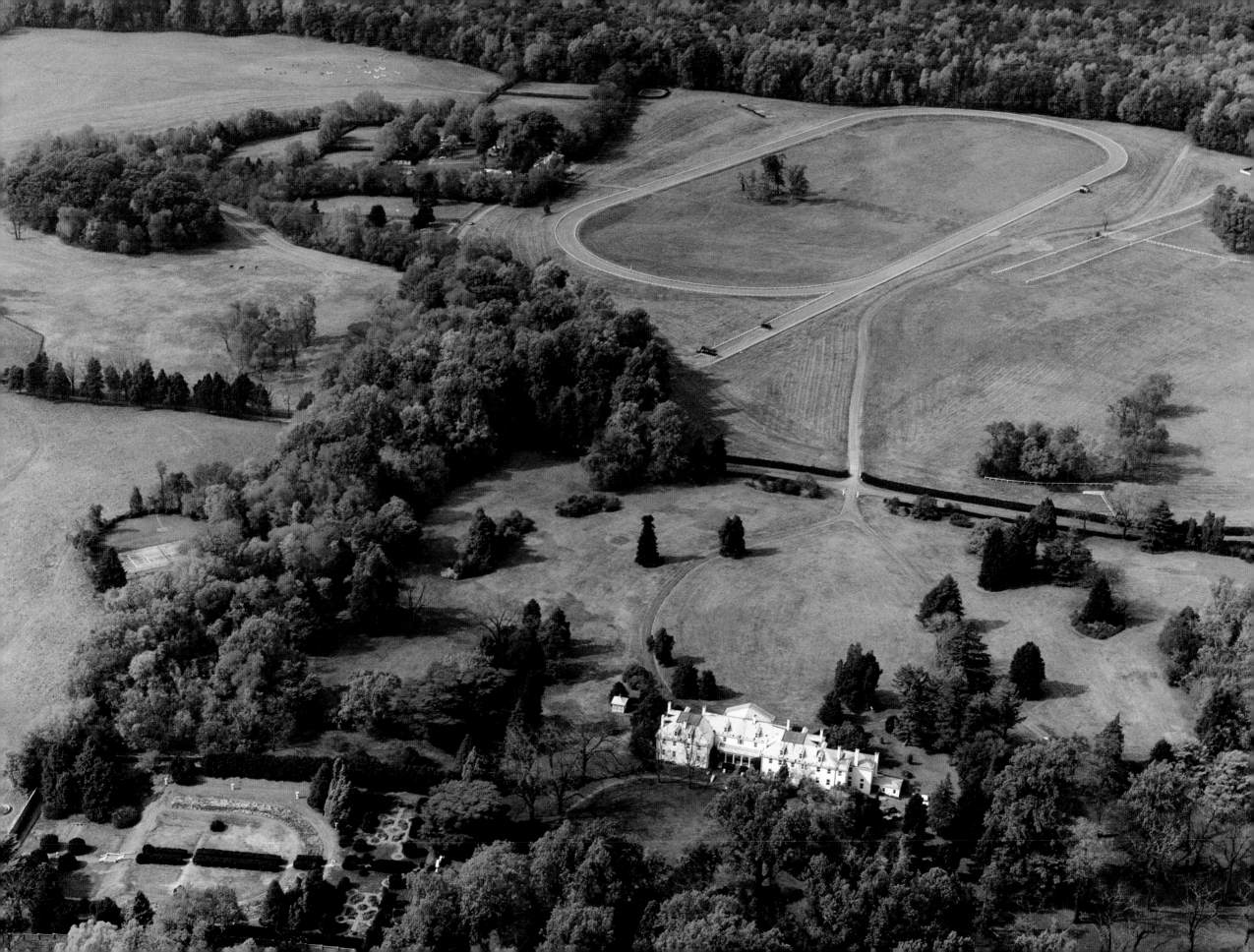

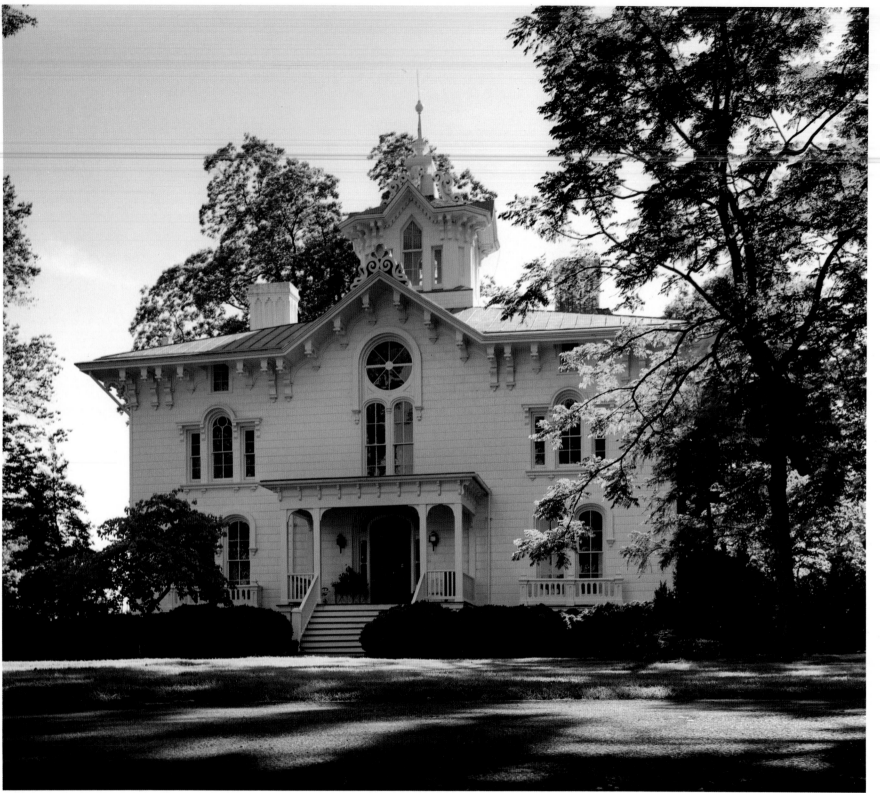

Mayhurst, 1859

Orange County

Colonel John Willis, grandnephew of James Madison, retained a talented architect to build his Italianate mansion, but the designer's name has been lost. There are some indications that Norris G. Starkweather of Baltimore may have created the fanciful mansion with its oval staircase that soars four floors to the rooftop cupola. The 18-inch walls are hollow.

During the Civil War, Mayhurst, then known as Howard Place, was a headquarters for Confederate general A. P. Hill and once hosted General Stonewall Jackson.

Mayhurst, now owned and lavishly furnished as an inn by Stephen and Shirley Ramsey, is a prominent landmark on the south side of Orange. It is listed in the National Register of Historic Places.

Barboursville, *ca.* 1822 (right)

Orange County

Thomas Jefferson drew the plans for Barboursville for his friend James Barbour, whose Orange County plantation was about fifteen miles from Monticello.

The two-story house over a raised basement had a number of elements in common with Monticello, including an earthen ramp at the carriage entrance portico that created the illusion of a one-story building, and a projecting octagonal drawing room. The house was largely destroyed by a Christmas Day fire in 1884.

Thomas Jefferson advocated the establishment of a wine industry in Virginia and experimented with viticulture at Monticello. Theodore Roosevelt praised Virginia wines at the rotunda of the University of Virginia, but Prohibition later destroyed commercial wine production in the Old Dominion. The Zonin family of Italy, wine makers since 1821, planted *vitis vinifera* at Barboursville in 1976, and have established an award-winning winery at the antebellum plantation.

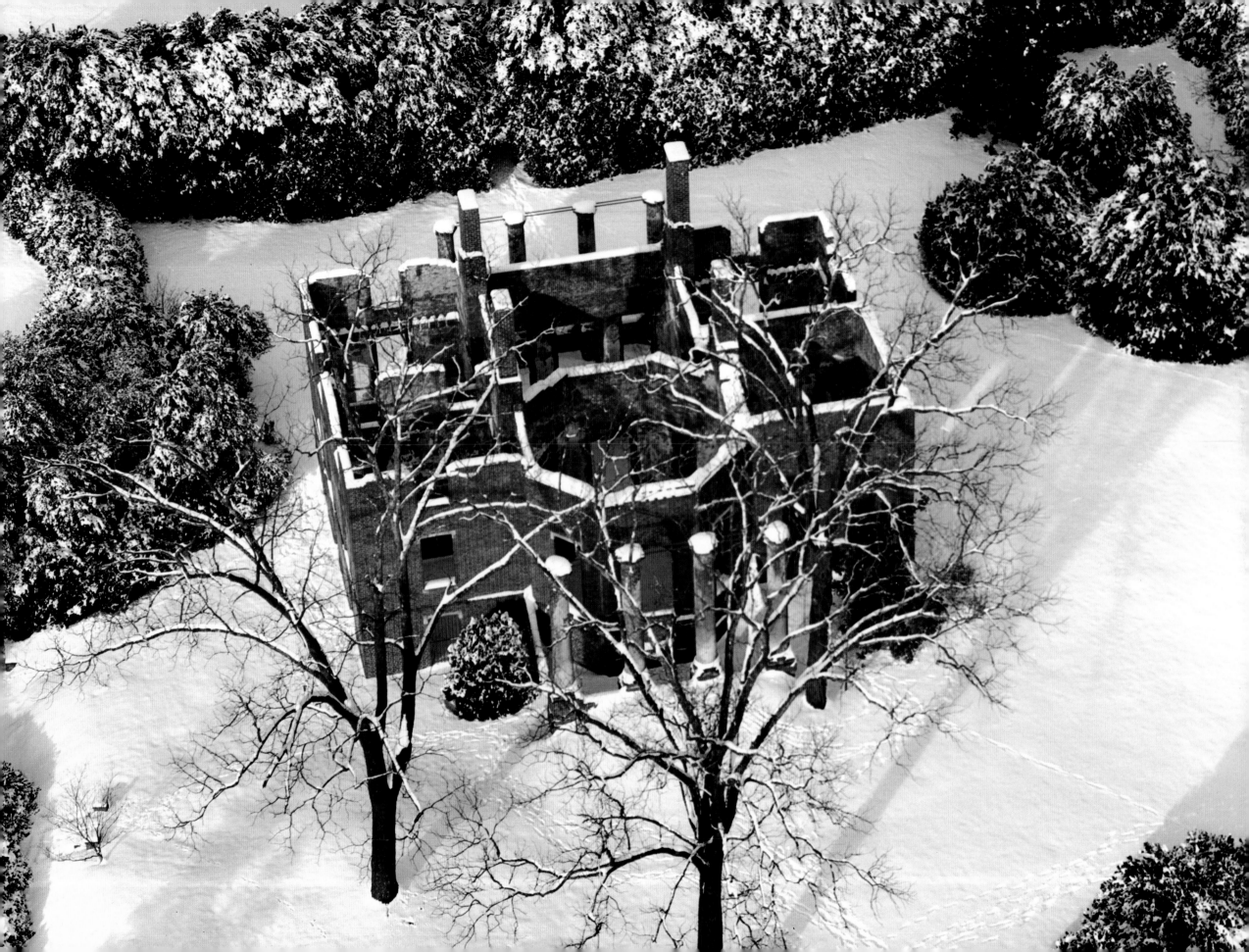

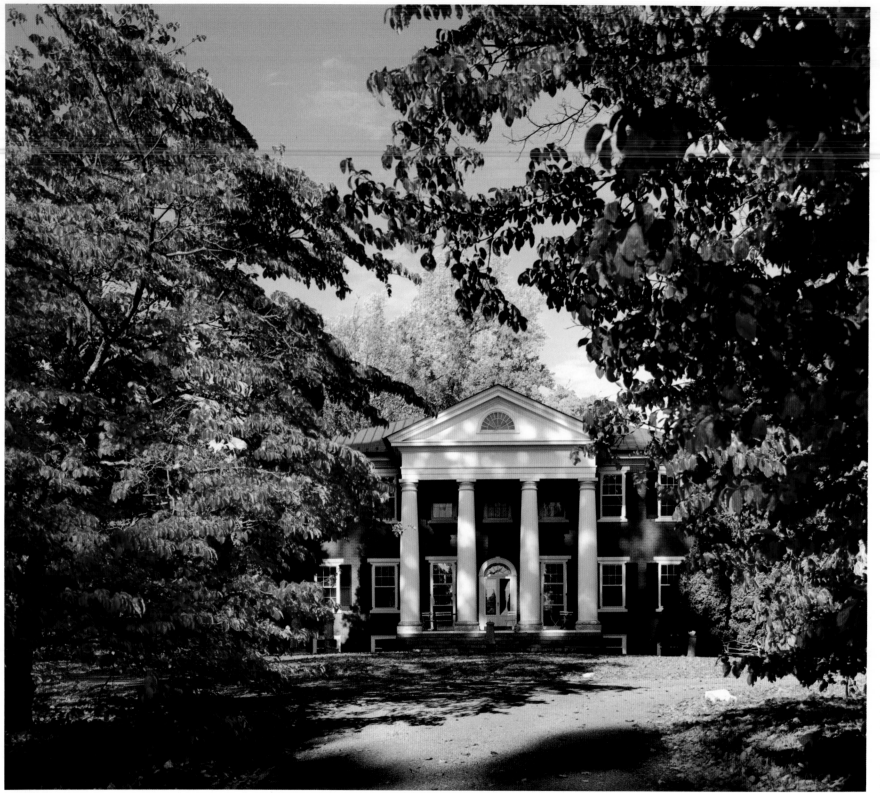

Estouteville, 1830

Albemarle County

John Coles III and his wife, Selina Skipwith Coles, named their new home Estouteville for a Norman ancestor of the Skipwith family that built Prestwould on Virginia's Southside.

James Dinsmore, who was Thomas Jefferson's joiner and supervisor for more than ten years, was chosen as architect-builder. Dinsmore had just completed alterations at Montpelier for James and Dolley Madison, and the Coles were duly impressed with his work. Dinsmore died by drowning in 1830, just before Estouteville was completed.

The house is distinguished by its great center hall (called the "summer living room" by the Coles), whose large, fanlighted double doors at either end open onto identical Tuscan porticos. The original roof was of imported German tin, only replaced in the 1980s by the present owners, Ludwig and Beatrice Kuttner.

Edgemont, *ca.* 1796 (right)

Albemarle County

In 1787 Colonel James Powell Cocke traded land in Henrico County, north of Richmond, for Piedmont acreage south of Charlottesville, where he hoped the mountain air would aid his recovery from malaria.

His compact, exquisitely proportioned house shows the strong influence of Thomas Jefferson. The carriage entrance indicates a one-story house, while the garden side shows two stories with a projecting octagonal bay under the south portico overlooking the terraced gardens.

By the mid-1930s Edgemont was nearly forgotten. Dr. Graham Clarke purchased the derelict house in 1936 and restored it with the guidance of architect Milton Grigg, who continued his work for the subsequent owners, Mr. and Mrs. W. S. Snead.

Edgemont is now the home of Mr. and Mrs. Patrick Montiero de Barras, who maintain the property with meticulous care.

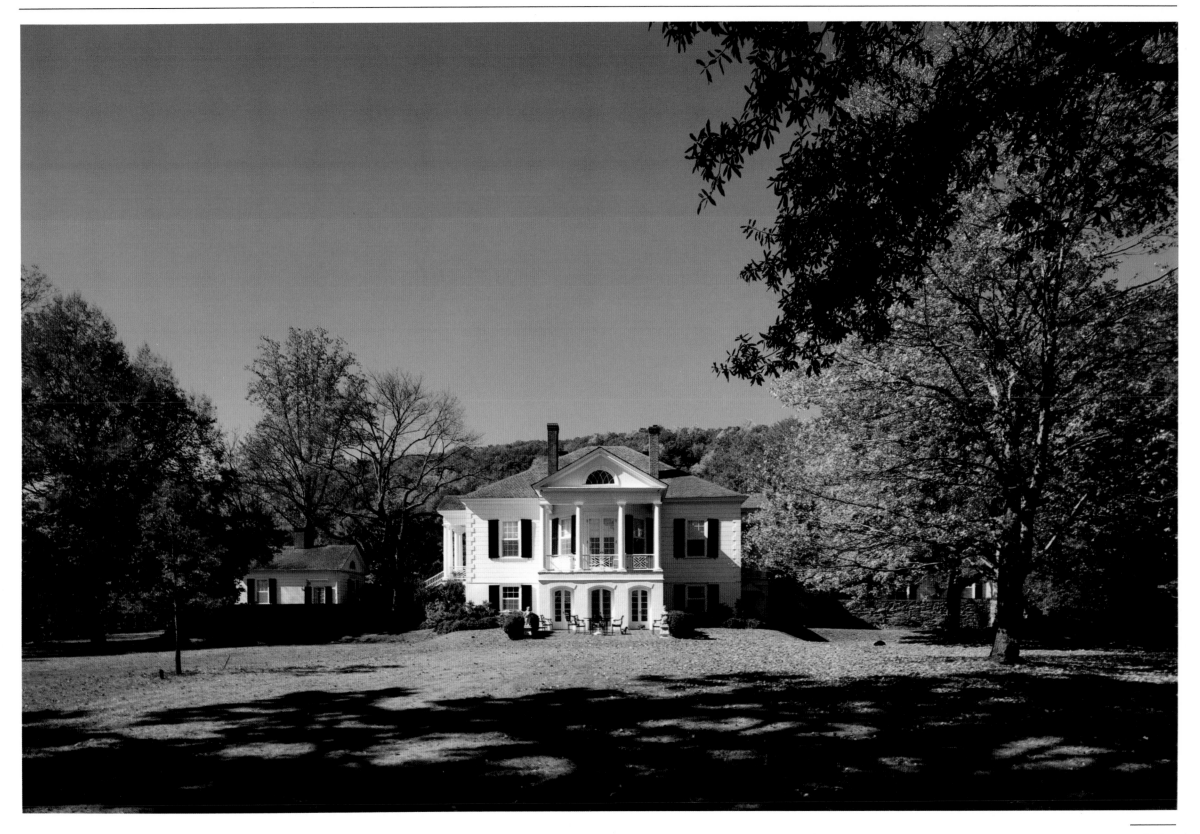

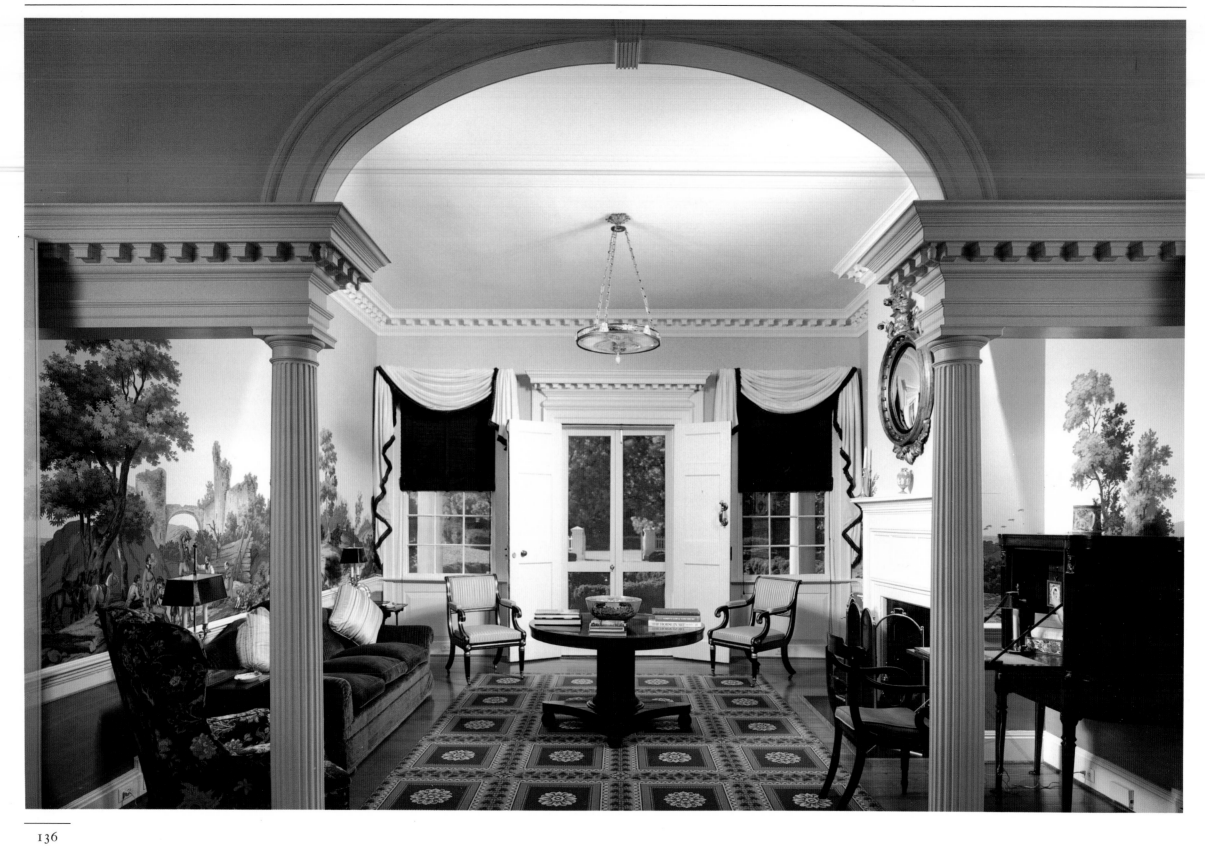

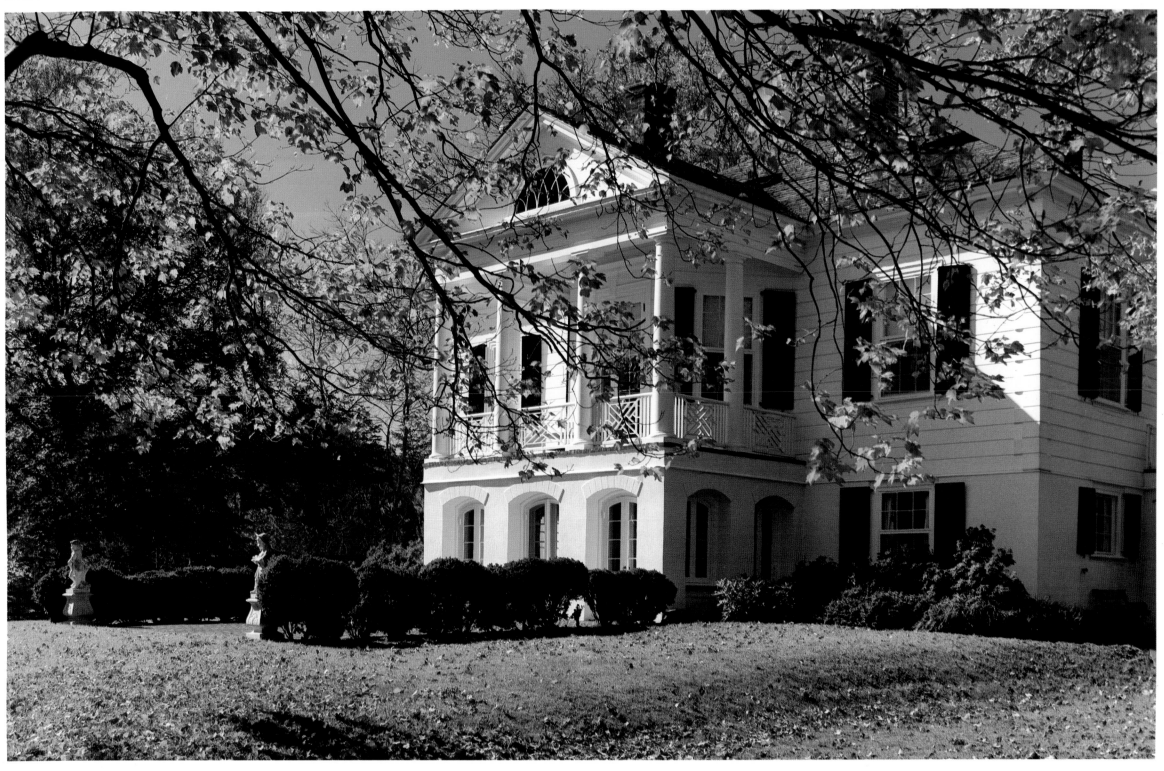

(left) *Entrance foyer and* (above) *garden side of*
Edgemont

Ash Lawn (Highland), 1799

Albemarle County

Thomas Jefferson encouraged his friend James Monroe to join him in creating "a society to our taste" in the countryside near Charlottesville, and in the 1790s Monroe purchased a 1,000-acre tobacco plantation (expanded to 3,500 acres by the early 1820s) near Monticello. Jefferson selected the site for the house and sent his gardeners to begin the orchards.

The "castle cabin," as Monroe called it, was completed in 1799, and the Monroes made it their home for over twenty years while Monroe served the young republic. President and Mrs. Monroe completed their new mansion at Oak Hill in Loudoun County in 1823 and sold Ash Lawn in 1826.

Parson John E. Massey made a more formal, two-story columned addition in 1860, and the house remained in the Massey family for many years. Philanthropist Jay Winston Johns bequeathed Ash Lawn to the College of William and Mary in 1974. The college has continued to restore the property and illustrate the period of the Monroe occupancy.

Farmington, *ca.* 1770s, 1802

Albemarle County

In 1787 George Divers bought a 3,000-acre plan-
tation in Albemarle County from Francis Jerdone
II. The property included a brick farmhouse built
by Jerdone's father, a Tory, before 1780. Divers
planned to enlarge it in 1802 and asked his friend
Thomas Jefferson for advice. Jefferson suggested
the addition of a two-story octagonal wing with
its own Tuscan portico.

Divers' death halted construction, but the addi-
tion was later completed by Bernard Peyton,
whose widow sold Farmington to Joseph Miller
in 1860. Farmington remained with the Miller
family until 1927, when Donald Gordon Stevens
conceived the idea of using the plantation as a
country club.

The Farmington Country Club has enlarged its
clubhouse a number of times, but has carefully
maintained Farmington's presence as the mansion
of a large Piedmont plantation.

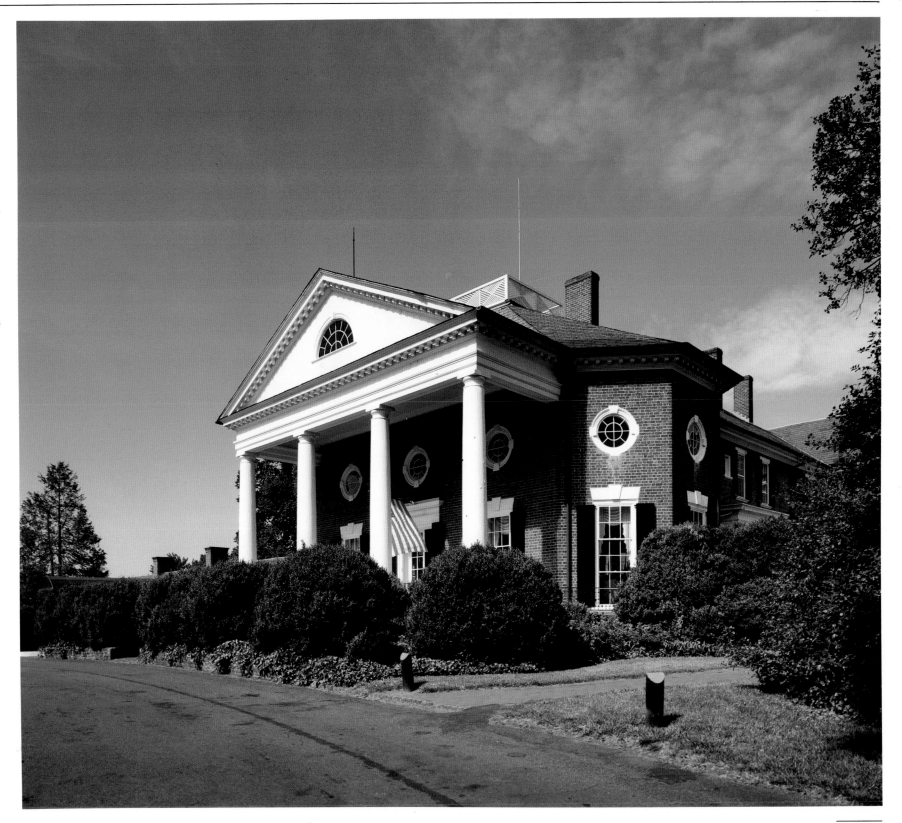

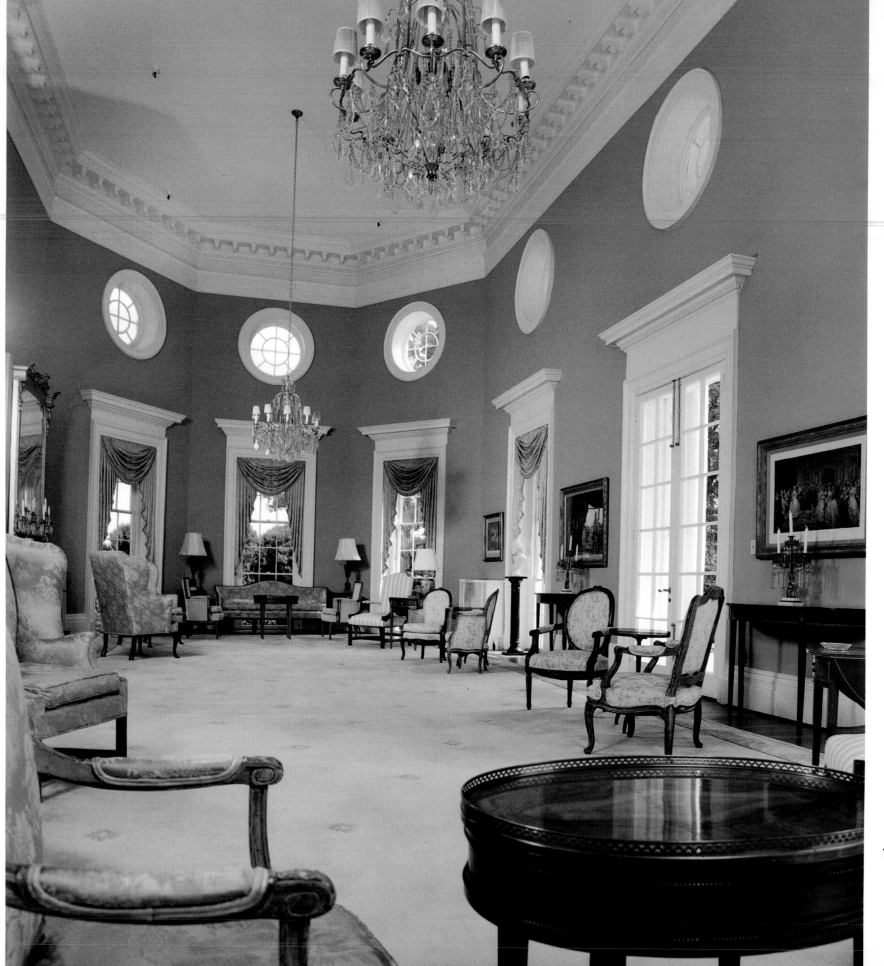

The parlor at Farmington

University of Virginia, 1819

Charlottesville

It was Thomas Jefferson's dream to build an "academical village" with ten pavilions, each a two-story, templelike building representing a classical order of architecture, with a classroom below, professor's lodging above, and gardens in the rear separated by brick serpentine walls. Students were to be housed in "cells" fronted by colonnades. Jefferson arranged the pavilions on two sides of a long rectangle, five to a side facing a green terraced area called the Lawn. At the high northern end of the Lawn, dominating the village, he placed a domed rotunda (suggested by Benjamin Latrobe) to house assembly rooms and the university's library.

Jefferson staked out the location of the first pavilion in 1817, hired the workmen, designed the school curriculum, and selected the faculty. When work was well under way, over one hundred artisans were involved, many of whom spread Jefferson's architectural ideals across the state.

In his epitaph, Jefferson wished to be remembered as "Author of the Declaration of Independence, and of the Statute of Virginia for Religious Freedom, and Father of the University of Virginia."

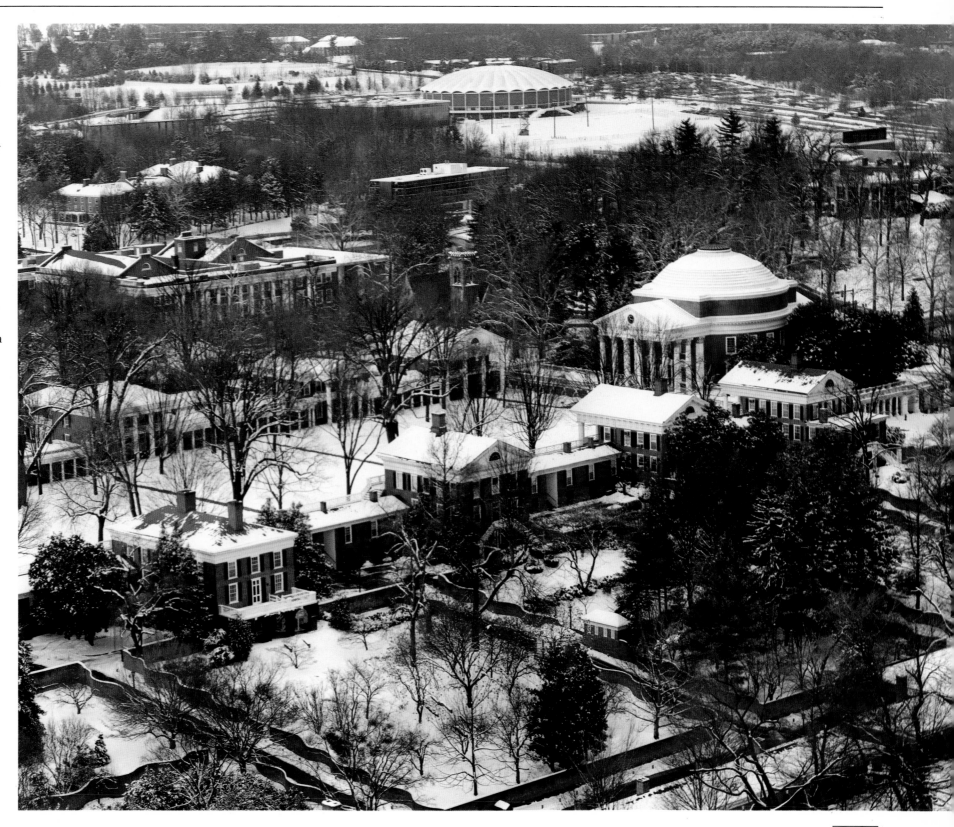

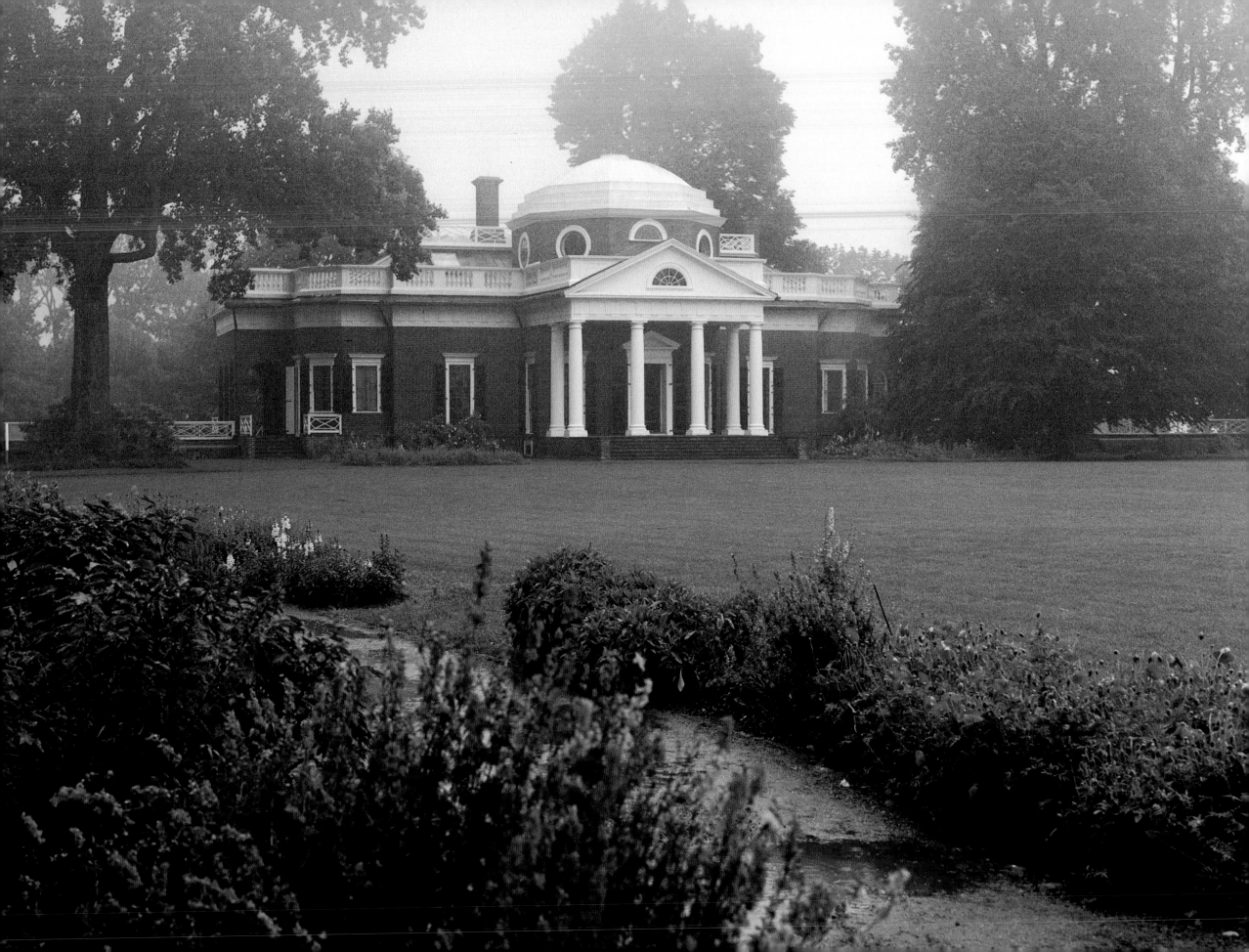

Monticello, 1768–1809

Albemarle County

Thomas Jefferson inherited 5,000 acres of Piedmont land near Charlottesville when he was only fourteen years of age. He began construction of his manor house when he was twenty-five by leveling the top of a "little mountain" where he was to spend the next forty years "putting up and tearing down," with time out to serve as governor of Virginia, United States minister to France, secretary of state for George Washington, vice-president for John Adams, and president.

After each tour of public service, Jefferson was eager to return to Monticello, making changes in the house, planting new crops, and, in his last years, planning the campus and buildings of the nearby University of Virginia.

Monticello was the center of a large agricultural enterprise and included stables, a smokehouse, house servants' quarters, and an icehouse concealed beneath the terraces. At a lower level below the crest of the hill were other buildings for weaving, making nails, and carpentry, as well as slave quarters and more stables.

Such a large enterprise requires the constant attention of the owner, and Jefferson was absent from Monticello serving the Republic for much of his life. The expense of regularly altering and repairing the house and of entertaining a constant stream of visitors gradually depleted the resources of Monticello. Within a year of Jefferson's death on July 4, 1826, most of the furnishings and many of the slaves were auctioned off to satisfy debts. The great house stood vacant for a number of years, its remaining acres tenant farmed, until the Thomas Jefferson Memorial Association bought the house and 600 acres from Jefferson Monroe Levy in 1923 and began a continuing program of restoration.

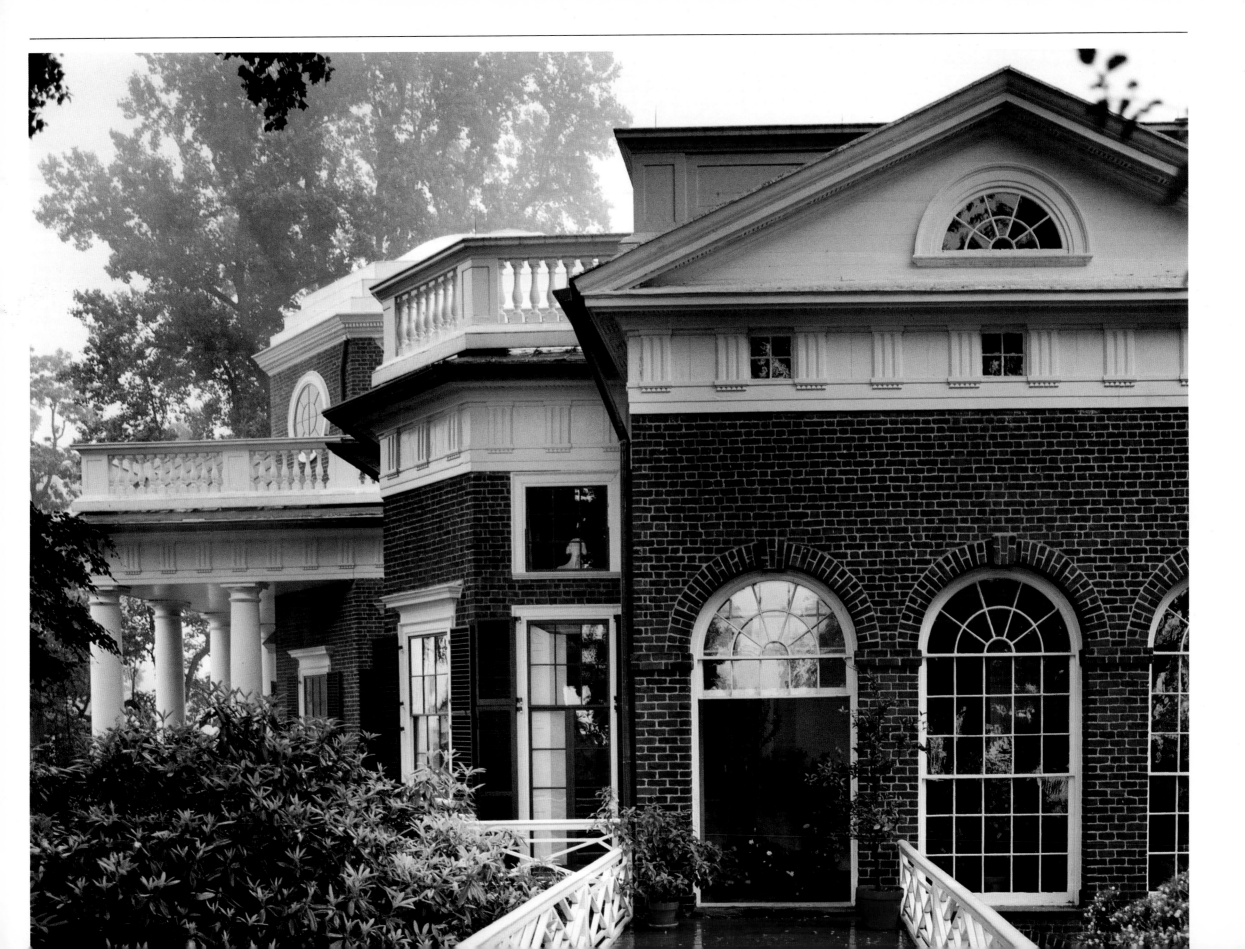

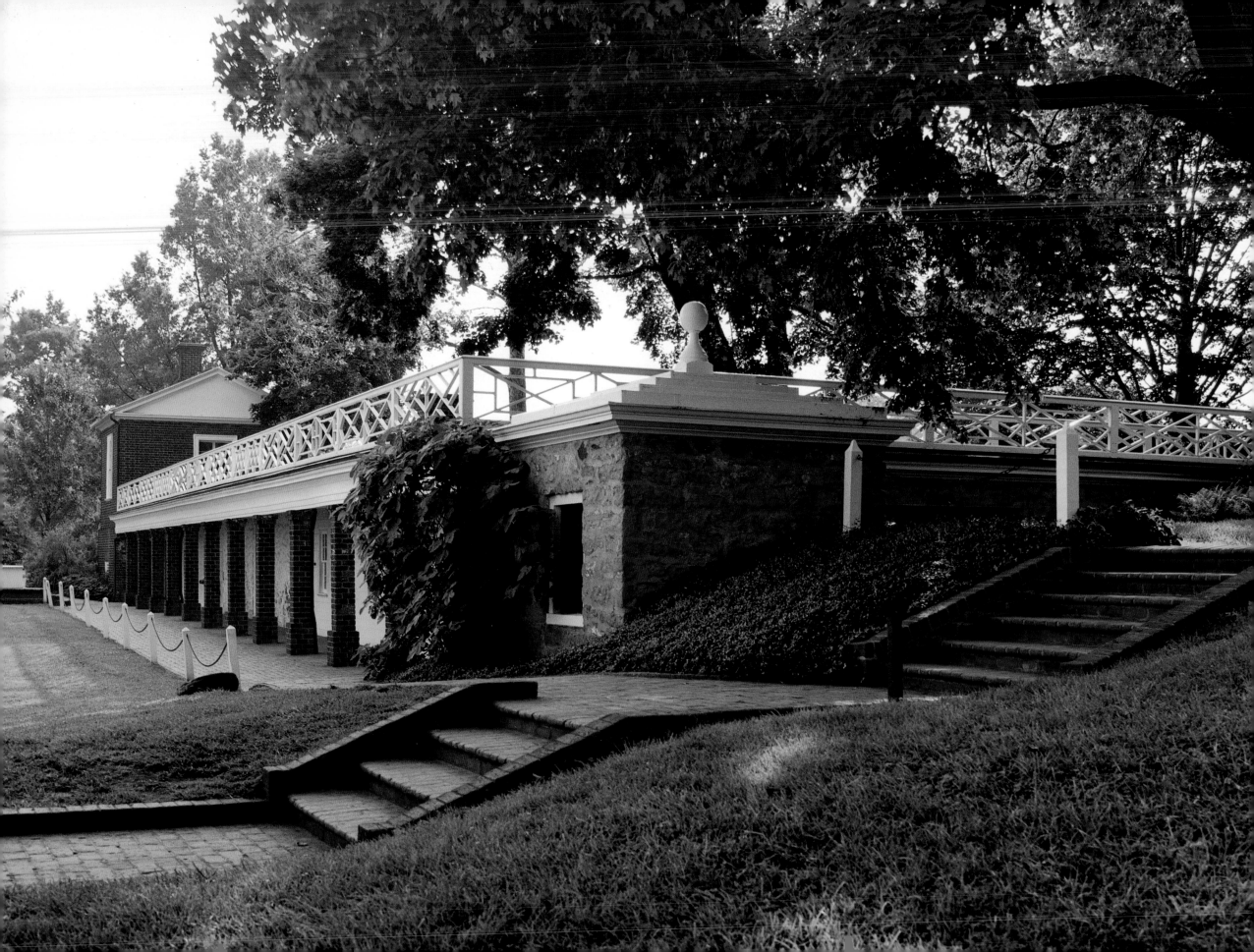

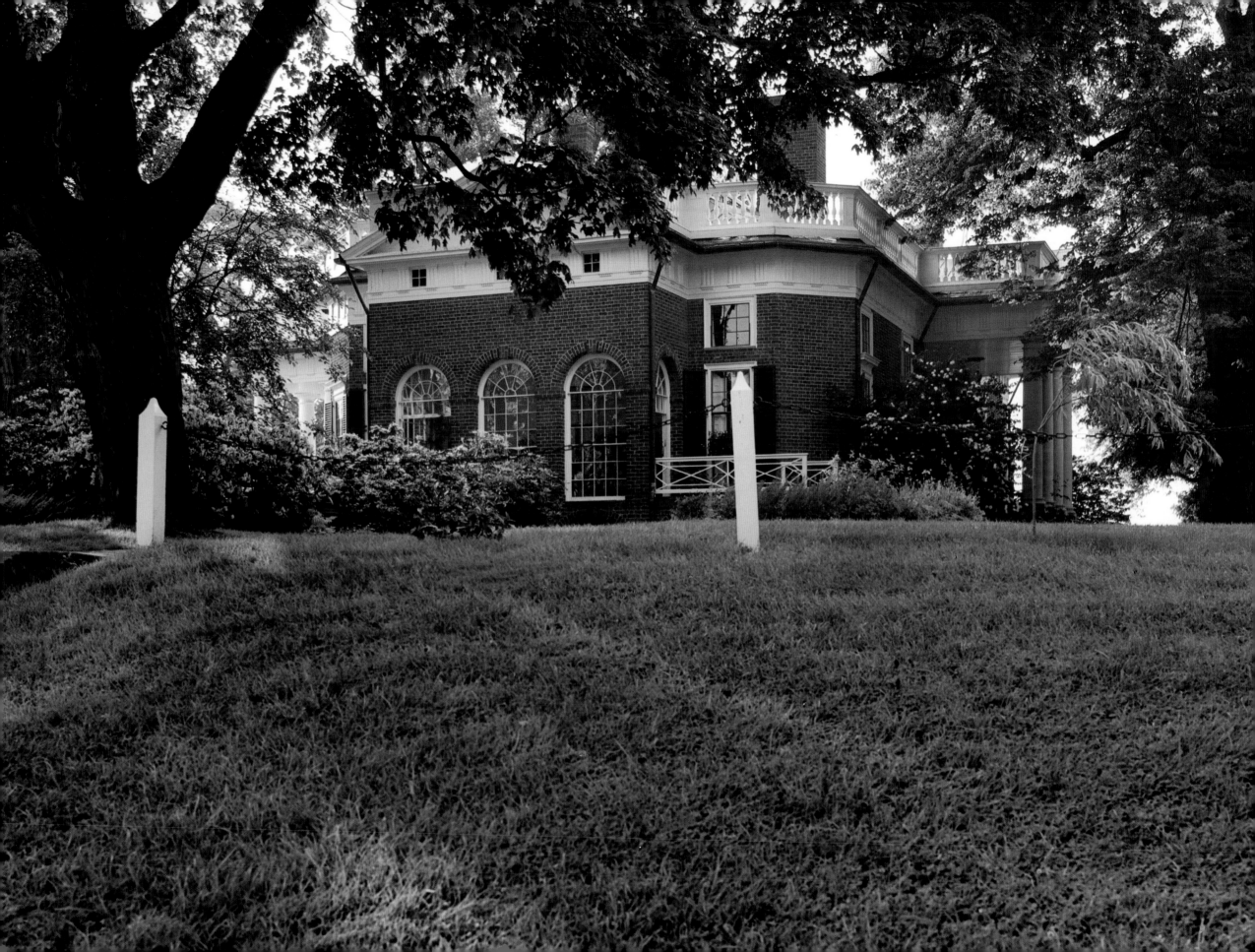

(left) *Thomas Jefferson's cabinet, or study. In the fore-ground are candles built into the handles of his chair, a pantograph, which made a duplicate copy while he wrote, and a revolving book stand. In the background is Jefferson's alcove bed, built into the wall dividing the study from the sitting room.*

(right) *The parlor at Monticello*

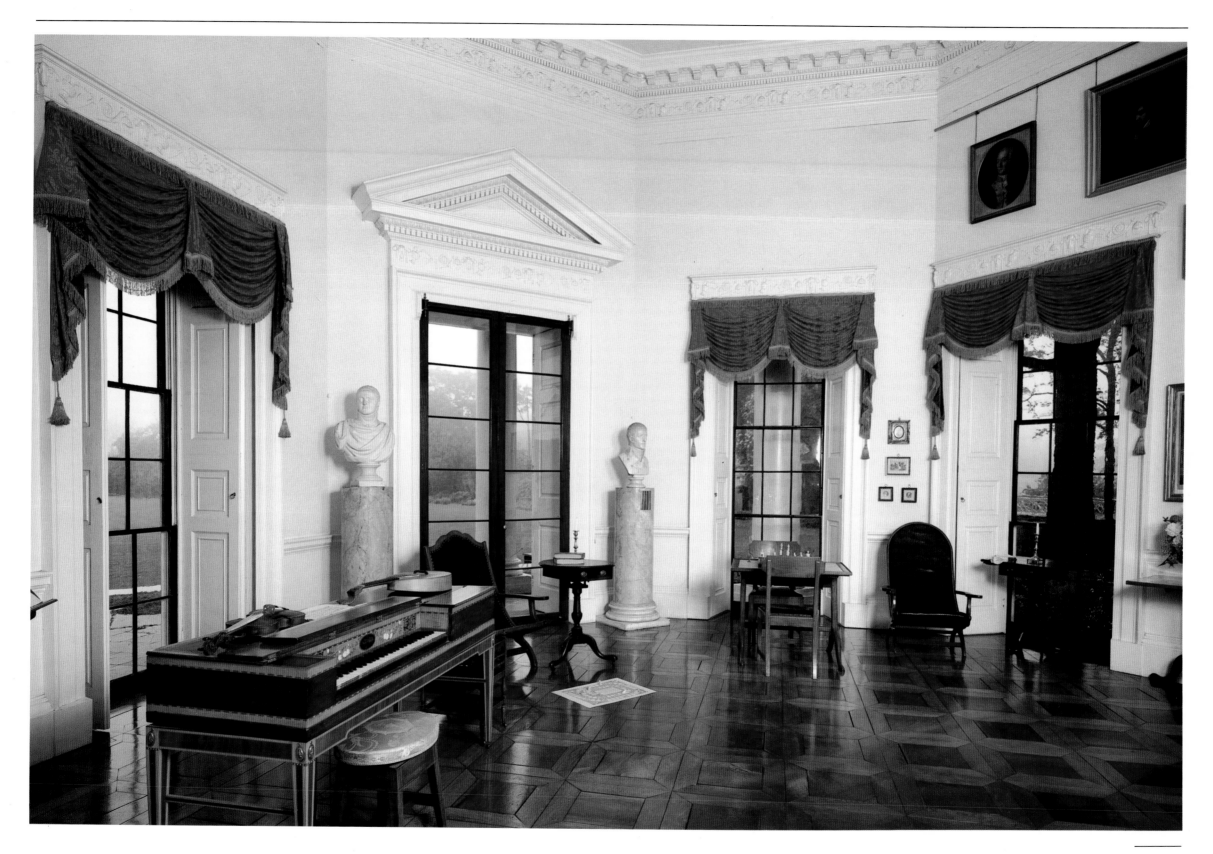

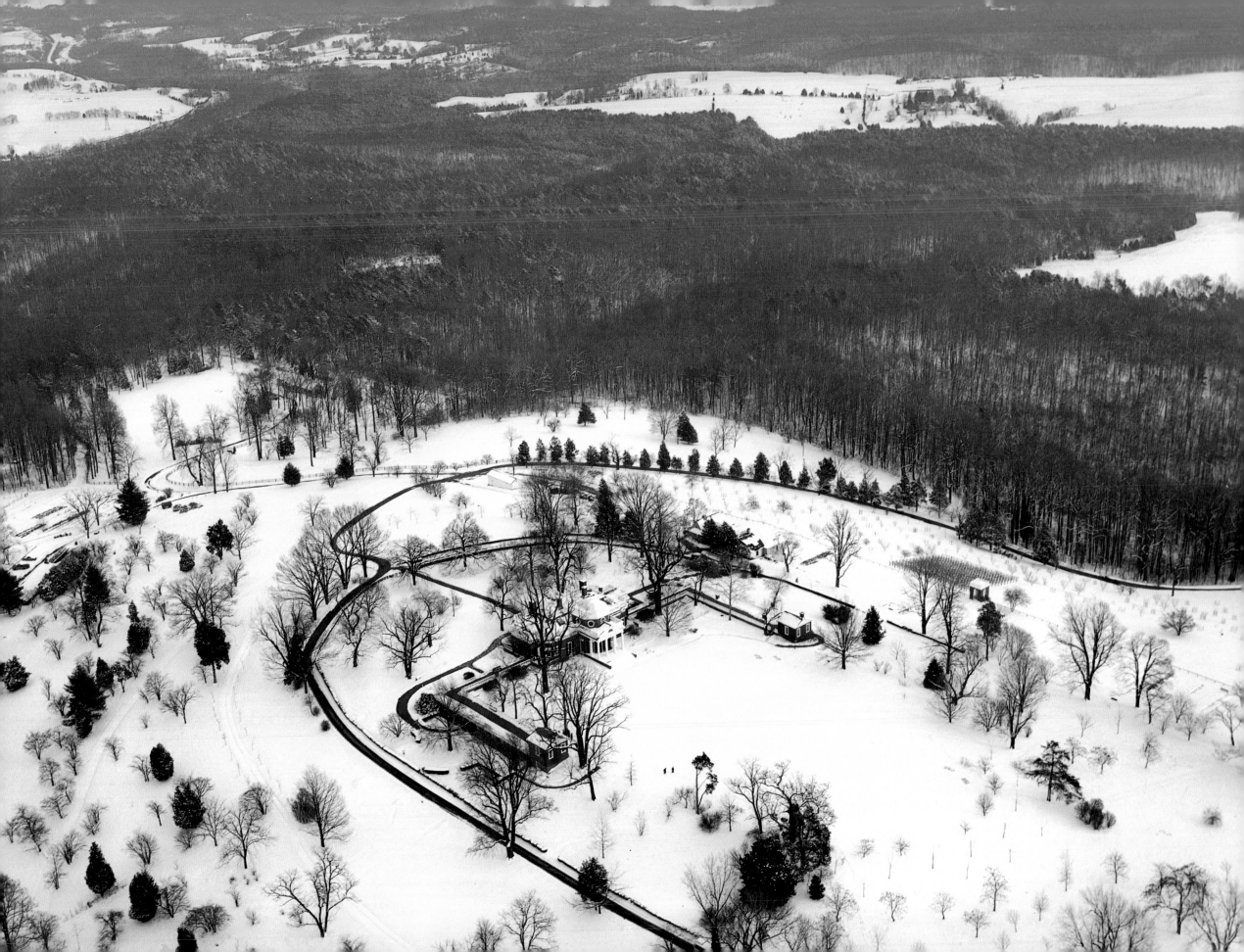

Index